THE ART INSTITUTE OF CHICAGO

VOLUME 12, NO. 2

Museum Studies

The Art Institute of Chicago Museum Studies
VOLUME 12, NO. 2

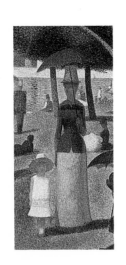
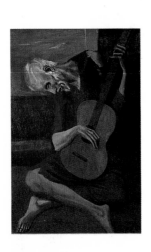

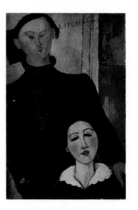
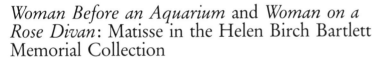
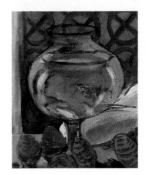

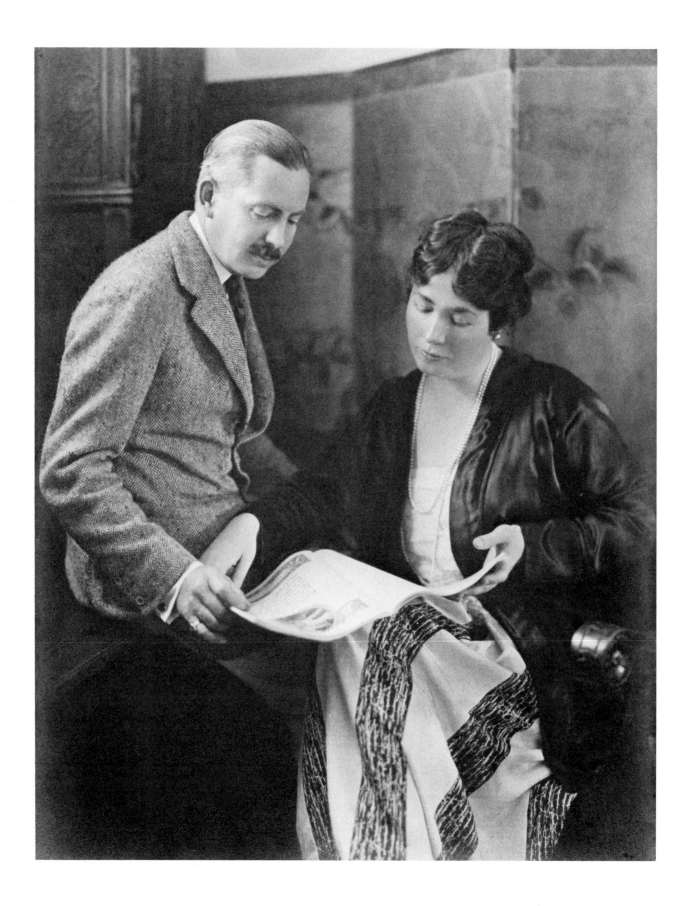

Preface

*I*t is with particular pride that we present this special issue of *Museum Studies*, dedicated to the Helen Birch Bartlett Memorial Collection. Since 1926, when this extraordinary collection of twenty-four "modern" paintings was presented to The Art Institute of Chicago, they have had a special meaning for the hundreds of thousands of visitors who have come to the museum to admire, enjoy, and study them each year.

A museum's character is determined by many factors—some accidental, some by design. The shape and distinction of the Art Institute's collections were certainly cast early in this century by men and women who were determined to provide a rough pioneer town with the best of man's artistic achievements. The Art Institute would not be the singular repository of nineteenth- and twentieth-century European art that it now is without the vision and efforts of many, not the least of whom were Frederic Clay Bartlett and his second wife, Helen Birch Bartlett (fig. 1). The Helen Birch Bartlett Memorial Collection forms the core of one of the finest holdings of Post-Impressionist and School of Paris work anywhere. At its center, of course, is one of the greatest paintings in the Art Institute, Georges Seurat's *Sunday Afternoon on the Island of La Grande Jatte*, which inspired its new owners to upgrade their collection and to strive to obtain pictures that would be worthy of a public institution rather than a private residence. In turn, once acquired, the collection has stimulated subsequent patrons and curators to make additions to the permanent collection that build upon the strong foundation the Birch Bartlett Collection provided.

While most of the collection's pictures have been published over the years, a separate publication of the collection itself is long overdue. We are pleased, therefore, not only to dedicate this entire issue of *Museum Studies* to the Birch Bartlett Collection but also, in response to its importance, to be able to expand the journal to twice its normal size and increase the number of color reproductions. This issue, which includes eight articles—two on the Bartletts and six on a selection of important works from the collection—and reproduces all of the collection, has been made possible by the generous support of Evelyn Fortune Bartlett, Frederic Bartlett's third wife (fig. 2). Now in her nineties and a painter of accomplishment in her own right, she has, in the years since her husband's death in 1953, maintained an interest in seeing her husband's wishes for the collection realized. Her

FIGURE 1 Frederic Clay and Helen Birch Bartlett, c. 1923. Photo: courtesy of Libby Bartlett Sturges.

encouragement of this publication includes not only generous support for its realization but also insightful information and advice. We are deeply grateful to her.

In shaping this issue, we decided not to produce a catalogue of the collection but rather to take advantage of the format of *Museum Studies*, using in-depth articles to profile the Bartletts, explore the history of the collection, and highlight some of its paintings. The lives of Frederic Clay and Helen Birch Bartlett have been related in a carefully researched and richly illustrated article by Courtney G. Donnell, Assistant Curator, Department of Twentieth-Century Painting and Sculpture, in which she traces Bartlett's accomplished career as a painter and decorator.

The transformation of the Bartletts from a couple who indulged their interest in art by buying works by fashionable artists into courageous collectors who consciously created one of the century's most significant major modern art collections is the subject of an article by Richard R. Brettell, Searle Curator of European Painting. Mr. Brettell's analysis of the Bartletts' taste and goals in light of the activities of other collectors during the period and the nature of the art market at that time is particularly fascinating.

The process of selecting those works in a collection of masterpieces to feature here was, of course, at once enviable and difficult. In the end, we decided to concentrate on paintings about which we knew that new research had recently been or should be done, and on works that have not been extensively published elsewhere. Thus, the reader will note the absence here of emphasis on such great paintings as Paul Gauguin's *Day of the Gods* or Paul Cézanne's *Basket with Apples*. *Day of the Gods* will be featured in the upcoming Gauguin exhibition coorganized by the Art Institute, the National Gallery of Art, Washington, D.C., and the Réunion des Musées Nationaux, Paris. The Cézanne has frequently been discussed in print. The *Grande Jatte* is treated in the aforementioned article by Mr. Brettell as the impetus for the formation of the collection; an entire future publication will be devoted to the painting in honor of its one-hundredth birthday.

We are particularly gratified by the probing and intelligent research displayed by Reinhold Heller, professor at the University of Chicago and a specialist on late nineteenth-century art, in his article on the collection's superb Toulouse-Lautrec, *At the Moulin Rouge*. As he writes here, a painting we all thought we knew we hardly know at all. His absorbing and thorough exploration of the painting's subject, its history, public and critical attitudes about the artist at the time of his death, and some surprising findings by the museum's Department of Conservation have resulted in a totally convincing re-interpretation of the painting's meaning.

The museum's conservation laboratory, under the direction of William Leisher, has figured prominently in the research involved in producing this special issue of *Museum Studies*. The laboratory's examination of the Toulouse-Lautrec was the fine work of painting conservator David Kolch, who joined the Art Institute staff in August 1985. His tragic, premature death this past June brought to an end a career of significant accomplishment and promise. His work on the Toulouse-Lautrec was instrumental in Professor Heller's investigation, and the resulting article stands as a testament to his talent.

The Department of Conservation was also instrumental in helping Richard R. Brettell determine what has been for many years a disagreement between scholars as to the sequence in which Vincent van Gogh executed his three versions of the *Bedroom at Arles*, one of which is in the Bartlett Collection. In addition to the physical evidence, Mr. Brettell explores the artist's eloquent letters and compares the versions—especially their slight but telling differences—in reaching the conclusion that the Art Institute's was, in fact, the first of the three.

Chicago art historian and Picasso specialist Mary Gedo also used the facilities and skills of the conservation laboratory in her article on another "icon" in the Bartlett Collection, Pablo Picasso's *Old Guitarist*. Under the famous composition are two others, painted over by the artist and revealed in x-rays. Rather than their being purely coincidental, Gedo argues that all of the images are interrelated and can be understood in light of the painful personal transition the young Picasso was involved in at the time—leaving his parents and native Spain for a professional and adult life in France.

Another well-known picture in the collection, Amedeo Modigliani's portrait of the sculptor Jacques Lipchitz and his first wife, is the subject of an article by Neal Benezra, Associate Curator of Twentieth-Century Painting and Sculpture at the Art Institute. A

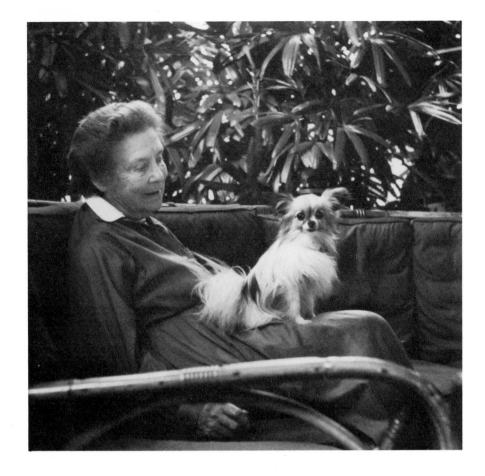

FIGURE 2 Evelyn Fortune Bartlett, c. 1982. Photo: Ralph Rinzler, Smithsonian Institution.

rare double portrait by Modigliani, the image of the Lipchitzes was commissioned by the sculptor at a moment when he had some money and his friend Modigliani had none. The deep connections and tensions between these two artists came to a head in the execution of this portrait; while not a satisfactory experience for either, it nonetheless stands as one of Modigliani's most intriguing and complex portrait studies.

Another portrait of an artist in the Bartlett Collection, but by and of much less well-known figures, is one of three works by the Swiss artist Ferdinand Hodler that together constitute a unique note in the collection. Not only was the artist Swiss, rather than French, and highly idiosyncratic, but his oeuvre has neither been well represented nor appreciated in America. In a highly informative article, Reinhold Heller provides the context of Swiss art at the turn of this century and situates the museum's three compositions—the portrait, a landscape, and a figure study—in the artist's career.

The final article in the issue highlights two paintings by the twentieth century's great colorist Henri Matisse. Catherine Bock, Professor of Art History and Criticism at the School of the Art Institute and a specialist on Matisse, considers the two compositions, both from the 1920s, in terms of the artist's formal concerns as well as in the context of his Nice period. Her discussion of the themes of the Art Institute's paintings—the modern and the costumed woman—in light of the mood of post-World War I Europe is particularly enlightening.

It seems wise to remind ourselves periodically that the Art Institute nearly refused this extraordinary gift because its quality and significance were simply not understood by the majority of the museum's leadership in the mid-1920s. Thus, in its near refusal, as well as in its acceptance and ever-increasing importance, the Helen Birch Bartlett Memorial Collection stands as a lesson and a model for us—a legacy, as Frederic Bartlett himself said, for Chicago, "the most forward-looking and advancing of all cities, [to] have an adequate expression of modern art."

JAMES N. WOOD, *Director*

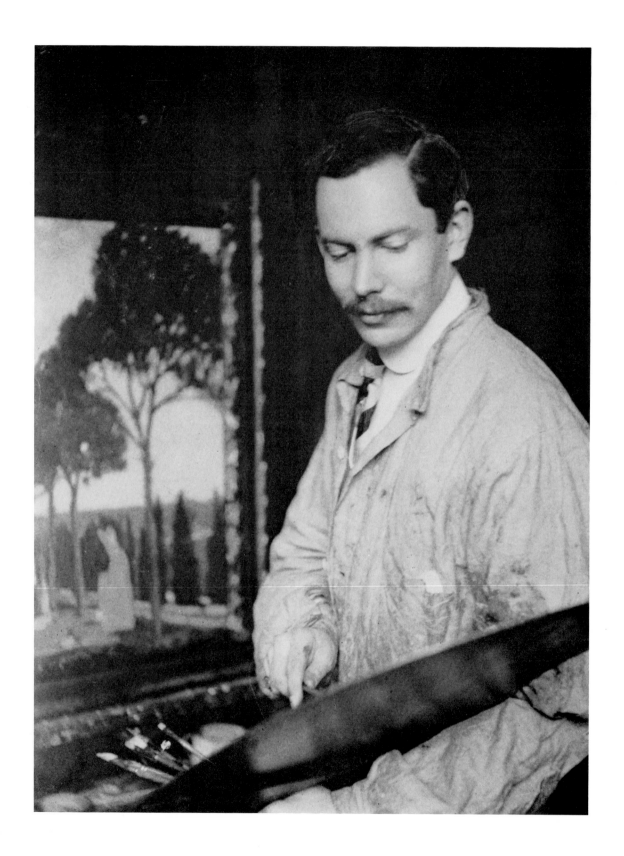

Frederic Clay and Helen Birch Bartlett: The Collectors

COURTNEY GRAHAM DONNELL,
Assistant Curator, Twentieth-Century Painting and Sculpture

*I*N 1902, when he was barely thirty, Frederic Clay Bartlett was asked by a reporter whether he should be called an artist or a collector. Bartlett replied:

I am a collector. It is a habit—a disease with me. I cannot help buying curios, antiquities, and works of art, even when I have no place to put them. . . . I store some, I weed out about half in favor of better pieces, I exchange, I sift, I sell, and then—well, then I go to work and collect more.[1]

The Helen Birch Bartlett Memorial Collection is testimony to this inclination. Given to The Art Institute of Chicago in memory of Frederic's second wife, Helen Birch, in 1926, it includes twenty-four paintings by artists then considered radically avant-garde—Matisse, Cézanne, van Gogh, Gauguin, and Seurat, for example. Bartlett's life as an artist and as part of the cultural and social circles of Chicago and elsewhere in the early years of this century is the fascinating story of a millionaire son of a millionaire who eschewed a traditional life as heir to a major mercantile establishment and instead embarked upon an uncertain creative path. His career brought him a degree of personal fame and success, particularly as a painter of murals but also as an easel painter and imaginative decorator of interiors.

Frederic Clay Bartlett (fig. 1) was born in Chicago on June 1, 1873, to Mary Pitkin Bartlett (1844–1890) and Adolphus Clay Bartlett (1844–1922).[2] His father had risen from office boy to the presidency of Hibbard, Spencer and Bartlett, a prosperous hardware company. Adolphus Bartlett came from New York State to Chicago in the 1860s. As his position in Chicago business rose, so did that as a civic leader. Among many other activities, Bartlett became a governing member of the Art Institute in 1883, just a few years after the museum's founding, and served on its board of trustees for thirty-five years.

FIGURE 1 Frederic Clay Bartlett (American, 1873–1953) at his easel, 1906.

Although he attended preparatory schools such as St. Paul's in Concord, New Hampshire, and the Harvard School for Boys in Chicago, Frederic chose not to go to college. Instead, at the age of nineteen, he left Chicago to study art in Europe. Chicago's World's Columbian Exposition of 1893 was a major inspiration for this move. In memoirs he wrote in 1932–33, Bartlett told the story of what motivated him to study abroad with his friend, Chicagoan Robert Allerton:

Tired as we were, for as was our custom, we had walked past miles and miles of pictures, a never-ending wild excitement for us. To think that men could conceive such things, and actually bring them into being on a flat bare canvas . . . we pledged our lives to the creation of beauty and forthwith determined to leave the security and luxury of home, and at nineteen to forge out into the world, to learn the techniques, secrets, and methods of artists.[3]

In 1893 or 1894, Bartlett and Allerton became among the few Americans admitted to the Royal Academy in Munich. For both, this was a vindication of sorts, since it showed their industrialist fathers, who had hoped their sons would follow them into business, that they were worthy of undertaking careers in art. During this time in Munich, Frederic met the woman who would become his first wife, Dora Tripp of White Plains, New York. After his studies in Munich ended, he and Allerton next went to Paris, where, according to his memoirs, in 1896 they enrolled in the Ecole Collin (run by Louis Joseph Collin) for drawing classes in the morning and in the Ecole Aman-Jean (directed by Symbolist painter Edmond François Aman-Jean) for painting classes in the afternoon. Bartlett spent two years studying in Paris, interspersed with trips home to see his family and fiancée and travels in Italy.

In October 1898, he and Dora Tripp were married in New York State and shortly afterward left for an extended stay in Europe, first in Paris, where Bartlett was one of the first students to enroll in the short-lived school opened by American expatriate painter James Abbott McNeill Whistler. After it closed, he devoted his full attention to mural painting and was introduced to the French master of this genre, Puvis de Chavannes. Puvis did not take pupils but offered Frederic encouragement and critical help. In a little less than a year, he and Dora found themselves drawn back to Munich, which Frederic regarded as "always to me the most beautiful city in the world."[4] Finally, after more than five years of European study, he concluded that his schooling was over, and he brought Dora to Chicago, where they settled. In 1900, he rented a studio on the tenth floor of the Fine Arts Building on Michigan Avenue, which housed many of the city's artists, musicians, and writers; and he received his first commission, a portrait, for which he was paid $75.[5]

In 1902, Frederic built his own home on fashionable Prairie Avenue, designed by the Chicago firm of Frost and Granger,[6] and named it Dorfred House, a combination of his and Dora's names. The house was only two blocks away from the Prairie Avenue home in which he had grown up. The modest brick exterior belied the extensive interior decoration by Frederic, which incorporated painted woodwork, furniture, curios, prints, and other objects, including the paneling of a German Louis XVI room the couple had found in Europe. Frederic decorated the walls of his entry vestibule with trompe-l'oeil shrubbery, pedestals, and grotesques, and painted the beams of his Renaissance music-room ceiling with animals, mottoes, and swags of fruit alternating with beams inscribed with names of great artists and musicians (see fig. 2). Running the entire width at the rear of this house was Frederic's studio. This residence

FIGURE 2 Dorfred House, Chicago, Residence of Frederic and Dora Bartlett, designed by Frost and Granger, 1902. Italian Renaissance Music Room with beams decorated by Frederic Clay Bartlett. Photo: *The House Beautiful* 12 (Sept. 1902), p. 206.

was unconventional enough to have been the subject in 1902 of a long article in *The House Beautiful* magazine.[7] Just as his house on Prairie Avenue was a joint venture with the architects, in the same way, Frederic collaborated with Chicago architect Howard Van Doren Shaw in 1905 on the design of Bartlett's father's country estate, House in the Woods, at Lake Geneva, Wisconsin.[8] Here, Frederic's wall decorations consisted of patterns of flower baskets, garlands, and wreaths. His studio in Wisconsin was a detached structure, placed in symmetrical relationship to the main house and gardens in a traditional Italianate manner. The house on Prairie Avenue has been torn down, but the Lake Geneva residence still stands.

In his work, Frederic always integrated painting, architecture, and decoration. His career was most active during the years after he returned to the United States and before the death of Dora in 1917. In 1900, he received his first large mural commission, for the decoration of the Second Presbyterian Church in Chicago. He filled this building, redesigned by his friend Shaw after a fire, with frescoes depicting the Tree of Life and a Heavenly Choir painted in the Byzantine manner.[9] In 1904, for the lobby of the Frank Dickinson Bartlett Memorial Gymnasium at the University of Chicago, given by his father in memory of Frederic's younger brother, who died in 1900, he painted a frieze (fig. 3) showing a medieval tournament procession. He also designed the drop curtain in the university's Reynolds Club Theater. In 1909, he created an extensive series of over fifty panels, depicting a Gothic hunt and feast, for the ceiling of the Michigan Room of the University Club of Chicago. His cartoons for these panels and designs for stained glass for the club were exhibited at the Art

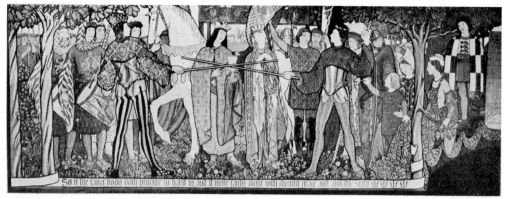

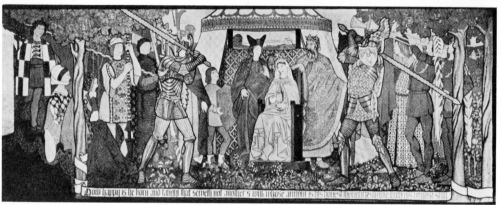

FIGURE 3 Frederic Clay Bartlett. *Medieval Athletic Tournament*, 1904. Murals for the lobby of the Frank Dickinson Bartlett Memorial Gymnasium, University of Chicago. Photo: University of Chicago Archives.

FIGURE 4 Frederic Clay Bartlett. *Bassin de Diane (Fountain of Diane), Fontainebleau*, c. 1907. Oil on canvas; 68.4 × 76.2 cm. The Art Institute of Chicago, Mr. and Mrs. Martin A. Ryerson Collection (1933.1181). This painting appeared in the Art Institute's American Exhibition in 1907.

FIGURE 5 Helen Louise Birch,
date unknown. Photo: Antiochiana
Collection, Olive Kettering
Library, Antioch College, Yellow
Springs, Ohio.

FIGURE 5 Helen Louise Birch, date unknown. Photo: Antiochiana Collection, Olive Kettering Library, Antioch College, Yellow Springs, Ohio.

Institute in 1908. This was not the first time his work was shown at the museum. In fact, it appeared regularly in the Art Institute's annual American Exhibitions starting in 1898 (see fig. 4) and continued through the "Century of Progress" exhibition of 1933; Bartlett was also represented in the museum's Chicago Artists Exhibitions beginning in 1901, and he had numerous one-man shows at the Art Institute and elsewhere throughout his career. Among his awards were an honorable mention at the Carnegie International, the Art Institute's Cahn Prize in 1910, and silver medals at the St. Louis Exposition of 1904 and at the Pan American Exposition in San Francisco in 1916. His work was acquired for the collections of the Carnegie Institute, Pittsburgh; the Corcoran Gallery, Washington, D.C.; and The Art Institute of Chicago. Bartlett's easel paintings were competent reflections of the academic techniques he absorbed from his various teachers, from the Munich Academy to Whistler. While his murals were perhaps more individualized, they reveal an allegiance to the compositions of Puvis de Chavannes and the style of the Pre-Raphaelites.[10]

Dora and Frederic soon became part of Chicago's fashionable circle.[11] Their son, Frederic Clay Bartlett, Jr., called Clay, was born in 1907.[12] Ten years later, Dora, who was described as "one of the prettiest, sweetest, and most entertaining women of the South Side,"[13] died, after nineteen years of marriage.

In 1919, Helen Louise Birch (fig. 5) became Frederic's second wife. She was also a child of a pioneer Chicago business and civic leader. Born in Chicago on February 27, 1883, to Maria Root Birch (1848–1913) and Hugh Taylor Birch (1848–1943), Helen was the only one of three children to survive past her twenties. Hugh Birch was as much a self-made man as Adolphus Bartlett. Like Bartlett, he arrived in Chicago in the 1860s. He had left Yellow Springs, Ohio, where his father, Erastus Birch, had followed educator Horace Mann to participate in the early days of Mann's educational experiment, Antioch College, as a financial supporter and trustee of the school. Although Birch had nearly completed all his studies at Antioch, he lacked one passing grade for graduation (he did not receive his degree until 1929 in a special ceremony). Nonetheless, he set out to become a lawyer in Chicago.

Through a family introduction, he obtained an unpaid position in the firm of Hervey, Anthony and Galt, in exchange for use of the law firm's library. At the time of the 1871 Chicago Fire, he was a junior partner; it is said that he and another junior partner, having stayed in the firm's offices to save its papers and records, were the last to cross the bridge over the Chicago River before flames engulfed it.[14] Hugh Birch became a partner of Galt, Birch and Galt and in 1872 was appointed the first State's Attorney of Cook County, Illinois.

The World's Columbian Exposition of 1893 propelled both Hugh Birch and Frederic Bartlett away from Chicago, although for entirely different reasons. Always a lover of nature, Birch became uncomfortable with the commotion created by the fair and sought respite in the then unpopulated land along the Florida coast. Leaving his wife and family in Chicago, he took the railroad to its terminus in Florida and then sailed to the area that is now Fort Lauderdale. Some of his early land purchases included acreage he later deeded to the state, most significantly Birch State Park.[15]

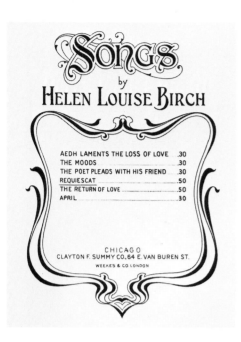

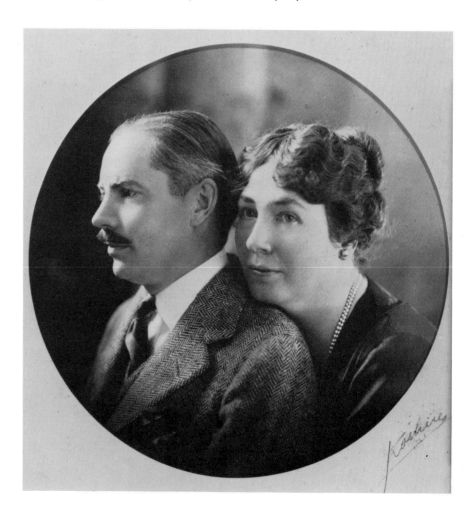

Helen Birch was educated mainly by governesses. As the only daughter, she was doted upon by her father; she went as a young girl to Europe with her parents and spent much time with her father on their land in Florida. According to one report, "Even when her mother wanted her to go to Europe for the opera season the little girl always stipulated that before sailing she was to have her winter with her father in Florida."[16] Helen's mother died in 1913.[17]

Even though she could have led a comfortable and idle existence, Helen chose not to. She was both a published composer and poet. She studied music with the German expatriate Bernhard Ziehn, a music theorist and teacher of harmony and composition in Chicago; in 1915 and 1916, several of Helen's songs, settings for poems by Yeats, Matthew Arnold, and others, were published by a Chicago music company (see fig. 6). Between 1919 and 1926, her poems and book reviews were published in *Poetry* magazine, the famous journal started in Chicago in 1911.[18] Since its founder, Harriet Monroe, was a friend, Helen's first submission to the magazine was sent in 1917 under a fictitious name. *Capricious Winds*, a book of her collected poems, was published posthumously in 1927.

Helen Birch and Frederic Bartlett (fig. 7) were married January 22, 1919, in Boston at a private ceremony attended only by Senator and Mrs. Albert

FIGURE 6 Title page of sheet music by Helen Louise Birch, 1915. Photo: Janet Fairbank Collection, The Newberry Library, Chicago. Used by permission of Summy Birchard Music Division of Birch Tree Group, Ltd., successor to Clayton F. Summy Co.

FIGURE 7 Frederic Clay and Helen Birch Bartlett, c. 1923. Photo: courtesy of the late John Gregg Allerton.

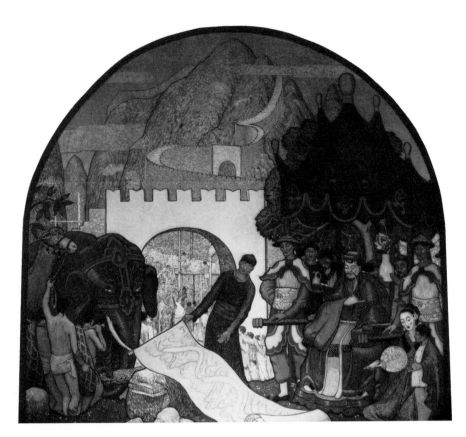

FIGURE 8 Frederic Clay Bartlett. *Great Walls: The Great Wall of China*, 1920. Mural lunette in Ryerson and Burnham Libraries, The Art Institute of Chicago. 144 × 138 cm. Gift of Frederic Clay Bartlett (1921.106a). (No longer visible.)

Beveridge and Mrs. Marshall Field, Sr., relatives of Helen's. A widower for two years, Frederic was forty-five and Helen, who had never before been married, was thirty-six. Helen's father called Frederic Bartlett a "splendid son-in-law,"[19] and, indeed, the couple was well suited, alike in their cosmopolitan experiences and in their tastes for music and art in many forms. They spent their honeymoon in the Orient, traveling to Japan, China, and the Philippines. The trip inspired paintings by Frederic that were shown in the Art Institute's American Exhibitions of 1919 and 1920, as well as in his one-man exhibition at the Montross Gallery in New York in 1921. The twenty-one paintings in this exhibition included landscapes of Hong Kong, Canton, Shanghai, Soochow, Peking, and Manila and formed the core of exhibitions held later that year at the Art Institute and at the Memorial Art Gallery in Rochester, New York. Perhaps the most dramatic outcome of Bartlett's Chinese experience were two large lunettes he did for the Art Institute's Ryerson Library in 1920. Entitled *Great Walls: The Great Wall of China* (fig. 8) and *Great Walls: Walls of Steel Scraping the Sky*, these murals were covered in later remodeling.

During their brief marriage, which lasted only six-and-one-half years before Helen's death in 1925, the Bartletts actually spent little time in Chicago, leading instead a rather nomadic life. Their many trips to Europe alternated with stays in their residences in New York City, Massachusetts, and Fort Lauderdale.[20] Frederic continued to paint and exhibit in these years, showing one painting in each of the 1921, 1922, 1924, and 1925 American Exhibitions at the Art Institute.

While he had been eclectic in his collecting tastes in prior years, in the 1920s, after his marriage to Helen, Frederic turned his attention to works of avantgarde, mainly French, artists. There is no written evidence that indicates why this focus occurred, whether it was due to Frederic, Helen, or to the influence of an outside advisor. As we have seen, Frederic was no stranger to experiencing

the new. He was in Paris when the Durand-Ruel Gallery showed an exhibition of the Impressionists in 1896. He later wrote: "Looking back on it, it hardly seems possible that such an uproar could be created because a small group of men, banded together by a common creed, saw vibration in sunlight and blue and purple in shadows."[21] As for Helen, a friend said that "contemporary experience and expression enthralled her."[22] Family sources suggest that Helen played an active role in their collecting activities.

Helen wrote a friend in 1922 that, after a trip to Europe, "Frederic brought away treasures of painting and sketches which someday not far in the future will be seen."[23] This statement reflects an idea that made the Bartletts somewhat unusual among collectors at the time: their clear intent to share the contemporary art they were collecting with a public audience. Despite its small size, the Bartletts' collection soon amounted to one of the most adventurous and radical groups of work by Post-Impressionist artists to have come to America, rivaled only perhaps by the collections assembled by the New York lawyer John Quinn and by Albert Barnes in Philadelphia. The article "The Bartletts and the *Grande Jatte*," by Richard R. Brettell (pp. 103–13), details the history of the formation of the Bartlett Collection and the climate in which it was assembled.

In 1929, Frederic was a guest speaker at a meeting of the Art Institute's Antiquarian Society, where, according to the museum's newsletter, he "told of interesting experiences he and his wife had while acquiring the . . . collection, which was gathered in France, one at a time, and at much labor and expense."[24] Regrettably, a more detailed record of this talk does not exist, and much of the history of the collection's formation remains unknown.[25]

Prior to the memorial gift, the Birch-Bartlett Collection was exhibited five times. When it was first shown at the Art Institute, in September 1923, the museum's newsletter carried the following announcement:

Studying a group of paintings thoroughly for weeks at a time, going back and forth each time to gain a fresh viewpoint, is a good way to find out whether a picture "wears" well or not. That is the method pursued by Mr. Frederic Clay Bartlett, who collected the modern French paintings of the Birch-Bartlett Collection now being shown in Gallery G.60, in the Art Institute. Mr. Bartlett has just returned from Paris, where the paintings were purchased, and many of them are now being shown in a public gallery for the first time. Mr. Bartlett, who is a painter of widely established reputation, has acquired some of the canvases, not because he is a convert to the revolutionary theories of the post-impressionists, but because he wished to make a thorough study of their methods at first hand. Examples of practically all of the French artists of the modern school are in the Birch-Bartlett Collection, which will remain on view through October.[26]

The somewhat apologetic tone of this statement indicates a need on the part of the museum to justify the display of "revolutionary" art in 1923. In that year, Frederic, like his father before him, became a trustee of the Art Institute, a role he filled until 1949, when he was made an honorary trustee.

Helen Birch Bartlett died of cancer on October 24, 1925, in New York at the age of forty-three. Her personality and philosophy were described by a friend in the introduction to Helen's book of poetry:

The delight of life! That was Helen Birch Bartlett's precious gift, both to give and to receive. In the few years of her marriage her quickened interest in existence led her into new fields. . . . Modern art made an irresistible appeal to her. She had always wanted people to express life as they really saw it, unsentimentalized and un-shadowed by tradition, and this at once made rational to her the new forms in music, letters and painting. . . .[27]

Newspaper reports of her death listed monetary bequests to relatives and friends and said that the art collection would go to the Art Institute.[28] The deed of gift was proposed in December 1925 and accepted by the museum's Painting and Sculpture Committee on January 26, 1926, as elaborated further by Frederic. One of the conditions he asked for in making the gift was that "the . . . collection of pictures shall, when exhibited, always be hung as a unit with certain exceptions, and designated as the 'Helen Birch-Bartlett Memorial.'" Another was the stipulation that Frederic be allowed, with trustee approval, to make additions to the collection that would either exemplify the newest trends or be works of an earlier period that influenced the modern movement.[29] In making this stipulation, Frederic seems to have been influenced by the flexible nature of a gift presented to the Art Institute by Chicago businessman Joseph Winterbotham. In 1921, Winterbotham had established a fund for the purchase of thirty-five paintings by foreign artists, chosen by the trustees and a Winterbotham Committee, on which Frederic actively served as trustee chairman for several years. A unique provision of the Winterbotham Plan allows for sale or exchange of paintings taken into the collection based on curatorial and committee decision.[30] Accompanying the deed of gift was a letter from Frederic that ends with the following: "I trust that the simple fact may shine through that along with those who have made gifts for contemporary art at the Institute, our thought has been that Chicago, the most forward-looking and advancing of all cities, should have an adequate expression of modern art."[31]

It is likely that the acceptance of the Birch Bartlett gift was not easy or unanimous. In considering the gift, the museum's trustees were in effect being asked to trust the instincts of a private collector and a director, Robert Harshe, who favored the modernists. In several articles about the reception of the collection, phrases can be found such as "finally accepted after seriously debating the acquisition," "accepted, a bit grudgingly," and "rather reluctantly, at first."[32] In a 1935 newspaper article, Harshe is described as nearly having had to go down on his knees to beg for acceptance by skeptical trustees of the paintings, prophesying that within ten years the collection would be the "glory of Chicago." Acceptance was by "narrow vote, probably more out of deference to the Bartlett family than for any convictions about the paintings."[33]

The Helen Birch Bartlett Memorial Collection was permanently installed at the Art Institute on May 4, 1926. This event was recorded in newspapers from Fort Worth and Pittsburgh to Des Moines and in periodicals such as *Art News*, where it was featured as a front-page story in the May 8, 1926, issue. A heavily illustrated article appeared in the June 1926 issue of *The Arts* and others followed in different publications. A small catalogue of the collection was published in 1926 with reprinted editions in 1929 and 1946.[34]

In accordance with Frederic Bartlett's intention to "build up the quality rather than the quantity of the collection to the highest point within [his] means and ability during [his] lifetime,"[35] several changes in the content of the collection occurred in the late twenties, with the final addition being made in 1932 (see below). Friesz's *La Myrka* (fig. 9), a painting that was included in the original gift, was returned to Paris and sold; Maurice Utrillo's *Rue d'Orchamps* was also removed.

FIGURE 9 Emile Othon Friesz (French, 1879–1949). *La Myrka (Nude)*, 1924. Oil on canvas; 116.8 × 81.3 cm. Present whereabouts unknown. Photo: *Modern Paintings in the Helen Birch Bartlett Memorial from the Birch-Bartlett Collection* (Chicago, 1926), p. 29.

When the collection was unveiled, one newspaper called it "the best and most representative collection in the United States, if not in all Europe."[36] The headline of an editorial in a New York paper read: "Chicago Leads the Way." The editorial said, "Americans who wish to enjoy the acquaintance of the leading European modernist artists must make the journey to the metropolis of the Middle West, for since the disposal of the John Quinn collection here, there is no representative aggregation of their work in this neighborhood."[37]

That Chicago, rather than New York, had the first collection of works by Post-Impressionists and first-generation modern artists on permanent display in a public gallery was a major event. But it should be remembered that Chicago was consistently in the forefront of adventurous exhibiting and collecting. The Potter Palmers and Martin Ryersons, founding members of the Art Institute, traveled widely and collected paintings by Monet, Renoir, and other Impressionists before they were widely accepted and later presented their collections to the museum. In 1913, the Art Institute hosted the famous Armory Show.[38] Forty years old at that time, Frederic Bartlett would have seen represented there many of the avant-garde artists whose works he later purchased: Cézanne, Gauguin, van Gogh, Matisse, and Picasso.

While Bartlett did not buy work from the Armory Show, several Chicagoans did. One of them, Arthur Jerome Eddy, a lawyer, published in 1914 the first book in English on modern art.[39] The Helen Birch Bartlett Memorial Collection was established in Chicago three years before the founding of New York's Museum of Modern Art. It is not surprising that Frederic was asked to join the board of directors of that new museum, which he served as a trustee from 1929 to 1935, when he was elected an honorary trustee.

As he had done for so many of his own interiors, Bartlett personally oversaw the initial installation of his collection at the Art Institute, specifying that the

FIGURE 10 The Helen Birch Bartlett Memorial Collection, installed with frames designed by Frederic Clay Bartlett, The Art Institute of Chicago, c. 1931.

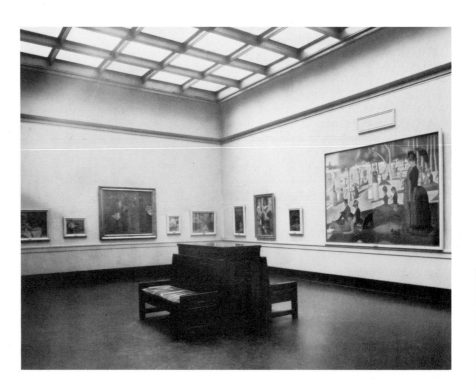

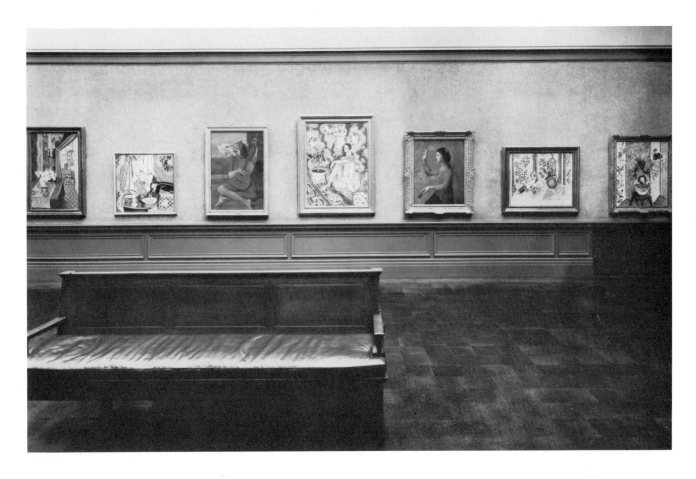

woodwork and frames of the paintings be uniform in style (see fig. 10) and done in white, an effect that was described at the time as "a novel setting of ivory."[40] The room was stripped of extraneous decorative moldings and ample space was provided between the works of art. With this neutral, modernist environment, Bartlett sought to provide a harmonious and unified arrangement.[41]

Over the years, changes have been made at the Art Institute in the location of the gallery and in the framing of the collection. One drastic change came about as a result of the Art Institute's "Century of Progress" exhibitions, monumental loan shows held in conjunction with the World's Fair in 1933 and 1934. Since the exhibitions used almost all the museum space and also since many of the Birch Bartlett pictures were included, juxtaposed with other paintings by the same artists (see fig. 11), the collection's display as a unit was disturbed. When it was proposed to keep the chronological arrangement of the museum's collections after the "Century of Progress" exhibitions closed, Frederic objected to Harshe: ". . . a very strong point for keeping this particular collection as a unit is that it covers one period only Cezanne to Matisse. . . . To be very concrete I believe the value to the Art Institute, in which I am primarily interested, of the Helen Birch Bartlett Memorial room as a unit is far greater than could ever be scattered historically through various rooms."[42] Frederic Bartlett's wishes were followed, and the collection today, as it has for many years, hangs together in one room (see fig. 12).

FIGURE 11 "Century of Progress" exhibition installation, The Art Institute of Chicago, 1933, showing Picasso's *Old Guitarist* (third from the left), from the Bartlett Collection, integrated with other paintings by Picasso and Matisse lent to the exhibition.

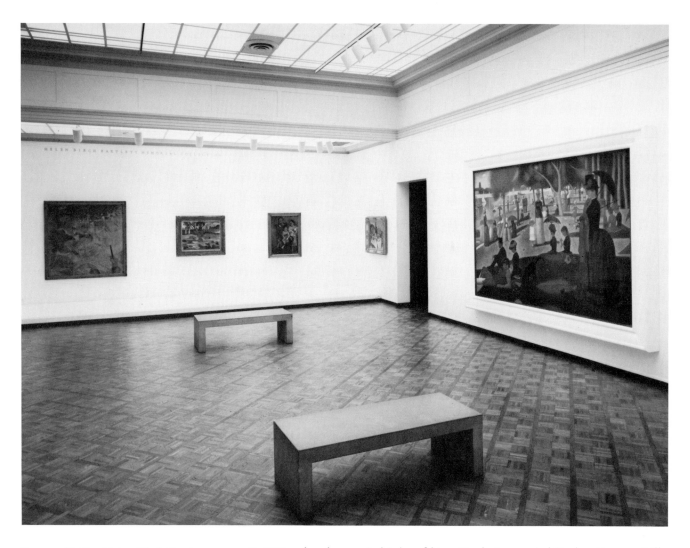

FIGURE 12 The Helen Birch Bartlett Memorial Collection, The Art Institute of Chicago, as installed in 1986.

In 1931, when he was in his late fifties, Frederic married Evelyn Fortune Lilly (b. 1887), of Indianapolis (fig. 2, p. 83). They had first met while Helen was still alive, and their paths crossed again, after Helen's death, in Beverly, Massachusetts. Frederic's ties to Chicago loosened with this marriage, as he gave up his apartment on Astor Street and studio in the Fine Arts Building to live instead in Massachusetts and Florida. A cataract operation in 1932 curtailed his own painting career but propelled Evelyn Bartlett toward one of her own.

Even though Frederic was unable to paint because of his failing eyesight, they took a studio in Munich, where he wrote his memoirs[43] and where Evelyn, with her husband's encouragement, took up painting. Her work in watercolor and oil, mainly still lifes and portraits, rapidly developed and she began to exhibit. An *Art News* review of her solo exhibition at New York's Wildenstein Galleries in 1935 described her work as "sophisticated paintings, clever in their color harmonies and contrasting patterns."[44]

Toulouse-Lautrec's *Ballet Dancers*, purchased in 1932, was not only the final addition to the Helen Birch Bartlett Memorial Collection but also the last painting acquired by Bartlett.[45] His intense involvement in collecting was over.

In the years that followed, no other institution ever received a gift from Bartlett of the magnitude of the Art Institute's. The Indianapolis Museum of Art was presented with a bust by Paul Manship of Senator Beveridge, and The Museum of Modern Art was given Amedeo Modigliani's *Bride and Groom* of 1916 in 1942 (see fig. 2, p. 190). In the last decades of his life, Frederic indulged his interest in beautifying his Florida estate. He suffered a partially disabling stroke four years before his death in 1953. In May 1954, the Art Institute staged a memorial exhibition comprising nearly twenty of his paintings.

In his letter proposing his memorial gift, Frederic stated, "With the Potter Palmer and Martin Ryerson collection of Impressionists and Mr. Winterbotham and Mr. Ryerson's examples of the moderns, and the Birch-Bartlett Collection . . . I think that we can justly feel that we have a stronger collection of modern art along these lines than any other museum."[46] The Helen Birch Bartlett Memorial Collection brought to the Art Institute's permanent collection its first paintings by Picasso, van Gogh, and Cézanne. In fact, the only other works by modern European artists in the museum prior to this gift were by Matisse and Gauguin, both part of the Joseph Winterbotham Collection. Even though Bartlett's own art never reflected the influence of the artists he later sought to acquire, the contribution he made as a collector to furthering the acceptance of modern art cannot be underestimated. As the permanent home of the magnificent paintings collected by Helen and Frederic Bartlett, the Art Institute continues to enrich its visitors with this public legacy of the finest sort.

NOTES

The author is especially grateful for the valuable support and guidance received from Evelyn Fortune Bartlett, and for the assistance of Frederic's nephew, Bartlett Heard, and of his grandchildren, Libby Bartlett Sturges and Eric Wentworth. Special materials and assistance were provided in particular by the late John Gregg Allerton; Margaret A. Fusco, Stanley Howell, and Daniel Meyer, The Joseph Regenstein Library, University of Chicago; Nancy Johnson, Librarian, National Academy and Institute of Arts and Letters, New York; Tambrey Mathews and Carol Anderson, Office of the Assistant Secretary for Public Service, Smithsonian Institution, Washington, D.C.; Emily Miller and Diana Haskell, The Newberry Library, Chicago; Nina D. Myatt, Curator of Antiochiana, Olive Kettering Library, Antioch College, Yellow Springs, Ohio; Ralph Ramey, Director, Glen Helen, Antioch College; Rhona Roob, Assistant Librarian, Archives, The Museum of Modern Art, New York; Charles Schille, Curatorial Assistant, Harvard University Archives; and the late Carl J. Weinhardt, Jr., Director, Bonnet House, Fort Lauderdale, Florida. Appreciation is extended to M. Sheryl Bailey, who assisted with the initial research for this article, and to Andrea Hales for her careful attention to details.

1. Isabel McDougall, "An Artist's House," *The House Beautiful* 12 (Sept. 1902), p. 199.

2. Frederic had two sisters and a brother (who died before he graduated from Harvard College), as well as a half-sister through his father's second marriage. His two sisters were active art collectors, but their interests differed from Frederic's and from each other's. Maie Pitkin Bartlett married Dwight B. Heard and in 1929 founded with him the Heard Museum in Phoenix, Arizona. This was originally an art and anthropology museum based on their collection of American Indian art and native art from other parts of the world and is now devoted particularly to Southwest Indian art. Florence Dibell Bartlett gave many works to the Art Institute's collections of decorative arts and textiles and established the International Museum of Folk Art in Santa Fe, New Mexico, in 1953.

3. Frederic Clay Bartlett, *Sortofa Kindofa Journal of My Own* (Chicago and Crawfordsville, Ind., 1965), p. 4.

4. Ibid., p. 53.

5. Ibid., pp. 65ff. Because of its skylights and other features, the tenth floor of the Fine Arts Building was where artists established their studios. John T. McCutcheon, a cartoonist for Chicago newspapers, occupied the studio next to Frederic's. Others who shared the floor were mainly conservative and successful artists such as Frank Peyraud, Ralph Clarkson, Charles Francis Browne, and the sculptor Mario Korbel. Perhaps the most illustrious tenant was sculptor Lorado Taft. Studios were used in common when social events were held on the floor, and a salon of sorts, called the Little Room, was established in 1892 and lasted until World War I. Members met to share ideas after the Friday afternoon Chicago Symphony concerts. Murals by seven of the artists, including Bartlett, were painted to decorate the tenth-floor lobby and are extant.

6. Granger later wrote an article on Bartlett. See Alfred Hoyt Granger, "Frederick Clay Bartlett, Painter: An Appreciation—not an Analysis," *The Sketch Book* 5 (Feb. 1906), pp. 247–53.

7. McDougall (note 1), pp. 199–210.

8. See Henry H. Saylor, "The Best Twelve Country Houses in America: XI: The House in the Woods, The Home of A. C. Bartlett, Lake Geneva, Wis., Howard Shaw, Architect," *Country Life in America* 29 (Mar. 1916), pp. 38–41.

9. See Virginia Robie, "Church Decorations by Frederic C. Bartlett," *The House Beautiful* 17 (Dec. 1904), pp. 8–10.

10. Exhibitions of Bartlett's work were held at the Art Institute in 1907, 1919, 1921 (paintings of China), 1954 (memorial exhibition), and 1982 (with Evelyn Fortune Bartlett; the last exhibition was first shown at the Smithsonian Institution, Washington, D.C.); at the Cincinnati Museum in 1918; the Memorial Gallery, Rochester, New York, in 1921 (with Truman E. Fassett and William J. Potter); and the Montross Gallery, New York, in 1921 (paintings of China).

In addition to the murals mentioned in this article, extant examples include those in the Fourth Presbyterian Church, Chicago (geometric designs and angels painted in the ceiling arches of the main sanctuary), 1914; and in his own residences in Florida (Bonnet House), Chicago (Astor Street apartment occupied in the early 1930s), and Lake Geneva (restored). Murals executed in the Chicago area and no longer existing included a series for the George Howland Memorial Hall, McKinley High School, 1904 (Music, Painting, Sculpture, Architecture, Science); an altarpiece, "Vision of Angels," for the Trinity Episcopal Church, Highland Park, 1905; an extensive series showing the rise of commerce for the Council Chamber, Chicago City Hall, 1911; a group for the Hofbrau Restaurant, and decoration for the New Theater, as well as a number of undocumented murals for private residences.

11. Starting in 1905, he was listed as a member of the Art Committee of the Art Institute, a small, six-man group when it began. His close allegiance with the Art Institute took many forms: he first served on the Jury of Selection and Hanging for the "12th Chicago Artists Exhibition" in 1908. He was asked to serve in 1909 on the State Art Commission of Illinois and was invited to be on the Jury of Selection for the Art Institute's "22nd Annual Exhibition of Oil Paintings and Sculpture by American Artists" and the "21st Exhibition of Water-Colors, Pastels and Miniatures by American Artists" of that year. He was the President of the Chicago Society of the Archeological Institute of America. He was in demand as a lecturer. In 1916, Frederic was asked to become a member of the prestigious National Institute of Arts and Letters. Also, in 1916, he began his long association with the Arts Club of Chicago, as a founding member and director of this pioneer organization dedicated to bringing all forms of contemporary art—musical, literary, and artistic—to its membership and the city of Chicago.

12. Clay Bartlett (1907–1955) also became an artist who showed numerous times in Art Institute exhibitions and elsewhere.

13. Joan Landour, "In the World of Society," clipping from unidentified newspaper, *Bartlett Scrapbooks*, The Art Institute of Chicago, Ryerson and Burnham Libraries.

14. Marion Wieman, "Antioch Benefactor Known for Donations," *The Springfield News-Sun*, Springfield, Ohio, Jan. 17, 1943.

15. Hugh Birch also donated land for the Orton State Park in Ohio named in honor of geologist Edward Orton, and for the Sally Milligan Park in Beverly, Massachusetts, named in honor of his mother. He reclaimed and beautified much old farmland around Chicago that was later developed and sold as residential property and golf courses.

16. Lucy G. Morgan, comp., *The Story of Glen Helen: The Enlarged Campus of Antioch College* (Yellow Springs, Ohio, 1931), ch. 3, n. pag.

17. As it turned out, Hugh Birch outlived both his wife and his daughter by several decades. In 1929, the name Glen Helen was given to eight hundred acres of land Birch presented in Helen's memory to Antioch College for its extended campus. Hugh Birch's plot in Chicago's Graceland Cemetery is not only the burial place for his family but also for Frederic, Dora, and Clay Bartlett.

18. The following were published in *Poetry: A Magazine of Verse*: Helen Birch, "Pale Colors: *Minna and Myself* by Maxwell Bodenheim," book review, 13 (Mar. 1919), pp. 342–44; Helen Birch-Bartlett, "Koral Grisaille: *Kora in Hell: Improvisations*, by William Carlos Williams," book review, 17 (Mar. 1921), pp. 329–32; Helen Birch Bartlett, "Four Poems," 29 (Oct. 1926), pp. 18–19. A review of her book of poetry, *Capricious Winds* (see note 22), appeared in vol. 31 (Nov. 1927), pp. 94–96. It is interesting that both Frederic and Helen were founding guarantors of *Poetry* magazine in 1912, seven years before they married.

19. See Joy Elmer Morgan, *Horace Mann at Antioch* (Washington, D.C., 1938), p. 134.

20. Hugh Birch had given the couple some land in Fort Lauderdale as a wedding gift. When asked the dimensions of this lot, he described it as "about as far as you can swing a cat." See Carl J. Weinhardt, Jr., "Bonnet House," *Connoisseur* 215, 875 (Jan. 1985), p. 101. The lot actually measured about seven hundred feet along the Atlantic Ocean and extended thirty-five acres inland. Today, this is the last undeveloped area of land on the Fort Lauderdale beach and surrounds a residence designed, built, and decorated in 1921 by Frederic for Helen and himself. This home, called Bonnet House (for the Bonnet lilies found growing nearby), and its surrounding land have recently come under the protection of the Florida Trust for Historic Preservation. The Bartlett homes in Beverly, Massachusetts, and in Florida are presently occupied by Evelyn Fortune Bartlett, Frederic's third wife.

21. Bartlett (note 3), p. 25.

22. Helen Birch Bartlett, *Capricious Winds* (Boston and New York, 1927), intro. by Janet A. Fairbank, p. xiii.

23. Letter from Helen Birch Bartlett to Harriet Monroe, Nov. 7, 1922, *Poetry* Magazine Papers, Box 1, Folder 37, University of Chicago, Regenstein Library, Department of Special Collections.

24. *Chicago Art Institute Newsletter*, Jan. 26, 1929.

25. In addition to the paintings in the Helen Birch Bartlett Memorial Collection, the Bartletts' private collection contained paintings (rarely sculpture) by other modern European artists, among them Vlaminck, Dufy, Herbin, Foujita, de la Fresnaye, Valadon, Dufresne, Marcoussis, Severini, and Pascin, which were not part of the final donation to the Art Institute. Still others were by artists whose names are no longer easily recognized, such as Lotiron, Beaudin, Waroquier, Pruna, and Marmorek. Among the few Americans represented in the collection were John Marin and Charles Demuth, whose

watercolors *The Brook* and *Flowers*, respectively, the Bartletts acquired in 1924. (While the present whereabouts of most of these works is not known, the aforementioned watercolors are in the Art Institute.) The Bartletts' lack of interest in collecting modern American art occurred despite the fact that Frederic was a founding member of the Art Institute's Friends of American Art, established in 1910 as the first organization in any museum to purchase current work by American artists for the collection. This group, which lasted into the 1940s, provided the Art Institute with the substance of its collection of twentieth-century American painting and sculpture but it tended to overlook the work of the American avant-garde.

26. *Chicago Art Institute Newsletter*, Oct. 13, 1923.

27. See note 22.

28. *The Art Institute of Chicago Scrapbooks* 50, microfilm reel no. 8 (June 9, 1925–Jan. 16, 1926), pp. 84, 107, 109.

29. Trustee minutes, Jan. 26, 1926, The Art Institute of Chicago, Archives.

30. In 1929, Bartlett, as trustee chairman of the Winterbotham Committee, purchased in Paris five paintings for the Art Institute's Winterbotham Collection, of which Braque's 1919 *Still Life* remains an important component today. See The Art Institute of Chicago, *The Joseph Winterbotham Collection: A Living Tradition*, essay by Lyn Delli-Quadri (Chicago, 1986).

31. See note 29.

32. These articles were written by the museum's manager of publications Walter J. Sherwood, "The Famous Birch Bartlett Collection," *Chicago Visitor* (Oct. 1932), pp. 17, 40; and by a later director, Daniel Catton Rich, "The Windy City, Storm Center of Many Contemporary Art Movements," *Art Digest* 26 (Nov. 1, 1951), p. 28; idem, "The Art Institute of Chicago—And Chicago," *Art in America* 32 (Oct. 1944), p. 250.

33. Frank Holland, "How Bartlett Won Fame As Collector," *Chicago Sun-Times*, July 12, 1935.

34. See Forbes Watson, "A Note on the Birch-Bartlett Collection," *The Arts* 9 (June 1926), pp. 303–12; and Morton Dauwen Zabel, "An American Gallery of Modern Painting," *Art and Archeology* (Dec. 1928), pp. 227–35, 245. In 1926, vol. 20 of the *Bulletin of The Art Institute of Chicago* carried the following announcement and articles: "Helen Birch Bartlett Memorial" (Apr.), p. 53; "Cézanne, Rousseau, Picasso" (May), pp. 62–64; "Van Gogh in Arles" (Oct.), pp. 92–94. The collection's catalogue is *Modern Paintings in the Helen Birch-Bartlett Memorial Collection* (Chicago, 1926; 2d ed. 1929; 3d ed. 1946).

35. See note 29.

36. Unidentified newspaper article, *The Art Institute of Chicago Scrapbooks* 51, microfilm reel no. 8 (Jan. 17–June 16, 1926), p. 126.

37. Unidentified newspaper article, May 8, 1926, *The Art Institute of Chicago Scrapbooks* 51, microfilm reel no. 8 (Jan. 17–June 16, 1926), p. 143. John Quinn died in 1924; his collection was sold at auctions in 1926 and 1927.

38. The Chicago portion of the "International Exhibition of Modern Art" (Armory Show), on view Mar. 24–Apr. 15, 1913, attracted 180,000 visitors in three weeks and much public controversy. For example, students at the Art Institute's School burned an effigy of Henri Matisse, whom they named "Henry Hair-Mattress."

39. Arthur Jerome Eddy, *Cubists and Post-Impressionism* (Chicago, 1914; rev. ed. 1919). Eddy was a major early collector of German Expressionism.

40. Unidentified newspaper article, *The Art Institute of Chicago Scrapbooks* 51, microfilm reel no. 8 (Jan. 17–June 16, 1926), p. 101.

41. No pictures exist of the Birch Bartlett paintings as they were installed in their home.

Not only does it seem that Frederic and Helen were continually traveling, with their only permanent residences in Florida and an estate, White Hall, in Beverly, Massachusetts, purchased early in the year Helen died, but their collections seem to have been on continuous loan beginning in 1923.

42. Letter from Frederic Clay Bartlett to Robert Harshe, July 12, 1933, The Art Institute of Chicago, Archives.

43. See Bartlett (note 3).

44. "Evelyn Bartlett: Wildenstein Galleries," *Art News* 34 (Dec. 7, 1935), p. 8. See the informative essay by Anne Cannon Palumbo in the brochure accompanying the exhibition "The Paintings of Frederic Clay Bartlett and Evelyn Fortune Bartlett," Smithsonian Institution, Washington, D.C., Sept. 17–Nov. 17, 1982.

45. Conversation between Evelyn Fortune Bartlett and author, May 29, 1986.

46. See note 29. The Potter Palmer Collection was given to the Art Institute in 1922. The Martin Ryerson Collection was often on loan to the museum before it was bequeathed in 1933.

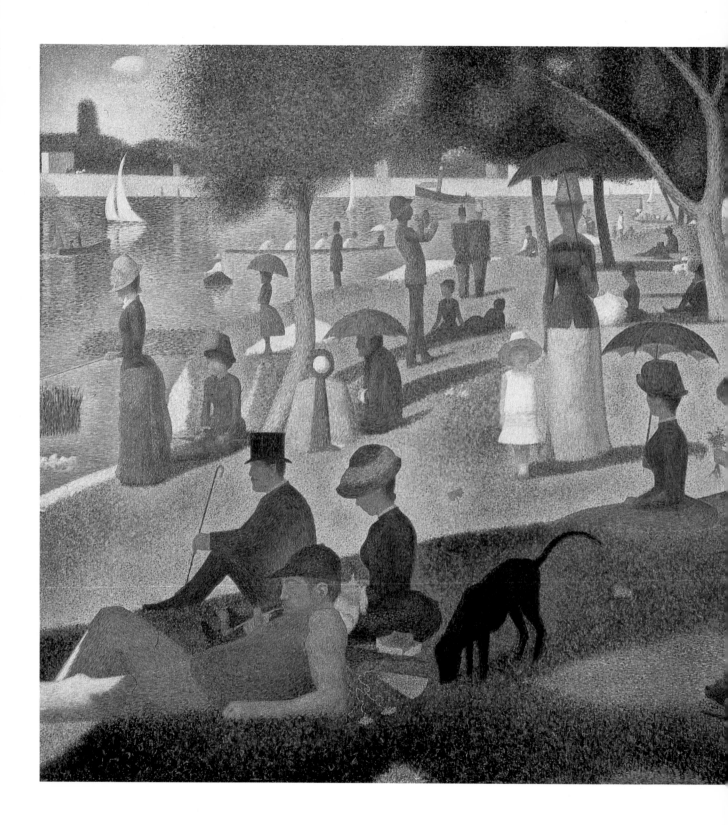

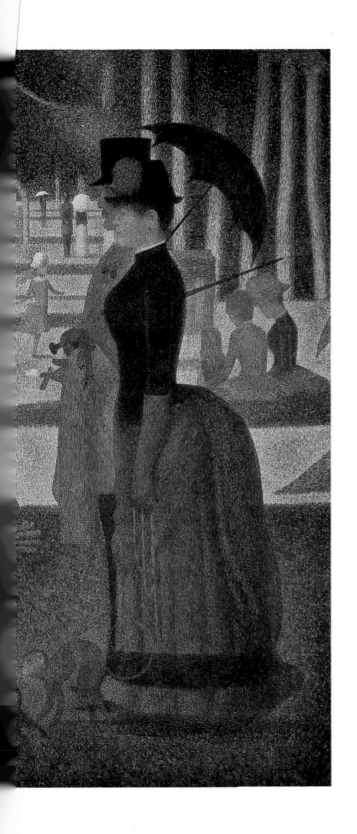

The Bartletts and the *Grande Jatte:* Collecting Modern Painting in the 1920s

RICHARD R. BRETTELL,
Searle Curator of European Painting

HAD Frederic Clay Bartlett died in 1924, leaving his entire collection to The Art Institute of Chicago, he would be forgotten today, overshadowed even in Chicago by Arthur Jerome Eddy and Annie Swann Coburn.[1] Yet, he is remembered today as one of the great American collectors of modern art for a gift he made to the Art Institute in 1926 and added to in 1927, 1928, and 1932. In the short period between 1924 and 1928, he became a major collector. He began as an amateur, buying minor works by fashionable artists as souvenirs and gifts. By 1928, however, he could be ranked with such figures as Madame Hélène Kröller-Müller from Holland and Samuel Courtauld from England.[2] A great collector in a decade of great collectors, Bartlett embarked on a career that was intimately bound up in the purchase of a single work of art, Georges Seurat's *Sunday Afternoon on the Island of La Grande Jatte* (fig. 1).

This purchase was made in 1924 by a man who had, only one year earlier, become a trustee of The Art Institute of Chicago, and it seems to have been made with

FIGURE 1 Georges Seurat (French, 1859–1891). *Sunday Afternoon on the Island of La Grande Jatte*, 1884–86. Oil on canvas; 207.6 × 308 cm. The Art Institute of Chicago, Helen Birch Bartlett Memorial Collection (1926.244).

that institution in mind. Hence, it was not in the least a private purchase. Indeed, the *Grande Jatte* never hung in any of the several houses and apartments owned or rented by the Bartletts. It was sent directly to the Art Institute, where it has remained ever since, except for three short exhibitions in Minneapolis, Boston, and New York.[3] It entered the permanent collection of the museum in January 1926, only a year and a half after its purchase. There was, at that date, no work by Seurat in a public collection in France.

What happened to transform a conservative painter of decorations who spent most of his time traveling throughout Europe and America into a serious collector? The answer is not easy to find but perhaps can be discovered by situating Bartlett's collecting in the larger context of European and American taste for modern art in the mid-1920s. Certainly, this decade was the heyday for the market in Post-Impressionist and "modern" paintings. Although low by today's standards, prices for works by artists like Gauguin, Cézanne, van Gogh, Toulouse-Lautrec, and even Matisse, Braque, and Picasso had risen sufficiently to ensure that there was no problem finding works by these artists in supply. In the almost virgin market of the 1920s, many of the greatest masterpieces of modern art changed hands. Several dozen men and women had both the business acumen and the finances to seize this opportunity and, fortunately for Chicago, Frederic Bartlett and his wife Helen Birch Bartlett were among them.

We must keep in mind, however, that they were not alone. Indeed, there were other courageous collectors in Chicago, as well as in New York, London, Paris, Berlin, Washington, D. C., Brussels, Oslo, and Otterlo. The names are legion: John Quinn, Justin K. Thannhauser, Oskar Reinhardt, Chester Dale, Max Pellerin, Daniel Tzanck, Charles Pacquemart, and the Comte de Beaumont. They all bought from the same dealers, confided secrets to the same agents, and vied for the same masterpieces. Sometimes—as in the case of the *Grande Jatte*—the Bartletts won. Other times, as we shall see below, they lost. Such are the fortunes of the collector. Although Frederic met Samuel Courtauld, there is no evidence that either of the Bartletts knew any of their other major competitors personally.[4]

The story of the purchase by Mr. and Mrs. Bartlett of Georges Seurat's *Sunday Afternoon on the Island of La Grande Jatte* has been told many times, and each version varies in its dates and details. According to the most recent telling, which is also the most incorrect, the painting was bought for $22,000 in 1921 while the Bartletts were in the midst of a trans-Atlantic crossing. The deal, we are told, was consummated by cable.[5] An earlier version of the tale, published in 1932 in *The Chicago*

Visitor, is different, and more accurate, in every respect: Bartlett and his wife met Lucie Cousturier, the owner of the painting, in 1924, just one year before her death in 1925. Seeking to create a pension fund for her retirement through the sale of the painting, her principal asset, she countered the Bartlett's offer of $12,000 with a final price of $20,000. At this point in the narrative, Mr. Bartlett himself is cited:

We went to our hotel considering this offer and talked it over for a long time, wondering how we could trim our expenses, cutting out this and that contemplated purchase. The more we talked, the more determined we became to possess this masterpiece. Finally, our minds were made up and we arose at an unearthly hour the next morning and went over and made the purchase.[6]

Unfortunately, the author listed no source for this statement, but the fact that it appears to be a direct quotation published in Chicago within Bartlett's lifetime leads one to accept it as true.

The scanty records that do survive corroborate all details of this early account. They tell us that Bartlett did pay $20,000 for the painting, although he insured it for $25,000 just after its purchase.[7] We also know that it arrived at The Art Institute of Chicago, shipped separately from its stretcher and probably rolled, on July 7, 1924, indicating that the purchase was made no later than the spring of that year. And, we know from numerous sources that the seller was Lucie Cousturier, who had owned the painting for more than twenty years and whom we see posed "au japonais" in a famous photograph in front of Seurat's painting while it was still in her collection (fig. 2).[8]

These few facts record what could be the most important transaction in the history of the Art Institute, as well as the single greatest event in the lives of Frederic and Helen Bartlett. All the evidence tells us that this purchase was neither natural nor easy. None of their earlier acquisitions can compare in either aesthetic or monetary value, and there are many indications that they were certainly not the first to attempt to purchase the work that has come to be known as the greatest French painting outside of France. Forbes Watson, a brilliant American critic, indicated in an article on the Bartlett Collection published in 1926 that The Metropolitan Museum of Art, New York, had attempted to buy the painting as early as 1911, but that its trustees refused to support the acquisition.[9] A letter on file in the Department of European Painting tells us that the English economist and Bloomsbury figure John Meynard Keynes had tried to buy the *Grande Jatte* in the early 1920s at the urging of artists Vanessa Woolf and Duncan Grant.[10] No doubt, there were other potential buyers,

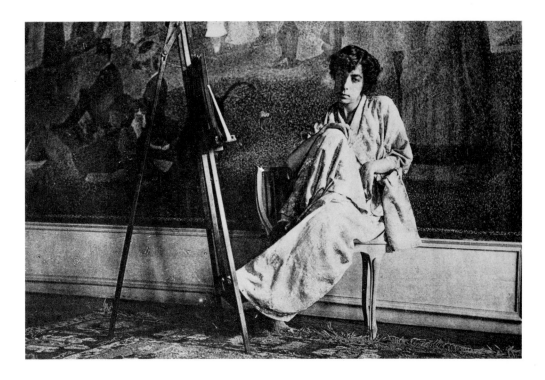

FIGURE 2 Lucie Cousturier (French, 1876–1925), posed before the *Grand Jatte*, which she owned from c. 1891/94 to 1924.

because the existence of Seurat's painting was scarcely a secret in the 1920s.

The fact that the painting was of interest to collectors other than Bartlett is certainly proof of the brilliance of the purchase; the purported failure of the Metropolitan to acquire the *Grande Jatte* has often been cited by passionate Chicagoans as proof of the wisdom of their city. Other local commentators have noted that a French syndicate offered the Art Institute $400,000 for the painting in 1931 so that it could be returned to France, and that, in 1953, its insurance value was set at $1,000,000. Even today, the museum is often asked to assign a monetary value to this priceless work of art. Thus, for many, the painting's value seems to prove more mightily than the intense competition for it that the Bartletts were correct!

Unfortunately, we know nothing about how or from whom the Bartletts found out about the availability of the painting, where they saw it, and why they bought it. All accounts suggest that the purchase was made privately, without the intercessory advice of a dealer. Indeed, the only name associated with the purchase other than Bartlett's is that of the shipper, Lerondelle, who arranged to have the painting packed and sent to Chicago.[11] The mystery surrounding the Bartletts' acquisition of the *Grande Jatte* contrasts with the process involved in every other purchase for the collection, for no other acquisition seems to have been made privately. Instead, Bartlett shopped for pictures, visiting dealers who

did the work for him. Thus, it is most likely that, in the negotiations for the Seurat, an anonymous intermediary was involved.[12]

Analysis of Bartlett's collecting habits before and after the acquisition of the *Grande Jatte* proves beyond the shadow of a doubt that this decision radically changed his attitude toward works of art. Fortunately, paintings from the Bartletts' personal collection went in and out of the Art Institute during the 1920s, providing us with a fair indication of their taste.[13] Before the summer of 1924, the Bartletts bought, and probably traded, many small paintings by artists of the School of Paris for prices ranging from $50 to $500. These were used as "decorations" in their various homes and apartments in Chicago, New York, Massachusetts, and Florida. All of these works were purchased at fashionable galleries in Paris, Munich, and New York. After acquiring the Seurat, however, Bartlett made a series of major purchases: van Gogh's *Bedroom at Arles*, Toulouse-Lautrec's *At the Moulin Rouge*, Picasso's *Old Guitarist*, and Cézanne's *Basket of Apples*—all truly staggering in quality.

Even before 1924, the Bartletts knew what they were doing. They bought from the "right" dealers—Léonce Rosenberg, Paul Guillaume, Percier, and Bernheim-Jeune in Paris; French Galleries (a subsidiary of Wildenstein) and Knoedler in New York; Thannhauser in Munich; and Theodore Fisher in Lucerne. And they

bought—in a certain sense, at least—the "right" painters. Mostly contemporary, but conservative, the paintings were by French artists like Herbin, de la Fresnaye, Utrillo, Derain, Lhôte, Lotiron, Dunoyer de Segonzac, Friesz, and Beaudin. Yet, from today's vantage point, this is hardly an inspired list; many of the paintings seem to have been small and only marginally significant within the careers of these then-fashionable artists. In fact, none of the works acquired before the *Grande Jatte* could be considered essential to the history of modern art. They were, in the end, private collectors' pictures, appropriate for the embellishment of the cultivated domestic environments of the international rich during the heady years before the Depression.

There were, however, exceptions. It was in Bartlett's choice of an important 1922/23 painting by Henri Matisse, *Woman Before an Aquarium* (fig. 1, p. 200), and van Gogh's *Madame Roulin Rocking the Cradle* (fig. 3), both of which arrived at the Art Institute in separate shipments in August 1923, that we see the first glimmerings of his future brilliance as a collector. However, the Bartletts continued their essentially fashionable buying of contemporary art early in 1924, when works by the Spanish Cubist Pruna, paintings by Friesz, Pascin, Dunoyer de Segonzac, and Lotiron, as well as the superb double portrait of Jacques Lipchitz and his wife (fig. 1, p. 188) by Modigliani, were shipped to Chicago by Galerie Percier in Paris. Later that year, the Bartletts bought paintings by Severini, Herbin, and Hodler from dealers in Paris, New York, Chicago, and Lucerne. All of this was accomplished before the deal was struck with Lucie Cousturier.

The evidence suggests that the Bartletts recognized immediately that *Sunday Afternoon on the Island of La Grande Jatte* could never look truly "at home" at home. It is surely no accident that Bartlett began to collect with an institution in mind after he was appointed in 1923 to succeed his father as a trustee of the Art Institute. Many of his earliest documented purchases were made on a buying trip with his fellow trustee, Robert Allerton, which commenced in the spring of that year, and the *Grande Jatte* was acquired less than a year after his elevation to trusteeship. As a trustee, he was required to think more seriously about the museum than he had as a passionate amateur. In 1924, Bartlett made a correct and, given his income, courageous decision to form a small collection of masterpieces that, surrounding the *Grande Jatte*, could make it make sense. Of the paintings he already owned, only those by Matisse and van Gogh were truly comparable. He began to buy well, and expensively, using larger and larger amounts of his income. Quality rather than quantity became his obsession. In a certain sense, this decision was inevitable. What, after

all, could one select to hang among the Herbins and Dunoyer de Segonzacs in his collection with so towering an aesthetic achievement as the *Grande Jatte*?

Bartlett started his "quality" collection rather oddly, buying two figure paintings by the Swiss artist Ferdinand Hodler, one of which, *James Vibert, Sculptor*, is outstanding. In Chicago, he found a Hodler landscape, *The Grand Muveran* (on Bartlett's Hodlers, see pp. 167–87). In the aesthetic world of high society in 1924, Hodler and Seurat did not exist in the same realm, and perhaps the inclusion of these Swiss paintings in a French context is the single most original aspect of the collection. The Bartletts' other purchases were less eccentric—van Gogh's small, early view of Montmartre (see p. 227) was bought in the spring of 1925 and Gauguin's Tahitian masterpiece *Day of the Gods* (fig. 4) was purchased in the summer or fall of the same year.

The Bartletts' paintings were exhibited at The Art Institute of Chicago in 1923, 1924, and 1925. In 1925, they traveled to the Minneapolis Institute of Art, whose director, Russell Plimpton, later made brilliant purchases of Post-Impressionist art for this museum; and to the Boston Art Club. While the connections to Boston were numerous (the Bartletts spent summers in nearby Beverly), those to Minneapolis are perhaps more interesting. Plimpton was one of the most important museum directors in the Midwest during the 1920s, and the fact that he wrote to Bartlett asking for the loan of the collection indicates that they knew each other. Plimpton's later acquisition of works by Gauguin, Cézanne, and Seurat for the Minneapolis museum was clearly made in response to the Bartlett Collection after it was given to The Art Institute of Chicago.[14]

While the collection was in Minneapolis, Bartlett was acquiring other great paintings, several of which he added to the exhibition in Boston. In Boston and Minneapolis, pamphlets were produced, and the collection was called the Birch-Bartlett Collection of Modern French Paintings.[15] The inclusion of Helen Birch Bartlett's maiden name in the collection title has still never been adequately explained. The surviving correspondence in the Art Institute's Archives about the collection—its purchase, exhibition, shipment, and insurance—was directed to Frederic. Since this must reflect the prevailing sexism of the 1920s, it cannot be used as proof that he alone was responsible for the collection.

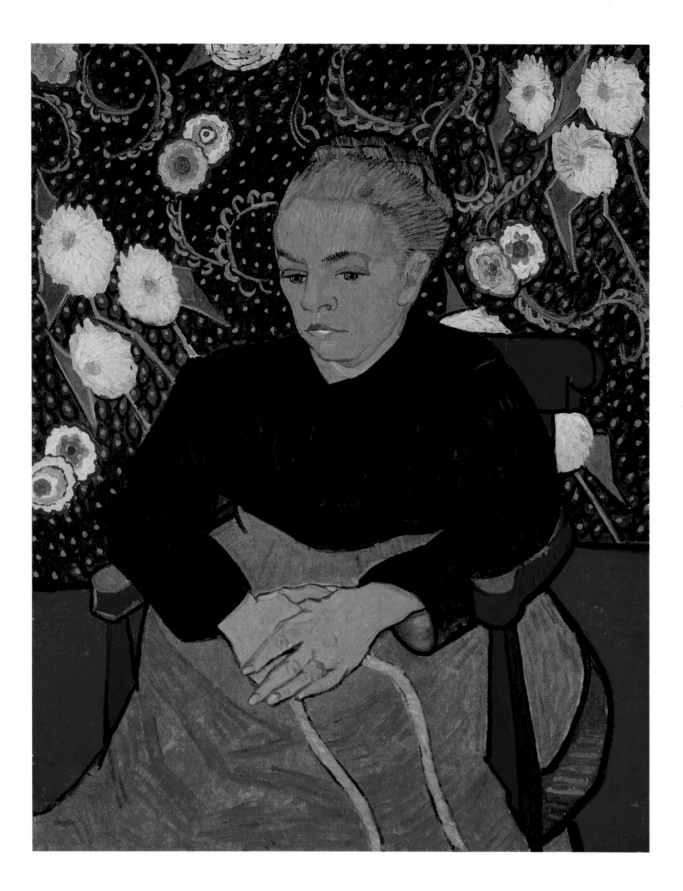

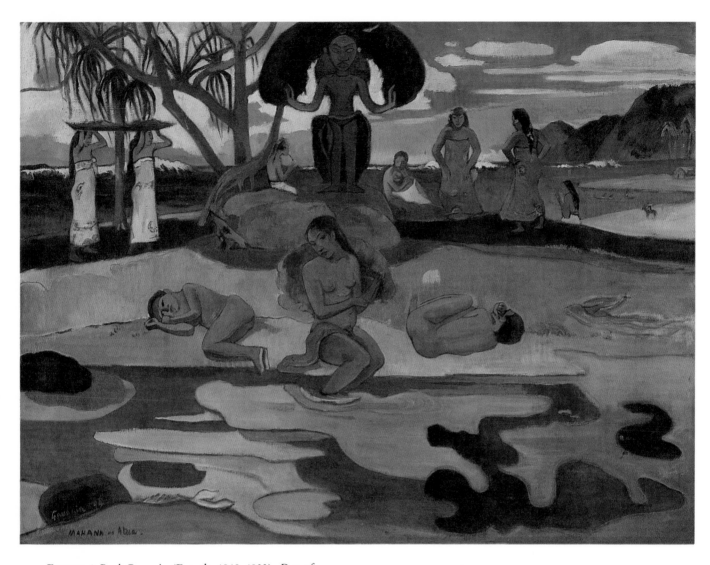

FIGURE 4 Paul Gauguin (French, 1848–1903). *Day of the Gods*, 1894. Oil on canvas: 68.3 × 91.5 cm. The Art Institute of Chicago, Helen Birch Bartlett Memorial Collection (1926.198).

One thing, however, is clear: Helen Birch Bartlett died in October 1925 of cancer, indicating that several key purchases were made during her last illness, possibly as a form of memorial.

Helen's death seems to have accelerated Frederic's purchases: indeed, they became more costly and confident. He was already negotiating for what was to become his most expensive acquisition, Cézanne's *Basket of Apples*, in the months surrounding her death, and there is little doubt that the price he paid, $50,000, was a record for a work by that artist in 1925–26. How different a purchase this was from those made just before the *Grande Jatte*: $100 for a Pruna, $250 for a Lotiron, $500 for a Utrillo.

In her will, Helen Birch Bartlett left the collection to the Art Institute; shortly after her death, her husband arranged for the collection to become a memorial gift. The make-up of the Birch-Bartlett Collection was not defined precisely at the time of its acceptance by the museum in January 1926. After its accession by the museum, several minor paintings, by Dunoyer de Segonzac, Friesz (see fig. 9, p. 93), and Utrillo, were sold and major works by van Gogh, Toulouse-Lautrec, Gauguin, Rousseau, and Picasso were added. The number of objects it contained was honed to twenty-four. Indeed, the works were so carefully selected that they hang with as great an authority today as when they were first installed (see pp. 94, 95, 96).

We can draw several conclusions from this story. First, the acquisition of the *Grande Jatte*, Bartlett's association with the Art Institute, and his wife's premature death gave an institutional character to what had begun as a private collection. Second, Bartlett was willing and able to pay very high prices for works of art, placing himself squarely in competition with other major collectors of modern art. Third, he developed his taste around certain dealers of School of Paris and Post-Impressionist painting, never really accepting Cubism and the geometric abstract styles of avant-garde art in Paris during the mid-1920s.

After he acquired the *Grande Jatte*, he bought major works by each of the other Post-Impressionist masters—Gauguin, van Gogh, Cézanne, and Toulouse-Lautrec—as well as paintings by the masters of monumental form who followed in their stead. Apparently, he was never moved by the work of Vuillard and Bonnard, despite the fact that he made purchases of works by Matisse from their primary dealer, Bernheim-Jeune; his collecting never extended to the Cubist works of Picasso and Braque or to the then avant-garde paintings of Léger and the Purists. For the Bartletts, modern art was essentially Post-Impressionist figure painting brought forward into the twentieth century.

Most histories of private collecting deal with the actual purchases made by those collectors, analyzing them for the aesthetic and social attitudes they reveal. Looked at in this way, the Bartletts participated in the conservative, socially cautious collecting world exemplified by French Galleries in New York and Bernheim-Jeune in Paris. It is clear that their decision not to buy truly avant-garde painting was an aesthetic one. Indeed, the Bartletts could easily have formed an entire collection of Cubist paintings for what they spent on the Seurat and the Cézanne alone. If Bartlett was forming a history of modern art from Seurat to the present, as many people thought, it was a skewed and partial history. Far from being a "personal" collection with idiosyncratic choices, it reflected a "solid," socially acceptable taste for masterpieces of exactly those Post-Impressionist painters who had been given retrospective exhibitions and had been validated by both critics and art historians for more than a generation. The Bartletts were not like the Potter Palmers, who boldly bought works by the Impressionists as they were painted.

Because Bartlett's taste was conservative and institutional, all but one of the paintings he bought for the collection after the death of his wife were painted in the nineteenth century. Given the extraordinary market for Post-Impressionist painting in the 1920s, we must ask how successful a collector he really was. In certain cases, he was brilliant; he found *At the Moulin Rouge*, the best Toulouse-Lautrec available in the 1920s (see pages 115–35), which he probably saw first at The Art Institute of Chicago, where it was shown in 1924 in a small exhibition of the artist's works. He tried to buy Seurat's late masterpiece, *The Circus*, from the Quinn Collection, only to discover that Quinn had bequeathed it to the Musée du Louvre.[16] Bartlett is also reported to have made a stab at Manet's great composition *The Bar at the Folies Bergère*, which was bought in 1924 by Samuel Courtauld. Indeed, there are indications that he was the major competitor of Courtauld, who bought Seurat's *Bathers at Asnières* for the Tate Gallery in London in 1924, just after Bartlett bought the *Grande Jatte*.

While Bartlett's Cézanne is a beautiful and important late still-life, it is not comparable in quality to the *Grande Jatte* or Toulouse-Lautrec's *At the Moulin Rouge*. Had he been able to get to Paris in the spring of 1926 to see the Cézanne retrospective at Bernheim-Jeune Gallery, he could have bought the greatest late painting by that artist, *The Large Bathers* (fig. 5), now in the Philadelphia Museum of Art. Then in the Pellerin Collection, this masterpiece, like others by Cézanne, was accessible during the peak period of Bartlett's collecting. He could also have bought Gauguin's greatest painting,

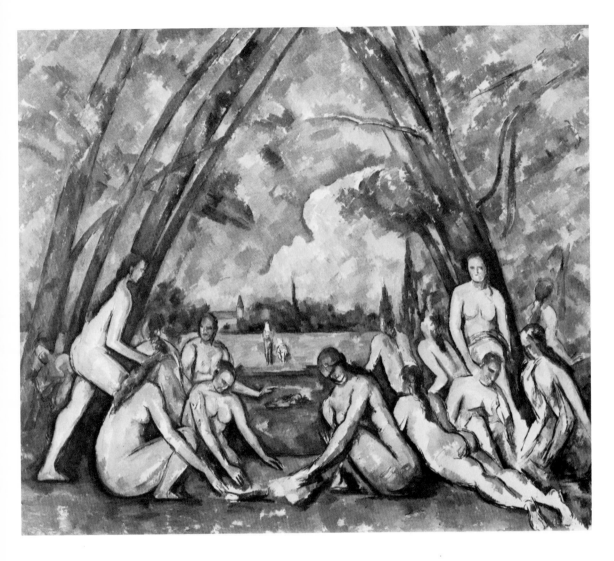

FIGURE 5 Paul
Cézanne (French,
1839–1906). *The
Large Bathers*,
1906. Oil on can-
vas; 208.3 ×
251.5 cm. Phila-
delphia Museum
of Art, W.P.
Wilstach Collec-
tion (W37-1-1).
Photo: J. Rishel,
*Cézanne in Phila-
delphia Collec-
tions*, exh. cat.,
Philadelphia Mu-
seum of Art
(1983), p. 46.

FIGURE 6 Paul
Gauguin. *Where
Do We Come
From? What Are
We? Where Are
We Going?*, 1898.
Oil on canvas;
139.1 × 374.6
cm. Boston, Mu-
seum of Fine
Arts, Tompkins
Collection.

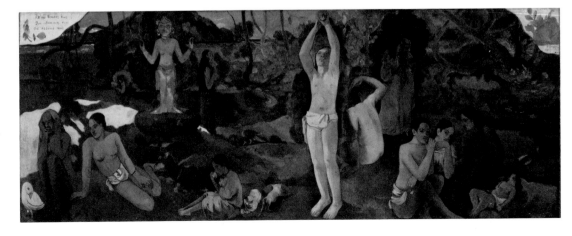

110

Where Do We Come From? . . . (fig. 6), now in the Museum of Fine Arts, Boston, and on the art market in 1925–26. Instead of what could have been another milestone purchase, Bartlett bought in May 1927 a fine late group portrait (see p. 228) by that artist from Thannhauser in Munich for $9,000.

His early Picasso, *The Old Guitarist* (see fig. 1, p. 152), purchased in May 1926 from French Galleries for $9,500 (it had previously been in the Quinn Collection), was a wonderful choice, especially considering the fact that Picasso's earliest paintings were neither well known nor well published at the time. The large picture by the Douanier Rousseau, *The Waterfall* (see p. 230), was bought from Georges Bernheim for $8,000 in March 1926. While perhaps not the artist's very best, it was nonetheless a solid purchase, among the finest of his large "jungle" landscapes. And, although his Matisses (see pp. 201–21), bought before the *Grande Jatte*, have stood up well, he could have acquired even greater paintings by this artist in the active market of the mid- and later 1920s. Bartlett's purchase of *Bedroom at Arles* (see pp. 137–51) by van Gogh was made from French Galleries in December 1926 for the high price of $17,500 (just $2,500 less than the *Grande Jatte*). Perhaps the single most important painting of van Gogh's Arles period, this was another brilliant acquisition, given the fact that the largest group of works by van Gogh still in the artist's family's private collection had not yet been exhibited.

Even a cursory analysis of Bartlett's purchasing suggests very specific patterns. He wanted representative works of each major "genre" explored by the masters of late nineteenth- and early twentieth-century painting. Of van Gogh, Bartlett owned a still life (currently considered to be a forgery), a landscape, a portrait, and the great interior. Of Gauguin, he owned a landscape and a portrait. Of Hodler, he owned a landscape, a portrait, and a figure study. Of Toulouse-Lautrec, he had a major painting and a decoration. Of Seurat, he had the *Grande Jatte* and had tried to secure *The Circus*. The single failure of the collection, which Bartlett tried to correct, was with Cézanne. Without a masterpiece like the Philadelphia *Bathers*, he needed to represent the Provençal master's figurative painting. In November 1927, he wrote to Art Institute director Robert Harshe:

I have been hunting for the past few years for a portrait by Cézanne and perhaps I have found it in the so-called Fabbri portrait of a boy Portrait of M.G. 1880 [fig. 7]. . . . This Portrait I can purchase for $36,000.00 and have asked Mr. Stransky to send it out to the Institute as I wish to see it in the Memorial Room before making up my mind further. Will ask you to put it in safe storage at the Institute until I can come out to Chicago at the end of the month. Would

FIGURE 7 Paul Cézanne. *Boy in a Red Waistcoat*, 1893/95. Oil on canvas; 89.5 × 72.4 cm. Upperville, Va., collection of Mr. and Mrs. Paul Mellon.

like very much to have Mr. Ryerson's opinion and that of the Art Committee. It seems like a high price, but as Cézanne portraits go it is fairly moderate in price, also it is a very well known canvas and to me very solid and complete and of monumental quality.[17]

For unknown reasons, the painting was shipped back to New York. Early in 1928, Bartlett tried again: a self-portrait by Cézanne was sent to the Institute on approval from Buffalo, where the museum had not been able to raise money for its purchase.[18] This picture is impossible to identify with precision and, like the portrait of a boy, was shipped back to New York. Today, we regret this loss.

Between his wife's death and February 1928, Bartlett

111

spent over $100,000 on the collection, and his interest then seems to have shifted to the proper installation of his works. He may have rejected the two works by Cézanne because they failed to harmonize effectively with those already in the collection. Indeed, Bartlett became obsessed by the pictorial unity of the memorial collection, and he worked hard choosing the correct moldings, frames, colors, and spacings for the paintings.[19] For this reason, it must have become increasingly difficult to add works to the collection. The longer it remained in its own gallery, the more "habitual" and, ironically, private it became.

We know from all descriptions and photographs of the first installations in the Art Institute that the room was stripped of extraneous decorative moldings, that the walls were painted an off-white, that the picture frames were white (or, in at least one case, "grayed"), and that there was ample space between the individual works of art. In this "neutral," modernist environment, the paintings were intended to glow harmoniously and to interact among each other rather than against their environment.

The fact that Bartlett's collecting came essentially to an end in 1928 is regrettable.[20] Bartlett lived until 1953, but he never collected again with the passion, intensity, and sense of quality that drove him for four years after the hotel-room decision to acquire Seurat's *Sunday Afternoon on the Island of La Grande Jatte*.

NOTES

1. For a brief summary of the roles of Eddy, Coburn, and other early collectors in the growth of the Art Institute's permanent collections, see Patricia Erens, *Masterpieces: Famous Chicagoans and Their Paintings* (Chicago, 1979), pp. 100–14. See also "The Arthur Jerome Eddy Collection of Modern Paintings and Sculpture," supplementary catalogue with preface by Daniel Catton Rich, *Bulletin of The Art Institute of Chicago* 25, 9 (Dec. 1931), pt. 2.

2. On the Kröller-Müller Collection, see "The Collections," *The Kröller-Müller Museum* (Haarlem, 1978), pp. 25–32. For a discussion of Samuel Courtauld and the development of his collection, see Canberra, Australian National Gallery, in association with the Courtauld Institute Galleries, London, "Samuel Courtauld and the Courtauld Collections," *The Great Impressionists: Masterpieces from the Courtauld Collection of Impressionist and Post-Impressionist Paintings and Drawings*, exh. cat. (1984), pp. 9–14.

3. After the painting entered the permanent collection of the Art Institute, it left the museum only once, to go to a major Seurat exhibition at The Museum of Modern Art, New York (Mar. 24–May 11, 1958), after being in the same exhibition at the Art Institute (Jan. 16–Mar. 7, 1958). In the catalogue, the

entire composition was featured as the frontispiece and a detail used on the cover (see The Art Institute of Chicago, *Seurat Paintings and Drawings*, ed. Daniel Catton Rich; essay by Robert L. Herbert, 1958). On the exhibitions in Minneapolis and Boston, see note 15 below.

4. The best study of the collecting system in Paris, on which much of this account depends, is Malcolm Gee, *Dealers, Critics, and Collectors of Modern Painting: Aspects of the Parisian Art Market Between 1910 and 1930* (New York, 1981), esp. Chap. 5, pp. 154–204 (on collectors), and Chap. 3, esp. pp. 88–100 (on collector-dealers). Bartlett referred to a conversation with Courtauld in a letter to Robert Harshe, July 12, 1933 (The Art Institute of Chicago, Archives).

5. Erens (note 1), p. 104. How Bartlett came to know of the Seurat has not yet been determined. Although there is no positive evidence that Bartlett saw it, the 1884 oil study for the *Grande Jatte* was exhibited in Chicago at the Arts Club in 1919. See The Arts Club of Chicago, *Exhibition of French Post-Impressionists* (Chicago, 1919), no. 19.

6. Walter J. Sherwood, "The Famous Birch Bartlett Collection," *The Chicago Visitor* (Oct. 1932), pp. 16–17, 40.

7. Uncatalogued insurance list, Oct. 29, 1924, as per a lost letter from Frederic Bartlett of Oct. 27, 1924, The Art Institute of Chicago, Archives.

8. For further biographical details about Lucie Cousturier, an important art historian, artist, and collector, see Ellen Wardwell Lee, *The Aura of Neo-Impressionism: The W. J. Holliday Collection*, exh. cat., Indianapolis Museum of Art (Indianapolis, 1983), pp. 92–95 (artist's biography by Tracey E. Smith).

9. Forbes Watson, "A Note on the Birch Bartlett Collection," *The Arts* 9 (June 1926), p. 304.

10. Letter from Quentin Bell to John Maxon, Jan. 15, 1973, The Art Institute of Chicago, Department of European Paintings files.

11. Receipt, July 7, 1924, The Art Institute of Chicago, Archives..

12. It is possible to speculate about the identity of this intermediary dealer. It was, perhaps, Paul Guillaume, who also acted as the New York agent for the great Philadelphia collector Albert Barnes, and from whom Bartlett purchased other paintings. For more on Guillaume and American collectors, see Gee (note 4), pp. 63–64.

13. This reconstruction of the formation of the Bartlett Collection is based on lists of various transactions concerning the Bartletts' paintings that went through the Art Institute; these are in The Art Institute of Chicago, Archives.

14. On Russell Plimpton and the Minneapolis Institute of Art, see Richard R. Brettell, "Diversity of French Nineteenth Century Painting," *Apollo* 117 (Mar. 1983), pp. 238–40.

15. The *Grande Jatte* was exhibited at the Minneapolis Institute of Art between April and September 1925 (see Minneapolis Institute of Art, *Exhibition of Modern French Paint-*

ings from the Birch-Bartlett Collection, checklist no. 9; and the Bulletin of the Minneapolis Institute of Art 14 [Apr. 1925], pp. 31–32). In the Minneapolis museum checklist, the painting is described as "the most stunning example of Seurat's works and an excellent illustration of the 'dot' method of painting, which he invented." It was also shown Dec. 9–16 of that year at the Boston Art Club (see Boston Art Club, Birch-Bartlett Collection of Modern French Paintings, checklist no. 26).

16. Bartlett mentioned his interest in The Circus in a letter to Robert Allerton, Oct. 27, 1924, The Art Institute of Chicago, Archives.

17. Letter from Frederic Bartlett to Robert Harshe, Nov. 14, 1927, The Art Institute of Chicago, Archives. On the Cézanne portrait, see Lionello Venturi, Cézanne: son art—son oeuvre 1 (Paris, 1936), p. 211, no. 682, as Garçon au gilet rouge, 1890–95.

18. Telegram from Frederic Bartlett to Robert Harshe, Feb. 14, 1928, The Art Institute of Chicago, Archives.

19. Bartlett discussed his approach to installation in a lengthy letter to Robert Harshe (see note 4). See also the essay by Courtney Donnell in this issue of Museum Studies, "Frederic Clay and Helen Birch Bartlett: The Collectors," pp. 94–95.

20. Bartlett did add one major painting by Toulouse-Lautrec, Ballet Dancers, to the collection in 1932, but this was an isolated event.

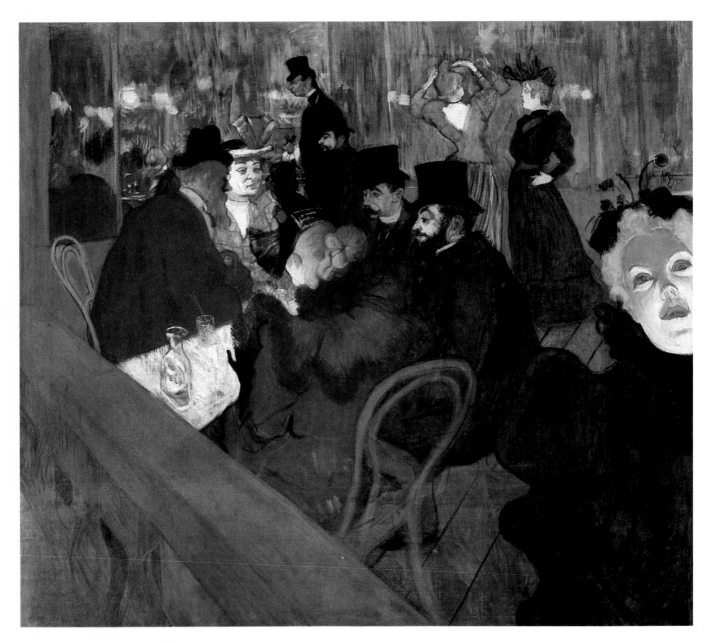

FIGURE 1 Henri de Toulouse-Lautrec (French, 1864–1901).
At the Moulin Rouge, 1894/95. Oil on canvas; 123 ×
141 cm. The Art Institute of Chicago, Helen Birch Bartlett
Memorial Collection (1928.610).

Rediscovering
Henri de Toulouse-Lautrec's
At the Moulin Rouge

REINHOLD HELLER,

Professor of Art and Germanic Languages and Literature,
The University of Chicago

THOSE works of art with which we are the most familiar often are the ones we actually know least. As we confront these objects, our expectations—molded by prior knowledge and beliefs—obscure the reality before us. We confuse, in turn, many art works with the biographies of their makers. The lives of artists, especially of those who were working during the Post-Impressionist era—extending roughly from Seurat and Gauguin in the 1880s to Picasso in his initial years in Paris around 1900—are encased in an envelope of myth and legend that associates the art with an imagined bohemianism accented by sexual license, alcoholic excess, genius merged with insanity, and deaths that are romantically youthful due to suicide or mysteriously decadent diseases. The art becomes a means of vicarious escape from our own lives into a novel and suggestive world whose diabolic excess we control through our ability to leave our aesthetic daydreams at will and thus avoid the final fates of those artists we have admired. In this process, the artworks lose their physical reality and become specters of themselves, ghostly apparitions of a cult whose shrines are the hushed halls of museums or galleries and whose sacred texts are the biographies, novels, and films filled with illustrations serving as rememorative substitutes for the art itself. Yearning for the familiar, we blind ourselves with comfortable precognition: We look through, not at, the works of art we know best and permit their aura to overshadow their material reality.

Henri de Toulouse-Lautrec's *At the Moulin Rouge* (fig. 1), one of a series of Post-Impressionist masterpieces in the Helen Birch Bartlett Memorial Collection of The Art Institute of Chicago, surely has earned its place among such icons of comfortable familiarity. Illustrated and discussed in the many volumes of writings on the legendary crippled, pathetic, but laughing dwarf of Montmartre; included in the numerous exhibitions of Lautrec's work that draw visitors by tens of thousands; among the most sought-out paintings at the Art Institute, *At the Moulin Rouge* is a work we may even find *too* familiar and one we avoid with some sense of embarrassment because of its, and Lautrec's, popularity. Our faith in our familiarity is misplaced, however: the painting is not what we have wanted it to be. Much of what we have thought to be true about it for over eighty years is false. Recent examinations of the painting by the Art Institute's Department of Conservation, particularly by conservator David Kolch, reveal a painting we have never seen.

Before we turn to those findings, we should review what we have believed and what we do actually know. Prior to entering the collections of the Art Institute in 1928, *At the Moulin Rouge* was displayed at the museum from December 1924 to January 1925 in a Lautrec exhibition organized by the Arts Club of Chicago. From the works in that exhibition, Frederic Clay Bartlett and other Chicago collectors selected those that today form

the core of the Art Institute's enviable Lautrec collection.[1] Before being purchased for the Chicago museum, the painting had been owned by Parisian collectors and art galleries since 1902, the year following Lautrec's death. It was ceded, along with other works in Lautrec's estate, to Maurice Joyant, codirector of the Galerie Manzi-Joyant in Paris and executor of the estate, by Lautrec's father, Count Alphonse de Toulouse-Lautrec, "with all my heart and without regret . . . [because] you believe in his work more than I do and because you have been proven right."[2] Joyant then apparently sold the painting to his partner, Manzi.[3] Also in 1902, *At the Moulin Rouge* seems to have been included among the group of some fifty works by Lautrec exhibited at the April Salon des Indépendants.[4] However, after that exhibition, the painting was not displayed in public again until 1914, when the Galerie Manzi-Joyant held a retrospective exhibition.[5] Although it may have been available in the intervening years at the Galerie Manzi-Joyant, for twelve years the painting essentially disappeared from public view. The 1914 exhibition was followed by another decade during which *At the Moulin Rouge* was again largely unseen.[6] Not until after the 1924 Chicago exhibition did the painting become a consistent part of Lautrec's oeuvre in shows devoted to his work. Then, and particularly after it entered the Art Institute's collections, the painting was on constant public display, either on loan to numerous exhibitions in the United States and Europe, or in the Art Institute itself.

The early exhibition history of the painting, therefore, is one filled with lengthy gaps during which it was not available to the public. Moreover, to this history of invisibility must be added even more significant years, because *At the Moulin Rouge* was apparently never exhibited prior to 1902, when Manzi purchased it.[7] Today universally identified as one of Toulouse-Lautrec's most important works, and one of the few large paintings created by him, it seems never to have been shown by him either in an exhibition devoted to his own art or in group exhibitions such as those of the Salons des Indépendants to which he consistently contributed. During Lautrec's lifetime, the painting remained in his studio. Lautrec's seeming reluctance to exhibit it deprives us of documentation that could establish the year in which he created it. Nonetheless, *At the Moulin Rouge* has consistently been assigned to 1892 since Maurice Joyant first listed it among a group of eight paintings with this title created in that year.[8] These eight paintings are clustered around a grouping of four that explore various aspects of the nocturnal life of the famed Montmartre music hall and that were exhibited in 1893 at the Galerie Goupil, which Joyant managed at the time.[9] The painting now in the Art Institute was not among them, however. None-

FIGURE 2 Henri de Toulouse-Lautrec. *Le Divan Japonais*, 1892/93. Lithograph in four colors; 80 × 61.5 cm. The Art Institute of Chicago. Mr. and Mrs. Carter H. Harrison Collection (1949.1002).

theless, in Joyant's biography and monograph on Toulouse-Lautrec, which in 1926 established authoritatively the compass and the chronology of Lautrec's works, he discussed the Art Institute painting as if it had been an essential component of the 1892 painting suite he had exhibited in 1893:

The renewal of the Moulin Rouge [under the new management of Joseph Oller in 1892] as new performers preferred by Lautrec were hired inspired him [to paint] . . . *La Goulue and her Sister*, *The Dance* or *The Beginning of the Quadrille*, *La Goulue and her Sister Entering the Moulin Rouge*, *The Dancers*, and finally: *Au Moulin Rouge* with several of his friends seen with La Macarona at a table.[10]

Joyant categorically stated: "This painting is one of the most important of all works by Lautrec. . . . It serves as

the summation of all his studies of the Moulin Rouge." He went on to identify the persons seen in *At the Moulin Rouge:*

Seated around the table, from left to right, are M. Edouard Dujardin [a Symbolist poet, critic, and dramatist associated with the *Revue Wagnerienne* and the *Revue Indépendante*], La Macarona [a dancer], Paul Sescau [a professional photographer], Maurice Guibert [a proprietor of the vineyard of Moët et Chandon champagne]; in the foreground to the right, seen full-face: Mlle. Nelly C. [a name otherwise unknown]; in the central part: [the dancer] La Goulue adjusting her hair and silhouettes of [Lautrec's cousin] Dr. G. Tapié de Céleyran, and of Toulouse-Lautrec himself wearing his bowler hat.[11]

Joyant's ability to identify with certainty various figures in the painting lends his information the quality of authority, as he intended, but this authority is undermined by his failure to even mention other figures. Joyant's writings about Lautrec are filled with personal reminiscences about the artist and the people he befriended.[12] Joyant should therefore have been able to identify with little difficulty the woman seen from the back, seated between Dujardin and Guibert. Her complex knot of fiery red hair, her tall hat of tulle and ostrich feathers, the gesture of her hand with little finger daintily extended—all these are identifiably the attributes of the dancer Jane Avril, described by Joyant himself as "Lautrec's most intelligent and complaisant model . . . with her very fine but pale facial features, angular, almost simian in figure and movement."[13] Jane Avril appears in the company of Dujardin, for example, in the 1893 poster for the music hall, *Le Divan Japonais* (fig. 2), in a pose quite similar to hers in *At the Moulin Rouge*, and in two painted sketches (figs. 3, 4), also closely related to her figure in the painting and certainly used by Lautrec as he worked out the composition. Another familiar dancer whom Joyant knew and failed to identify in the Art Institute painting is the woman seen in profile near La Goulue in the background, and easily recognized as La Mome Fromage, so closely associated with La Goulue as to be called her sister by Joyant in the painting of La Goulue entering the Moulin Rouge (see fig. 5), as well as elsewhere.

Joyant simply ignored the figures of Jane Avril and La Mome Fromage when he named the personnages of *At*

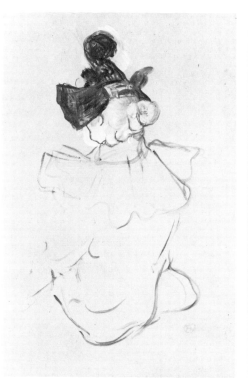 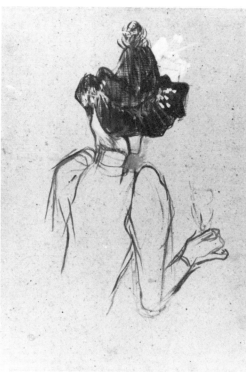

FIGURE 3 Henri de Toulouse-Lautrec. *Femme de Dos (Jane Avril)*, 1892/95. Oil or gouache on cardboard; 59.7 × 39.4 cm. Upperville, Va., collection of Mr. and Mrs. Paul Mellon.

FIGURE 4 Henri de Toulouse-Lautrec. *Jane Avril*, 1892/95. Oil or gouache on cardboard. Albi, France, Musée Toulouse-Lautrec.

the Moulin Rouge. More problematic, however, is his identification of the large right-hand foreground figure as "Mlle. Nelly C.," someone whose name is connected with Lautrec at no other time. The name is, in fact, a fiction that permitted Joyant to hide the actual identity of the person depicted: the English (or perhaps American) dancer May Milton.[14] Lautrec created a poster for her in 1895 (fig. 6), apparently for a tour of the United States, and used its composition for a black-and-white lithograph illustrating her dance in the August 3, 1895, issue of *Le Rire* (fig. 7). Moreover, in addition to printed sketches for the poster, he painted her portrait (fig. 8) and exhibited it at the London branch of Goupil's in 1898.[15] Her strange hat, perched on her head like a giant Art Nouveau insect with fibrous antennae and winglike bows, also appeared in Lautrec's cover of the sheet music for Yvette Guilbert's song "Eros Vanné" in 1894 (fig. 9). The features of the dancer seem to linger in those of the wearer of the hat as well.

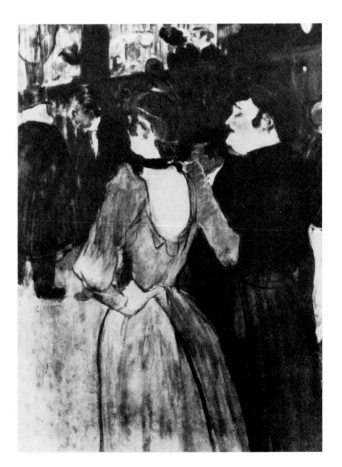

Despite Joyant's failure to properly identify May Milton as the major figure in *At the Moulin Rouge*, he is the source of the most information about her, but his description is tinged with distaste and notes of disdain:

> At the same time [as Lautrec discovered May Belfort, the Irish singer, in 1895] he also hunted down May Milton, but this May was no more than a dancer. Her pale face was clown-like and reminded one of nothing so much as a bull dog. Nothing in her face was attractive, but her movements' suppleness, her purely English choreographic training . . . [were] a sort of revelation to us then. . . .[16]

Others inform us that May Milton became the close friend of Jane Avril and that the two were in each other's company constantly, so that the lime-green face of May Milton, complementing the red-orange hair of Jane Avril in the painting, may serve as a commentary on their relationship. After 1895, however, Milton disappeared from the retinue of Lautrec, possibly after leaving for her American tour. With May Milton seemingly moving off the canvas and away from the central group, the painting could well symbolize her departure from the milieu of the Moulin Rouge.

Neither Miss Milton's brief appearance on the stages of Montmartre nor her departure suffice to explain Joyant's negative references to her, or certainly the vituperative description of her portrait (fig. 8) written in 1913 by Gustave Cocquiot:

> I remember having seen—with what a shudder [*frisson*]—this [portrait of] May Milton . . . with her yellowish-white complexion that left the impression of a bladder skin thinly stretched over some magma alternating between yellow and whitish green. This painting is of a hideous terror. This mouth, rubbed red, drops open like a vulva, lacking reserve, without solidity. It opens and lets enter whatever will! And the painter of this dreadful image was a lover of women! What entangled sadism! . . . or perhaps a sort of sermon addressed to other men? It is a singular problem.[17]

Cocquiot's bizarre, deprecating comments suggest that he was thinking of the apparition of May Milton at the right of *At the Moulin Rouge* more than of her other portrait, and that he was attempting to impart an apotropaic value to it, again as if something about the

FIGURE 5 Henri de Toulouse-Lautrec. *La Goulue Entering the Moulin Rouge*, 1891/92. Oil on cardboard; 79.4 × 59 cm. Philadelphia Museum of Art. Photo: M. G. Dortu, *Toulouse-Lautrec et son oeuvre* (New York, 1971), vol. 2. p. 243.

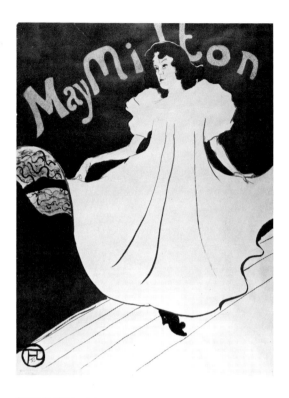

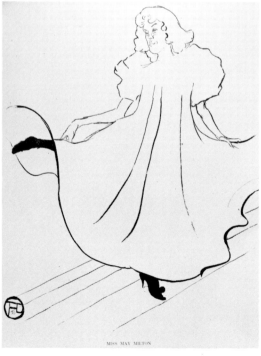

FIGURE 8 Henri de Toulouse-Lautrec. *May Milton*, 1895. Oil and pastel on cardboard; 65.9 × 49.2 cm. The Art Institute of Chicago, bequest of Kate L. Brewster (1949.263).

Top left
FIGURE 6 Henri de Toulouse-Lautrec. *May Milton*, 1895. Lithograph in five colors; 83 × 62 cm. The Art Institute of Chicago, Carter H. Harrison Collection (1948.451).

Left
FIGURE 7 Henri de Toulouse-Lautrec. *May Milton*, 1895. Lithograph in black. Published in *Le Rire*, Aug. 3, 1895. New York, collection of Herbert L. Schimmel. Photo: Nathan Rabin, New York.

memory of May Milton was so unpleasant or scandalous as to require rejection and condemnation. What this might have been is open only to conjecture: might Miss Milton's relationship with Jane Avril have been a lesbian one? At the time of the painting, in his depictions of prostitutes, Lautrec demonstrated definite interest in what the French identified as *l'amour anglais*, but polite society would surely have condemned such relationships outside the "perverse" atmosphere of the brothel. Joyant's and Cocquiot's references to vulgarity, ugliness, troupes of dancing "girls," overly receptive female genitals, and sermons to men can all serve as disguised references to what they did not wish to mention overtly: female homosexuality. Similarly, if the figure on the

cover of "Eros Vanné" (fig. 9) can be associated with the English dancer, the song's rhythmic ennui, its celebration of the tired sensibilities of *névroses*, of "secret maneuvers to resuscitate senses now defunct," and of "the quest for novel *frissons* [thrills]," all cause an eros:

Very old, worn out and satiated
Despite my twenty years, because I was born
on a bed of tarnished roses
and I am an exhausted Eros![18]

Thus, the song may signal forbidden erotic pleasures shared by two women such as those Lautrec depicted in *At the Moulin Rouge*. With one of the women in pseudo-masculine dress, the potential for identifying them as lovers and, by implication, as Jane Avril and May Milton, cannot be readily dismissed.

The conclusion we tentatively reach must remain conjecture, but it is one invited by the tone and content of Lautrec's ardent defenders as they discussed May Milton. Their need to denigrate—even annihilate—her memory appears to be the predominant motive, a motive that may explain the history of "vandalism" *At the Moulin Rouge* has suffered. The painting clearly shows, even in reproductions, that it is composed of two canvas segments: a rectangle measuring approximately one hundred and twenty-four by ninety-four centimeters and containing the group seated around the table; and a reverse-L-shaped segment, somewhat irregularly edged, measuring in its lower arm some twenty-seven centimeters high while its vertical portion is approximately sixteen centimeters wide and contains most of the figure of May Milton. Despite the easy visibility of this segmentation, it was not mentioned by Joyant or by M. G. Dortu in her six-volume catalogue of Lautrec's paintings and drawings compiled in 1971 to supplant Joyant's sixty-year-old listings.[19] Virtually all the literature on the painting, in fact, has been remarkably silent concerning the mounting of the two canvas segments on a new supporting lining canvas, the filling in with plaster of tacking holes surrounding the rectangle, and the efforts to touch up the junctures to make them less obtrusive. The first, and little noted, published mention (there are un-

FIGURE 9 Henri de Toulouse-Lautrec. *Eros Vanné*, 1894. Lithograph in black on tan wove paper; 49.6 × 33.9 cm. The Art Institute of Chicago, Carter H. Harrison Collection (1949.991).

published ones in the Art Institute's conservation and curatorial files dating back to the 1930s) is contained in a 1956 book by Douglas Cooper:

In its original form this picture was a straightforward conversation piece in which the spectator was imagined close to the table and looking down on the scene from just behind the back of the woman with orange hair. But Lautrec must have felt that this conception was too illustrative and banal, for at a later stage he enlarged his canvas. . . . Then he brought all the pictorial science at his command into play in order to transform the impressionistic or photographic image into a no less realistic but pictorially more effective one.[20]

The joining of the two segments to transform a genre scene of people in a café, such as had become common since Edouard Manet and the Impressionists began their systematic exploration of this theme during the 1860s, into a more radical composition, with a partial figure pushed to the edge of the canvas—that is, linked to the art of Edgar Degas and Japanese woodcuts—was not discussed further until twenty-two years later, when Gale B. Murray reviewed Mme. Dortu's catalogue:

No information is offered as to the way works may have been repainted or otherwise altered. *Au Moulin Rouge . . .* is again a most significant example, for at one point Lautrec radically enlarged and revised the painting by adding an extra piece of canvas and the prominent figure to the right. Dortu makes no mention of this fact and evidently did not find the reproduction of this painting in its original state, published in 1902.[21]

The photograph to which Murray referred (fig. 10) was republished shortly thereafter when the Art Institute organized a large exhibition of Lautrec paintings in 1979. In the catalogue, Charles Stuckey and Naomi Maurer referred to the photograph and, after identifying "Mlle. Nelly C." for the first time as May Milton, argued that the original painting of 1892 was revised by Lautrec after he met Milton in 1895.[22] The dating of the painting to 1892, first supplied by Joyant and accepted by everyone after him, was thereby revised, but not rejected, largely on the basis of its subject matter.

The conclusion that, in 1895, Lautrec was dissatisfied with his 1892 composition and revised it by expanding it is the one we would most readily seek. In this case, it also conforms to our image of Lautrec as an artist who moved from a relatively traditional realism toward a more radically stylized art, especially in his lithographs. The figure of the woman cut off by the edge of the canvas, her face tinted green and yellow, seems a jarring contrast to the more naturalistic rendering of the re-

mainder of the painting, and thus appears to justify the conclusion that Lautrec painted this work in two campaigns, separated by three years. That conclusion is what the logic of art history and biography demands; but that conclusion is also totally wrong. *At the Moulin Rouge* was painted all at one time, but not in 1892; as we shall see, it was later cut, the L-shaped segment was removed, and still later it was added back onto the rectangle from which it had been separated.

The examination of the painting during the fall of 1985 by Art Institute conservator David Kolch shows incontrovertably that Lautrec's original painting was cut up.[23] When the two canvas segments were inspected, the paint surfaces and manner of application were seen to be similar. In certain areas, such as the ballustrade at the lower left, which would have had to be partially painted over to make adjustments if the painting had been extended, no sign of overpainting is to be found. Lautrec's practice of using paint thinned with turpentine until it soaked into the ground of the canvas would have made the duplication of surface qualities extremely difficult, if not impossible, without remnants of this process remaining visible. X-radiographs of the painting, moreover, showed that brushstrokes of objects such as the bentwood chair extended from one canvas segment into the other. To the evidence of paint surface and brushstrokes can be added that provided by the weave of the canvas. Running horizontally through the canvas at several points are noticeably heavy threads; these "fat threads" cross the vertical seam joining one canvas segment to the other, thereby demonstrating that the two segments were once of one piece, not two distinct canvases later joined. The canvas painted by Lautrec must therefore originally have been at least its current size. The rectangular portion of the table group was later cut away and restretched to create the painting seen in the 1902 photograph, while the L-shaped portion was unstretched, folded diagonally near its center (paint loss here indicates this), and presumably stored away. Rejoined again later to its severed segment on a lining canvas, the seams resulting from this process were painted over to minimize and hide them. From this procedure of dismemberment and rejoining, the painting now in the Art Institute resulted.

The major question arising from this previously unrecognized process is, obviously, who cut the painting and when, as well as who patched it back together and, again, when? Was it Toulouse-Lautrec who initially removed the figure of May Milton and then preserved the canvas fragment with her on it, so that the executors of his estate were able to rejoin the two pieces? Or did Joyant both cut and then again patch the painting after the artist's death? Documentation that would defini-

121

tively answer these questions does not seem to exist, and there are also no critics' descriptions of it during Lautrec's lifetime to provide clues as to its appearance then. But, by examining once more the painting itself, the information concerning it supplied by Joyant, and the photograph published in 1902, we can arrive at a reasonable conclusion as to the probable circumstances and dates of the creation and alteration of *At the Moulin Rouge*.

As we now know, the photograph thought to represent an early stage of Lautrec's painting has been proven to be instead a "second stage"—in which the canvas was cut down and split in both dimension and content, with the offending image of May Milton removed. If the canvas of the painting itself today continues to testify to us that, in its original conception, May Milton, whom Lautrec met in 1894 or 1895, was very much a part of it, the photograph of the reduced version (fig. 10) provides us with a date—1902—prior to which the dismemberment took place. The circumstances of the photograph's publication may also tell us why this seeming "vandalizing" of an artist's work happened at all. The photograph was published along with those of thirty-six other works by Lautrec in the April 1902 issue of *Le Figaro Illustré*, an issue under the editorship of the Galerie Manzi-Joyant and devoted to a celebration of Toulouse-Lautrec's work. The publication date coincided with that year's Salon des Indépendants (March 29–May 5, 1902), referred to above, where in the central gallery there appeared a memorial collection of the artist's paintings and lithographs. Insofar as they can be identified, nine paintings listed in the catalogue were either then owned by Manzi or Joyant, or had recently been sold by their gallery. Many of these were included among the illustrations in this issue of *Le Figaro Illustré*, and presumably paintings such as *At the Moulin Rouge*, recently turned over to them by Count Toulouse-Lautrec, were among the forty or fifty additional paintings said to have been exhibited *hors catalogue* at the Salon.[24] The other paintings illustrated in the special issue of the magazine were exhibited in the large retrospective of 200 works by Lautrec that took place at the Galerie Durand-Ruel from May 14 to May 31, 1902. This exhibition excluded works from the Manzi-Joyant inventory; these may, therefore, have remained available for viewing at their gallery. The selection of paintings at the Salon des Indépendants and the thirty-seven illustrations all functioned as advertisements of gallery inventories at a time when the artist's name continued to attract public curiosity, still only months after his death.

The presentation of Lautrec to the public of 1902 not only served commercial ends but also existed in the context of a more encompassing debate concerning the

FIGURE 10 Henri de Toulouse-Lautrec. *A Table at the Moulin Rouge*. Photograph published in *Le Figaro Illustré*, April 1902. Photo: New York Public Library.

health, or lack of it, of modern art and of the bohemian existence, whether real or imagined, of many contemporary artists. Lautrec's death in 1901 was surrounded by sensationalized gossip, fed in part by memories of his confinement to a mental hospital for three months during 1899. His stay in an asylum for detoxification, his reputation for sexual libertinage, and his association with entertainers of various types sufficed to make the artist's death at the age of thirty-seven a subject of popular conjecture and tongue clucking, particularly when these were combined with the fact that he was "the last descendant of one of France's most noble and oldest families." "He died horribly," summarized the *Lyon Républicain*, "ruined in body and mind, in an insane asylum while subject to periodic fits of raging madness."[25] Toulouse-Lautrec's ancestry, physiognomy, life, death, and art—both its content and technique—seemed designed to demonstrate the truth of the then highly popular theories about the degeneracy in modern art and literature propagated by Max Nordau in his book *Entartung*.[26] It was to counter the image of Lautrec as an insane artist that Manzi-Joyant published the richly illustrated issue of *Le Figaro Illustré*.

In this carefully orchestrated denial of such charges, in texts alternating between factual description and poetic metaphor, such Parisian critics as Arsène Alexandre (who had befriended Lautrec and had already written defenses of the artist), Julien Leclerq, and Roger Marx, and such German critics as Julius Meier-Graefe, Hermann Esswein, and Julius Elias, admitted the alcoholism of their hero, but also identified him as a modern Dante who descended into the inferno of Montmartre and incisively depicted what he witnessed. Thus, Alexandre wrote in 1899, "In his thirst for truth, this strange and intrepid small man descended into hell, and his bristling hair was singed [by] the abomination of alcohol." Over his entire oeuvre, Alexandre continued, should be posted the warning inscription of Dante's *Inferno*: "Lasciate ogni speranza voi ch'entrate! [Abandon all hope, you who enter here!]"[27] This argument, which literally detoxified Lautrec by asserting his sanity and his noble nature in the midst of a degenerate milieu, was

masterfully summed up by Elias in the liberal weekly *Die Nation*:

They say he was a repulsive dwarf with a horridly large head; and in reality he was only a pitiful *boiteux* [cripple]. They say he was a slovenly debaucherer, but he was a member of [one of] France's noblest families, was always on the best of terms with his parents, lived in ideal circumstances that made him financially independent and disdainful of the tainted cash offered by dealers, and he was a noble man in every way: his mannerisms were not without a certain delicacy, and as a conversationalist he was unsurpassed. They go on to say that he lived in brothels and that he habituated the saloons and bars of the Boulevard de Clichy and of the lower city. We should add that he was a constant patron of the *Chat Noir* and the cabarets later emulating it, that he was the particular friend of Rodolphe Salis, the *chansonnier gentilhomme* [gentleman singer], that

he knew the best and least actors personally, that he was welcomed in the boudoirs of the most genial and beautiful *actrices* and singers. It was in that world that he found his life's element as artist and as thinker. He knew life, and knew best *la basse humanité* [human lowlife], and this life left its mark on him—one day more harshly than this weak body born of a genetically exhausted nobility could bear. It attacked his nerves first, and he sought the narcotic of strong drink. But then they say: Lautrec died of alcoholism in an insane asylum. In reality, tuberculosis ended his life and he died in the arms of his mother. I was privileged to see a letter written by this loving mother in which she said: ". . . it was astonishing to us to see how, in spite of his illness, his intelligence and the lucidity of his mind remained so extraordinary. It was phthisis that took him away from us." Then, last of all, they say: Lautrec was not a painter! I could claim with just as much justification that in modern Prussia there are no generals.[28]

Through a selective denying and affirming of general conceptions about Lautrec, mixed with irony and not a little pathos, the reputation of the man was defended from his attackers. If Lautrec the man could be retrieved from ignominy by asserting his normality, even his nobility, in a milieu of depravity, then much the same argument could be effective for his art. Judged by his detractors to be a perverse and pornographic caricaturist, not a true artist or painter, Lautrec was situated by his admirers in a pantheon of artists and writers who recognized the bizarre beauty of ugliness. Greek mythology, Shakespeare, Victor Hugo, Baudelaire, and others were cited to establish the sanity of Lautrec's observations, and his art was given an honored genealogy that encompassed the entire Middle Ages as well as a noble ancestry of individual geniuses:

Is it really necessary to indicate by citing names this series of geniuses, of unique talents, of free spirits in whom was perpetuated [the medieval] judgment—pessimistic, tragic, comic, laughing, loving—of the spectacle of life? Brueghel the Elder in Flanders, Holbein in Germany, Rembrandt in Holland, Michelangelo in Italy, Velasquez and Goya in Spain, the designers of woodcuts in Japan, Daumier in France: none of them hesitated before the horror and the ugliness that confronted them to express the truth of their observation and the profundity of their thought.[29]

Safely surrounded by universally praised tradition, Lautrec's example then became a means of attacking the very bourgeois mentality and capitalist society that had been mounting an attack on the artist. Not he, but society, was decadent, nearing its own demise and announcing its own death. Lautrec was the genius, the nineteenth-century Dante, who depicted this "divine comedy" of a dying century and a dying civilization. The milieu, not the artist, was crippled in body and mind, it was argued with mixed Darwinist and anarcho-socialist conviction, and Montmartre was the site in which was concentrated its modern inferno, "the neurosis of perverse orgies, the delerium of weakened senses whipped into arousal, the harsh biting laughter of despair drugged by alcohol and racing toward the abyss in a wildly danced *chahut*."[30] Lautrec, the seer, also served as the summation of this declining civilization in the tragedy of his life: "The fame of his family began in the Provence [during the Middle Ages] and ended between the locales of Aristide Bruant and the Moulin Rouge; between these temporal limits is inscribed the entire organic evolution of a great people's art and culture."[31]

It is within this context that we should consider *At the Moulin Rouge* and its transformation. It was given the title *Une Table au Moulin Rouge* (*A Table at the Moulin Rouge*) when it was illustrated, physically cropped, in

Le Figaro Illustré, and it was discussed under this title as well a few years later by the German critic Hermann Esswein. Using Lautrec's art as his focus, Esswein engaged in an extended discussion of decadence, and the issue of decadence in art, and concluded that it was the milieu, not the art, that deserved the epithet. In his argument, the fragmented *At the Moulin Rouge* played a pivotal role:

[Lautrec] often ate in the company of these two women and three men about town and at this table they distributed themselves thus, five isolated figures surrounding its torturous barrenness, its void surface. But all five of them fail to notice the two female figures behind them to the right, whom only Lautrec sees. Two women, one fixing her hair with a masterful, lifelike gesture as the other, with hands on hips, stares into the room through rigidly glazed, wide open eyes. In these two secondary figures, as well as in the two character types who saunter past the seated group toward the locale's exit, the entire genius of the painter has been brought into focus. This is not just some ingratiating slice of life arbitrarily selected. In this painting we are convinced that the scene fully *characterizes* the milieu.[32]

In addition to summarizing the argument against Lautrec's decadence, this account makes clear how different the effect of the painting fragment was from that of the entire composition. Closely focused on the table group, with the edges of the painting cropped and reduced even further as they were folded back around the stretcher for tacking, the abridged composition placed the viewer (or the painter, as Esswein suggested) immediately behind Jane Avril, somewhat above her and apparently on a platform behind the railing seen at left. At eye level were the four background figures, who thus assumed the significant role attributed to them by Esswein. With edges cut close to the figures and with the light green background visually pressing forward, the space in the painting was compressed and collapsed, and the viewer's eye bounced in a claustrophobic circle among the brightly colored faces, hair, and skin of the women over the incommunicative shadows of the men. Viewed in this manner, the fragment is a powerful image in and of itself, and certainly capable of independent presentation, whether seen in formal or psychological terms. It would not be difficult to imagine Lautrec presenting it in this fashion as a variation on similar scenes by Degas, whom he admired, as well as on his own *At the Moulin de la Galette* of 1889.

Although the severed composition would have been effective, and therefore testifies to the artist's sensitivity to composition, it lacks the internal visual logic found in other Lautrec images, whether paintings or prints. Following, in particular, the example of Degas in crea-

ting works containing unorthodox viewpoints and frequently cutting figures with the frame as if it were a physical limit imposed on the field of vision, Lautrec placed great emphasis on establishing the position from which a scene takes on its perspectival coherence. This is most noticeable in his lithographs, whose compositions tend to be bolder than those of his paintings. His concern for naturalistic vantage point and perspective seems to affirm allusions to volume and space, which his flat application of color seems to negate; it is in their tension that Lautrec achieved pictorial unity. As already pointed out, in the fragmented painting the viewer/painter would have to be immediately behind and slightly above Jane Avril. If one assumes this vantage point, one should also be looking downward onto her companions. However, this is not the case at all. Instead, the viewer is at about the same height as the profile face of Maurice Guibert, able to see the undersides of the hat brims of La Goulue, Dujardin, and Sescau. The viewer must also move his eyes upward to gaze at the four background figures. It becomes apparent to the viewer, in trying to define where he is in relationship to the table group, that he is, in fact, somewhere to the right of the group, out of the rectangular space of *A Table at the Moulin Rouge* and directly at eye level with May Milton. The entire scene is plotted so as to appear as if the viewer had just encountered her yellow-green apparition and only then sees to the left the table group and the others in the Moulin Rouge, with its green walls, windows, and expanses of mirrors. May Milton is more, then, than a necessary component of the composition; she is the very fulcrum around which the entire composition was conceived. She could not have been added in a later reworking of the painting; without her, the painting of Lautrec and his friends in the Moulin Rouge lacks any focus. It should also be apparent that, with May Milton as an integral part of the original painting, it could not have been created prior to 1894 or 1895, when the artist met her.

While it is not possible to document that it was not Toulouse-Lautrec who cut down the painting, it is certainly unlikely. Had he done so, surely he would have granted the fragment greater unity and logic. The 1902 photograph, when compared to the painting as it is today, does show some alteration, but all of it is concentrated on erasing the presence of May Milton, not on reshaping the composition so that it gains independence without her. Her right sleeve, which would have remained in the rectangle's lower right corner, must have been overpainted with the ocher of the floor and with lines suggesting floorboards. Part of Guibert's coat may also have been touched up in an effort to blend the new paint of the alterations with the old, something that may

have caused the changes in Jane Avril's bentwood chair that are apparent in the photograph, although the latter may be touch-ups on the photograph for the sake of clarification.

Since traces of these changes are not discernible in the painting today, they must have been made in a manner that would have allowed them to be undone later on. It is possible that an easily soluble medium was used, or that the pigments used to cover what remained of May Milton were applied over a coat of varnish. These would be the techniques less of an artist altering his own work than of a restorer who had been instructed to make adjustments in such a way that the painting could be restored to its original state. Thus, Joyant, rather than Lautrec, comes to mind as instigator of the alterations. Had the removal of May Milton taken place by Lautrec's hand, it would have been for unknown personal reasons, as former lovers might edit out the figure of a rejected, or rejecting, love from a photograph. By May 1898, such exorcising of May Milton from his oeuvre had not yet taken place, since Lautrec included her portrait in Goupil's exhibition of his work in London. Shortly thereafter, in January 1899, he was confined for detoxification. During the two years remaining to him, he developed a painting style quite unlike that of *At the Moulin Rouge*. There is no evidence of this later mode in the corrections visible in the 1902 photograph. Again, all this suggests a posthumous change in, and entitling of, Toulouse-Lautrec's *At the Moulin Rouge*. As long as it remained in the artist's possession, May Milton was very much a part of the painting.

We can safely conclude, therefore, that *At the Moulin Rouge* was cut apart after the painter's death on September 9, 1901, and certainly prior to publication of *A Table at the Moulin Rouge* in the April 1902 issue of *Le Figaro Illustré*. Similarly, the cutting and restretching must have taken place before the opening of the Salon des Indépendants on March 29, 1902. The alteration of the painting can be more closely dated to the weeks just after Joyant received the painting in the group of works deeded to him by the artist's father. He himself provided evidence suggesting this. In his book, Joyant described the painting as being signed by the artist with his monogram at the lower left of the canvas.[33] There is no such signature today, however; instead, what we see is the small red cachet of the artist's encircled monogram which Joyant himself applied as executor of the estate in 1902. Apparently never intending to exhibit it, Lautrec had no reason to sign the painting, and it was left to Joyant to do after it came into his purview. Had the canvas already been divided at that time, the cachet would have been placed onto the rectangular fragment containing the seated figures at table. Instead, on the

lower left corner of the L-shaped segment that is May Milton's realm, the cachet was stenciled prior to the cutting down of the canvas. It is one more factor affirming that *At the Moulin Rouge* was slit into separate sections under Joyant's immediate direction.

Why would the man who prided himself on being one of Lautrec's staunchest defenders, closest friends, first dealer, and the major authority on his art and life have done this to a work of art he was assigned to preserve? His very emotional involvement with the art and creator may well be the reason. May Milton was, after all, someone whose brief stay in Paris seems to have left behind it a trail of animosity among those of Lautrec's acquaintances who chose to write about her. The desire to eradicate her presence in the work of Lautrec must have been strong. Popular and influential, the poster in which she figured could hardly be destroyed, nor could the portrait in a private collection or on display at the rival gallery of Durand-Ruel be refuted. But the matter was different in a painting never seen before and in which her image seemed peripheral and easily removable from the main body of the picture. Even after he had restored the figure of May Milton to the canvas, Joyant continued denying her presence by identifying her as "Mlle. Nelly C." The effect of denying May Milton her identity was conceptually similar to, although certainly less drastic than, removing her figure from the painting.

To the complex of personal motivations must be added the commercial ones of an art-gallery director. The reduction of the canvas did not deprive it of commercial value and, in fact, may even have enhanced it. In the climate of repeated charges against Lautrec of insanity, depravity, alcoholism, and general signs of degeneration, the garishly green, yellow, and white face of May Milton was hardly a ready argument for sanity of vision measured in naturalistic terms. During this period, it was precisely the green faces or blue trees made by other artists that were constantly cited as symptomatic of their mental aberration.[34] Even if May Milton's bizarre complexion derived from a naturalistic rendering of the effects of stagelighting, her discolored, masklike face could certainly have been detrimental to the image of a healthy Lautrec fostered by Manzi-Joyant, and would have been a liability in their inventory. Skillful cuts and minimal reconstructive painting were ready and viable solutions of the gallery for removing the undesirable aspects of one of its major holdings.

If it can be established that *At the Moulin Rouge* was taken apart during the early months of 1902, after it had entered the inventory of the Galerie Manzi-Joyant, it is less certain precisely when Joyant and Manzi chose to resurrect the original composition. Esswein's description of the smaller painting was published in 1909, sur-

prisingly without an illustration in an otherwise well-illustrated book that made ready use of Manzi-Joyant holdings. Perhaps, by that time, the two parts of the painting were being reunited onto the lining canvas that now supports them. The restoration of the original composition was certainly completed by the June 1914 retrospective exhibition sponsored by Manzi-Joyant. *At the Moulin Rouge*, then owned by Manzi, appeared in the catalogue listing accompanied by the description, "Portraits of M. Henri de Toulouse-Lautrec, of Dr. Tapié de Céleyran, Sescau, Maurice Guibert, La Macarona, La Goulue, etc." The "etc." may indicate that May Milton had been reunited with her friends. But again, unfortunately, the painting was not illustrated. A photograph of *At the Moulin Rouge* in its restored state, looking like it does today, did appear two months later, however, as a full-page plate accompanying a lengthy laudatory review of the exhibition in the August 1914 issue of the prestigious, aesthetically conservative art-historical periodical, the *Gazette des Beaux-Arts*.[35] Written by Gustave Geffroy, the article announced the ready assimilation of May Milton's gaudy face into an art establishment whose sensibilities were being accosted by yet more offensive visages portrayed by Fauvists, Cubists, and Futurists as modern artists increasingly rejected the essentially mimetic values that Lautrec's art continued to maintain.

The restored painting nonetheless fails to reconstruct fully the composition that Henri de Toulouse-Lautrec painted during the 1890s. David Kolch's analysis of the canvas also revealed that several portions of the canvas on which the image was created are missing, having been removed in the course of the changes of 1902. Originally, *At the Moulin Rouge* may have been larger in one or both directions. At least the upper edge of the painting shows possible signs of having been trimmed, so that the precise dimensions of Lautrec's original painting can no longer be determined. It is likely, however, that little more than the inch required for a tacking margin would have been cut from the edges. However, within the current field of the painting, portions of canvas are absent as well: roughly an inch where the lower arm of the L-shaped segment and the bottom of the rectangular fragment are joined; and a smaller, erratically sized amount where the two pieces meet vertically (see fig. 11). The gaps, again, are the results of the painting's dismembering when a tacking margin was created around the rectangular portion seen in the 1902 photograph as it was attached to a stretcher. The process of folding and attaching naturally would have damaged much of the perimeter of this segment, and the areas that suffered the most loss must have been cut away when the two fragments were rejoined. Parts of the right-hand, vertical

tacking margin, which would have included elements of May Milton's hair and dress, were retained, the holes patched with plaster, and the repair hidden with paint; but the horizontal tacking margin was simply removed, thereby leaving a space between the two segments when they were aligned. To fill in this gap, the two canvas parts were deliberately misaligned in the rejoining by shifting the entire rectangular portion downward an inch in relation to the other section. The resulting disjuncture is most readily visible immediately above and behind the head of May Milton as the border of the ocher wall paneling and the green-hued doors suddenly lifts without any justification for it in the architectural details of the room.

That this has never before been noticed was probably due to the manipulations the form of May Milton's odd hat has undergone. As seen in the cover illustration for "Eros Vanné" and in the portrait of May Milton, this hat was composed of a tulle bow from which sprouted two feathers, or rather the denuded rachis of two feathers with all but the tips of their vanes removed so as to result in a form reminiscent of the club antennae common to many beetles. The hat's Art Nouveau insectile reference is clear in the lithograph and the portrait, but in the reconstructed *At the Moulin Rouge* it has been lost, as the two antennae were incorrectly restored and joined by other, more bulbous or flowerlike forms. These were added by the restorer to disguise the disjuncture of the rejoined canvas segments and to cover parts of the repair process. Also altered to suit the incorrect alignment was the profile of May Milton's hair and the pattern of her collar. In their original form and position, their swirling lines directly joined with the similarly shaped silhouettes of the seated and standing figures so that an Art Nouveau-like linear pattern moved gracefully through the entire composition, much as in Lautrec's lithographs. And, similarly disrupted were the lines of the floorboards that originally formed relatively accurate perspective patterns, as did the balustrade on the left, which now has a sudden bulge near the area of Jane Avril's chair to cover up the misalignment.

The removal of portions of canvas and the misaligned joining of the parts of *At the Moulin Rouge* disturbed the relaxed and undulating linear unity Lautrec had given his composition, so that May Milton now intrudes more harshly than before, her form angularly juxtaposed to the remainder of the work. This is also due, in part, to the contrast of the garish coloration of her face to the more muted tones dominant elsewhere. This is probably the result of attempts to restore and preserve the controversial portion of the painting. The painting today has at least one layer of glazing and probably more. While this serves to unify and protect the paint surface, the glazing

or varnishing of paintings was contrary to Lautrec's practice during the 1890s. Like many other artists of the time, he experimented with various techniques and materials in his painting and also with the resulting surface effects. During the late 1880s, he began to show a preference for painting with oils thinned with turpentine and sometimes mixed with gouache or crayon on cardboard and, from 1890 to 1894, apparently ceased to use canvas almost totally.[36] The choice of a nondurable and nonnoble cardboard material on which to represent scenes of café, theater, and brothel life surely appealed to Lautrec at a time when many of his friends and supporters openly espoused political anarchism, with its absolute rejection of the existing social order and values.[37] Whether or not Lautrec's cardboard paintings were material manifestations of a socio-anarchist advocacy, with their turpentine-dispersed pigments, they presented a surface quality quite unlike the oily and viscous surfaces of traditional oil paintings or those of the Impressionists, especially after varnishing. Paint and turpentine on cardboard creates a more mat surface, in vogue at the time. Lautrec developed a technique in which sheets of thin, subtly nuanced color arranged in veil-like, flatly rendered planes defined his figures. Like the linear patterns of the original *At the Moulin Rouge*, the flat, planar color layers have an effect closely resembling that of his lithographs. Varnish on such a surface would destroy the intended effect, and in the process at least some of the colors would also be altered.

All this has happened to *At the Moulin Rouge*. Although painted on canvas, not cardboard (which is, we should note here, material evidence that the painting was created in 1894 or later), the canvas was primed with gesso tinted to take on the color of cardboard, and this brownish tone serves as the color base of much of the painting. The paint applied to this ground is mostly the thinned oil paint Lautrec had used on his cardboard paintings and was likewise intended to melt into its support so as to create a soft, mat surface. The rich yet subtle variations of dark violets and browns that form the coats and dresses of the figures in the painting have also been lost beneath sheets of yellowing glazing.

The face of May Milton appears less affected by this darkening and dulling process than does the remainder of the painting, perhaps because when the rectangular fragment was varnished she escaped that fate. However, the L-shaped section was certainly varnished when it was reattached and when the painting was restored at the Art Institute in 1935.[38] The muted colors of the table group were originally more closely related to the now strong contrast of May Milton's facial colors. The reddish tones of hair and the whites of the women's skin, the tablecloths, and the reflected lights acted as constant

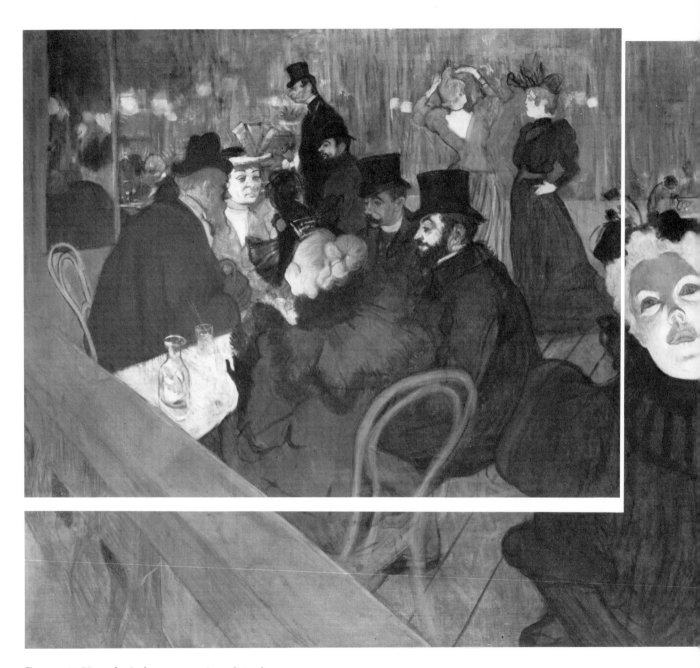

FIGURE 11 Hypothetical reconstruction of *At the Moulin Rouge* (fig. 1).

accents within the tonal harmonies of greens, ochers, violets, and browns offered by clothing, floor, balustrade, and walls. In that admixture of colors and hues, the limelit face of May Milton alone attracted them all, uniting in its form what is otherwise dispersed through the composition. Thus, she was as crucial to the coloration of the painting as to its composition. Joyant's interference with the painting negated the look Lautrec sought to impart to his paintings, a look whose source is the compositional and coloristic practices he developed in his lithographs.

In recent studies and exhibitions devoted to Toulouse-Lautrec, the preeminence of his lithographs over his paintings has been repeatedly asserted.[39] The lithographs, it is argued, often derive from one or more painted compositional studies, or even finished paintings, so that the artist must have viewed these as purely preliminary to the prints and clearly subordinate to them. More likely, Lautrec rejected any such hierarchy of media. His interest in lithography reflected a desire to extend the meaning and application of art outside the traditional limits of the "fine arts." In being executed on cardboard, the paintings came to participate in the essential temporary and disposable nature of posters or advertising brochures such as he designed for Yvette Guilbert. The technique constituted a denial to painting of its traditionally noble and elevated position and function by rejecting the physical components assigned to it, so that even the paint itself was thinned to liquid consistency to take on the quality of lithographer's ink. For Lautrec, paintings and prints devoted to the low life of Montmartre functioned as a visual accusation against the society in which he was relegated by virtue of his handicap to the role of eternal child. In *At the Moulin Rouge*, he expanded his repertory of ink and painted cardboard by applying consistently lessons learned in lithography—a manner of drawing and the use of large, flat color areas—to the medium of oil paint now on its traditional canvas support, but with a gesso ground tinted the color of cardboard. Rather than being a painting from which lithographs were derived, it is a painting derived from lithographs—a painting almost disguised as a lithograph.

These considerations are useful as we return to the question of when Lautrec painted *At the Moulin Rouge*. Joyant's attribution of the painting to 1892, which has been consistently followed until now, no longer can be defended on stylistic grounds, on the use of materials, or iconographically, since May Milton was not part of Lautrec's milieu until 1894 and 1895. Technique also ties the work closely to the manner of other paintings on canvas known to have been created between 1894 and 1896, such as *The Salon in the Rue des Moulins* (fig. 12)

or *Marcelle Lender Dancing the Bolero in "Chilperic"* (fig. 13). Painted on canvas prepared with tinted gesso, these too display a concern for broad planes of color and thinned veils of pigment, but not the flowing Art Nouveau lines of *At the Moulin Rouge*. The painting was definitely not executed before 1894, nor after 1896, when Lautrec assumed a style of greater sketchiness and loose brushwork. It is most likely that *At the Moulin Rouge* was painted late in 1894 or, more probably, in 1895.

This revised dating gives the image a different position in Lautrec's life than previously assumed. By grouping *At the Moulin Rouge* with other Moulin Rouge paintings of 1892, Joyant distorted the painting's position in Lautrec's career. The effort to extract May Milton may underlie this move, but the commercial virtue of a painting capping an already successful suite of paintings previously sold to collectors surely must also have been a consideration. Placed back into the milieu of 1895, the painting takes on different, and possibly more significant, connotations for Lautrec and the development of his work. If 1892 represented the renewal of the Moulin Rouge as noted dancers and singers were hired away from other music halls, by 1895 this energy was fading. La Goulue and others who had brought fame to the locale were leaving or had already gone. La Goulue set out to present her belly dances and can-cans at local fairs, and invited Lautrec to provide the exterior of her booth with paintings.[40] Possibly, this commercial production of publicity images on canvas for La Goulue reawakened in Lautrec an interest in painting on canvas, while the scenes he executed depicting La Goulue's "Moorish Dance" and her performance at the Moulin Rouge that was admired by Jane Avril, Maurice Guibert, Paul Sescau, Tapié de Céleyran, and Lautrec—all represented in *At the Moulin Rouge*—served as inspiration for creating his own private image of a milieu whose dissolution was imminent. Thus, *At the Moulin Rouge* is a memorial image that is a composite of past activity and of prior depictions by Lautrec of the persons participating in the scene.

Indeed, the practice of utilizing previous compositions and portions of compositions is one Lautrec favored in his lithographs; as we have said, his painted images and printed derivatives could be separated by years. *At the Moulin Rouge* demonstrates the same practice. The figure of Jane Avril seen from the back relates to the poster of *Le Divan Japonais* from 1892–93, as well as to the two oil sketches that more precisely duplicate the pose, both probably from 1893 or 1894. The face of May Milton is an adaptation of her painted portrait, possibly also done in 1895 while Lautrec worked on her poster, but is stylistically related to works of 1894 as well. The face of La Macarona in turn derives from

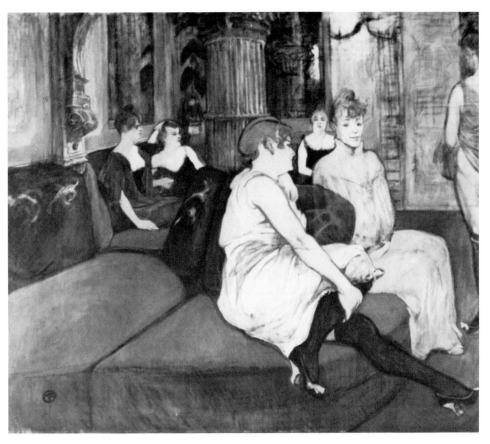

FIGURE 12 Henri de Toulouse-
Lautrec. *The Salon in the Rue
des Moulins*, 1895. Oil on canvas,
111.8 × 132.8 cm. Albi, France,
Musée Toulouse-Lautrec.

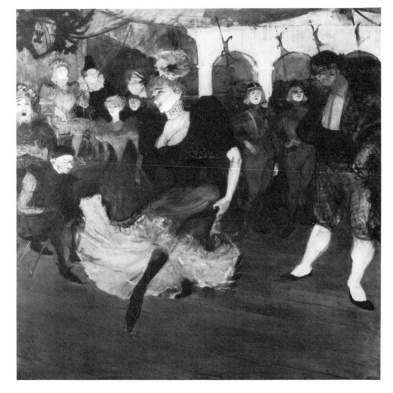

FIGURE 13 Henri de Toulouse-
Lautrec. *Marcelle Lender Dancing
the Bolero in "Chilperic,"* 1895/96.
Oil on canvas; 145.4 × 150.2 cm.
New York, collection of Mrs. John
Hay Whitney. Photo: John D.
Schiff, New York.

130

FIGURE 14 Henri de Toulouse-Lautrec. *La Macarona as a Jockey*, 1894. Oil and gouache on cardboard; 51.8 × 38.7 cm. The Art Institute of Chicago (1954.22).

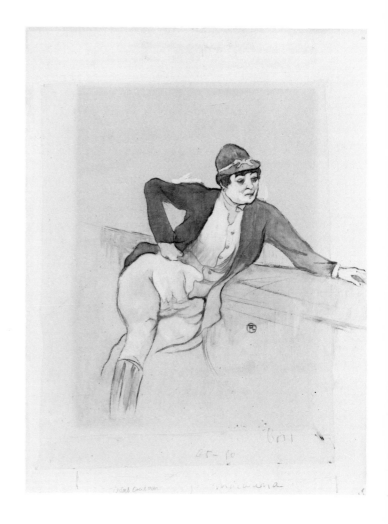

Lautrec's portrait of her as a jockey, published in the February 1894 issue of *Le Figaro Illustré* (fig. 14); the costume was changed, but the white face covered with rice powder and with heavily colored features remains the same. Dujardin's characteristic profile reverses that seen in the *Divan Japonais* poster. Sescau and Guibert appear either separately or together in several paintings, any of which might have presented a model portrait, but photographs too might have been used, just as one of Toulouse-Lautrec in the company of his cousin Tapié de Céleyran at the Moulin Rouge (fig. 15) surely was the source of their grouping in the background.

In 1890, Lautrec represented many of the members of his milieu in the painting showing the dancer Valentin le Desossé teaching the *quadrille naturaliste* to a new dancer at the Moulin Rouge; *At the Moulin Rouge: The Dance* (fig. 16), exhibited at the Salon des Indépendants and then publicly displayed in the foyer of the Moulin Rouge itself, is in many ways the antithesis of the Chicago picture. The 1890 painting was a public one in every sense, depicting the entertainment at the café-concert and dance hall along with the audience that participated vicariously in the energetic spectacle of the dancers. The raucous gaity and movement, the anonymous intermingling of people seen in that painting contrast sharply with the private world of the later work where women and men sit, stand, or saunter silently, without communication or focus, in isolation one from the other. They are gathered together in a scene of personal and sexual tension in an atmosphere of anxious ennui; both dancers have ceased performing and their male admirers have lost interest. In fact, the powerful motion and focal attraction of May Milton's figure and face, pushing out of the framed limits of the painting, threatens to pull the entire composition off the canvas itself.

In this way, May Milton functions in a manner contrary to figures situated at the periphery of other Lautrec paintings, where they are seen walking into an interior or acting as enframing and stabilizing elements (see fig. 16). Likewise, similar yet different from the group in other Lautrec paintings are the men and women seated at the table and staring blankly past each other. Uncommunicative figures seated and drinking in a café, with or

without dancers or singers providing entertainment above and behind them, had become a virtual trademark of the "painters of modern life" from Manet, the Impressionists, and Degas to less adventurous but successful artists such as Jean François Raffaëlli (also championed by Arsène Alexandre, incidentally). Lautrec adopted such scenes as he began to explore the world of Montmartre entertainment, first in illustrations for periodicals such as Aristide Bruant's *Le Mirliton*, or the more popular *Courrier Français* and *Paris Illustrée* during 1886–89, and then in paintings exhibited at the Salons des Indépendants beginning in 1890. They functioned essentially as images that presented a young artist with a persona established in an association of style and subject matter that countered the world of artistic and social propriety with an adopted argot and a posture of

perpetual antagonism and cynicism. As Lautrec "descended" into Montmartre's music and dance halls, it had become the site of artistic, literary, and musical bohemias advertising themselves under the names of Hydropathes, Incoherents, Hirsutes, and Zutistes. They occupied the Parisian "mountain" as if it were a "vengeful and clamorous citadel from which projectiles [rained] heavily onto the pontifs of the boulevards and onto the mummies of the Academy."[41] Along with poets and artists came professional entertainers, dancers, and singers to replace the unpaid amateurs or semiprofessionals of the Moulin de la Galette or the Elysée Montmartre. When the Moulin Rouge opened in 1889, many of the most popular performers, previously amateurs or part-time dancers, were hired and efforts made to entice the

bourgeois and upper-class patrons who had mixed with the more plebian inhabitants of Montmartre at the other cafés-concerts. Toulouse-Lautrec's painting of the dance at the Moulin Rouge and his other images of the dance hall's entertainment and entertainers publicized and celebrated not so much a vulgar, proletarian world as one that was becoming socially acceptable, a place where bourgeois and aristocrat could experience anti-bourgeois and anti-aristocratic plebian entertainment. It was a demimonde straddling professionalism and amateurism, respectability and vulgarity, the upper-middle and lower classes. This was a perfect setting for an aristocratic painter who could share in the world of the entertainers without being part of it, could indulge in alcoholic excess without suffering its financial consequences, could paint without needing to sell his art, and could adopt the role of commercial lithographer despite his financial independence in an existence balanced between reality and amusement.

At the Moulin Rouge represents a private world, not a public one. Here, the entertainers and the entertained fuse their existences, at a moment when they are about to be forced apart. Lautrec would frequent the Moulin Rouge less and less and instead would become part of the more sedate realm of literati and artists associated with Thadée Natanson's periodical *La Revue Blanche*. The Montmartre dance halls, too, continued their movement toward respectability and professionalism as innumerable imitating institutions appeared in Paris and elsewhere to draw away more and more of the audience and performers. The entertainers went on tour, collected governmental awards, and signed contracts with the newly fashionable Olympia music hall. By the mid-1890s, the Montmartre Lautrec had celebrated and whose image he had propagated was dying. *At the*

FIGURE 15 Photograph of Toulouse-Lautrec and Tapié de Céleyran at the Moulin Rouge, c. 1894. Photo: M.G. Dortu, *Toulouse-Lautrec et son oeuvre* (New York, 1971), vol. 1, p. 98.

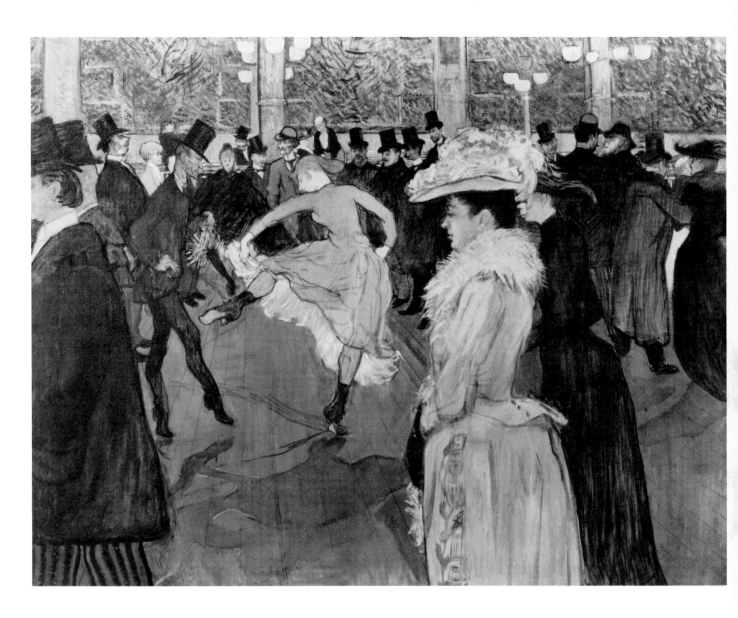

Moulin Rouge seems to have been painted by him to memorialize this world, which had embraced him. He consciously entered this "inferno" in rejection of his aristocratic background and values, but his entry was made possible only by his social status and his continuing reliance on it. Emerging from the private realm of Lautrec's memories, *At the Moulin Rouge* is a devotional image that immortalized this milieu just as it ceased to exist. Joyant's manipulation of Lautrec's image deprived it of its function as a document of this passing away. The Moulin Rouge was no longer for Lautrec a place of joy, abandon, and easy pleasure in which La Goulue danced her provocative *chahut* while circling on slender legs, her skirts hiked, her face a mask of overt sensuality. This artificial, exciting world of makeup and movement, sex

and alcohol came to a disturbing halt in the painting *At the Moulin Rouge* and was replaced by a silent ennui and separation, by rumors of forbidden attachments and bitter separations. The painting is the melancholy counterpoint to the painted *chahuts* in other works, a pictorial equivalent to the song of the Moulin Rouge:

> *On the mount of Martyrs*
> *I grind down dreams and harmony.*
> *I grind down gold and remorse,*
> *Redemption and shame*
> *I grind down a better future.*[42]

It is an image the myth of Henri de Toulouse-Lautrec and commercial concerns sought to destroy.

NOTES

1. For the exhibition history of *At the Moulin Rouge*, see M.G. Dortu, *Toulouse-Lautrec et son oeuvre* (New York, 1971), vol. 2, p. 258, entry for painting no. 427. Hereafter, all paintings by Lautrec will be identified according to Dortu's numbering: (P.) and the number.

2. Maurice Joyant, *Henri de Toulouse-Lautrec, 1864–1901* (Paris, 1926–27), vol. 2, p. 133.

3. Dortu (note 1), vol. 2, p. 258, identified Manzi as the first owner, as did Joyant (note 2), vol. 1, p. 275. Neither indicated the date of acquisition, but evidence to be discussed later in this article identifies the painting as part of Lautrec's estate in 1902.

4. Paris, March 29–May 5, 1902. It was not listed in the catalogue, which includes the following works by Lautrec: 1025, *Scène de théâtre*; 1026, *Etude d'acrobate*; 1027, *Nu*; 1028, *Portrait*; 1029, *Portrait*; 1030, *Femme en peignoir*; 1031, *Les Ambassadeurs*; 1032, *Femme en clown*; 1033, *Jeanne* [*sic*] *Avril*; 1034, *Lithographies*. Joyant (note 2), vol. 2, p. 255, noted that at the Salon was a "retrospective of H. de Toulouse-Lautrec. The catalogue does not contain titles. About 50 to 60 numbers." However, as seen here, the catalogue did contain titles, but of far fewer than fifty to sixty works, and it is likely that this inventory of paintings was expanded to include newly available paintings. See text, p. 122, for discussion of this.

5. Dortu (note 1), vol. 2, p. 258; Joyant (note 2), vol. 1, p. 275. The 1914 exhibition at the Galerie Manzi-Joyant consisted of 201 works; the catalogue, *Exposition retrospective de l'oeuvre de Henri de Toulouse-Lautrec (1864–1901)* (Paris, 1914), with an introduction by Arsène Alexandre, listed *At the Moulin Rouge* as no. 32.

6. Dortu (note 1), mentioned an exhibition of French art in Barcelona in 1917, with the painting cited as no. 2038, but it has not been possible to confirm this exhibition.

7. Neither Dortu (note 1) nor Joyant (note 2) identified exhibitions of *At the Moulin Rouge* prior to that of 1914 (see note 5). However, in *Toulouse-Lautrec en Belgique* (Paris, 1955), Dortu, M. Grillard, and J. Adhémar suggested that the painting was included at the ninth Les Vingt exhibition under the title *Nocturne* (see *Les XX Bruxelles: Catalogue des dix expositions annuelles* [Brussels, 1981], p. 272, no. 7). No evidence for this bizarre identification is provided. Currently, we do not know what painting, drawing, or lithograph (the catalogue fails to distinguish among them) may have been entitled *Nocturne* in Brussels, but it was certainly not *At the Moulin Rouge*, since, as this article will demonstrate, the painting did not yet exist in February 1892.

In matching *At the Moulin Rouge* with the titles of Lautrec paintings in exhibitions during his lifetime, the sole possible identification is with *Un Coin du Moulin Rouge*, exhibited at the seventh exhibition of *Peintres Impressionistes et Symbolistes*, which opened at Le Barc de Boutteville in Paris on July 10, 1894. The exhibition has previously not been considered in the literature on Lautrec, so no effort to identify this painting has been made. As with the Brussels *Nocturne*, however, a precise identification is currently not possible. One cannot deny unequivocally that *At the Moulin Rouge* was this painting, but it is highly unlikely. Stylistic, technical, and iconographic reasons for this will be considered in the course of this article, but here it should be noted that the title is not one that fits the painting well, whereas other paintings of the time could more readily fit the title's description. Also, all other paintings exhibited by Lautrec at this time bear his signature, while *At the Moulin Rouge* does not, displaying only the stamp of his estate. The proof is circumstantial, not absolute, but argues strongly that the painting was not exhibited either in 1894 or earlier. Between 1894 and Lautrec's death, no exhibited work can be identified with *At the Moulin Rouge*.

8. Joyant (note 2), vol. 1, pp. 274–75.

9. The suite of four Moulin Rouge paintings exhibited by Joyant at Goupil's in 1893 can be identified as follows: *Jane Avril Entering the Moulin Rouge* (Dortu [note 1], P.417); *La Goulue at the Moulin Rouge* (Dortu [note 1], P.422); *La Goulue Entering the Moulin Rouge* (Dortu [note 1], P.423); *At the Moulin Rouge: The Waltzing Couple* (Dortu [note 1], P.428).

10. Joyant (note 2), vol. 1, pp. 137–39.

11. Ibid., p. 138. Joyant had already similarly described the painting's subjects in his 1914 exhibition catalogue. See *Exposition retrospective . . .* (note 5), no. 32.

12. Much of what we know concerning the dancers and singers of Montmartre is due to Joyant and other acquaintances of Lautrec such as Gustave Cocquiot. One of the major problems, however, with our knowledge of Lautrec and his milieu is our dependence on such reminiscences, which tend to be highly subjective with an emphasis on colorful anecdote rather than consistent biography. Too frequently, as well, these "reminiscences" failed to be published until a half century after Lautrec's death, so that their reliability can be questioned. Among the first to write such a study of Lautrec and his work was Cocquiot, in *Lautrec* (Paris, 1913) and its revised version, *Lautrec ou quinze ans de moeurs parisiennes* (Paris, 1921). The context in which this type of approach to Lautrec developed is discussed later in this article.

13. Joyant (note 2), vol. 1, p. 139.

14. The identification of "Mlle. Nelly C." as May Milton was first made by Charles Stuckey and Naomi Maurer, *Toulouse-Lautrec: Paintings*, exh. cat., The Art Institute of Chicago (1979), pp. 187, 247.

15. Joyant (note 2), vol. 1, p. 288; Dortu (note 1), vol. 3, p. 348, P.572.

16. Joyant (note 2), vol. 1, p. 198.

17. Cocquiot, *Lautrec ou quinze ans . . .* (note 12), pp. 154–55.

18. "Très vieux, malgré mes vingt ans/Usé blasé; car je suis né/Sur un lit de roses fanées/Et je suis un Eros vanné!" Maurice Donnay, "Eros Vanné" (Paris, 1894), n.pag. See also

the discussion of this poem by Wolfgang Wittrock in *Toulouse-Lautrec: The Complete Prints* (London, 1985), vol. 1, p. 31.

19. See note 1.

20. Douglas Cooper, *Henri de Toulouse-Lautrec* (New York, 1956), p. 96.

21. Gale B. Murray, review of M.G. Dortu's *Toulouse-Lautrec et son oeuvre* (note 1), in *The Art Bulletin* 58, 1 (Mar. 1978), pp. 179–82.

22. Stuckey and Maurer (note 14), p. 187.

23. David Kolch's memo to Reinhold Heller, Jan. 23, 1986, summarizes the findings.

24. See note 3.

25. As cited by Joyant (note 2), vol. 2, pp. 129–30.

26. The first of several French editions of Nordau's book was published in Paris in 1894 as *Dégenerescence*.

27. Arsène Alexandre, "Une Guérison," *Le Figaro* (Mar. 30, 1899), as cited by Joyant (note 2), vol. 2, p. 124.

28. Julius Elias, "Henri de Toulouse-Lautrec," *Die Nation* 19, 51 (Sept. 21, 1901), pp. 809–901. Also compare Arsène Alexandre, "Toulouse-Lautrec," *Le Figaro Illustré* 20, 145 (April 1902), p. 2: "It is possible, in Paris, to be at once a *célèbre* and unknown. Henri de Toulouse-Lautrec has become one of the most striking examples of this misconception between public opinion and the actual person."

29. Gustave Geffroy, "Henri de Toulouse-Lautrec (1894–1901)," *Gazette des Beaux-Arts*, ser. 4, 12 (Aug. 1914), p. 89.

30. Erich Klossowski, *Die Maler von Montmartre*, vol. 15 of *Die Kunst*, ed. R. Muther (Berlin, 1903), p. 52.

31. Elias (note 28), p. 901.

32. Hermann Esswein and A.W. Heymel, *Toulouse-Lautrec*, vol. 3 of *Moderne Illustratoren* (Munich, 1909), p. 36.

33. Joyant (note 2), vol. 2, p. 250.

34. Compare Edvard Munch's complaint of 1891: "[People] do not believe that these impressions, these instant sensations, could contain even the smallest grain of sanity. If a tree is red or blue, or a face is blue or green, they are sure that is insanity."

Cited in Reinhold Heller, *Munch: His Life and Work* (Chicago, 1984), p. 65.

35. Geffroy (note 29), between pp. 100 and 101.

36. Joyant (note 2), vol. 2, p. 66, was surely mistaken in dating Lautrec's interest in the technique to an exhibition of paintings by Raffaëlli in 1890, since his use of the turpentine-thinned oil paint on cardboard appears at least as early as his studies for the illustrations of the essay "L'Eté à Paris" by Emile Michelet, published in *Paris Illustrée*, July 7, 1888, pp. 426–27.

The following paintings on canvas, traditionally dated to the years of 1893 and 1894, should be attributed to different years, either earlier or later, when the stylistic characteristics and techniques they display appear in other works by Lautrec:
Monsieur Boileau (Dortu [note 1], P.465); *The Loge at Mascaron Doré* (Dortu [note 1], P.470); *Man, Woman and Dog* (Dortu [note 1], P.494); *Doctor Tapié de Céleyran in a Theater Aisle* (Dortu [note 1], P.521); *In the Salon of the Rue des Moulins* (Dortu [note 1], P.559); *In the Salon of the Rue des Moulins* (Dortu [note 1], P.560).
The fact that they correspond to lithographic compositions or biographic events of the years 1893–94 does not preclude their having been painted earlier or later. In fact, given Lautrec's habits, it is likely that the dates of paintings do not correspond to such external factors at all.

37. Among critics praising Lautrec's work and also advocating the principles of anarchism were Arsène Alexandre and Gustave Geffroy. See John Rewald, *Post-Impressionism: From van Gogh to Gauguin*, 3d ed. (New York, 1978), p. 141.

38. Portions of the painting had lost paint and were blistering, particularly the face of Sescau, which was heavily retouched. (As noted in the files of the Department of Conservation, The Art Institute of Chicago, 1935.)

39. See particularly Wittrock (note 18).

40. Joyant (note 2), vol. 1, pp. 84–86.

41. Michel Herbert, *La Chanson à Montmartre* (Paris, 1967), p. 65.

42. Maurice Boukay, "Le Moulin Rouge," as cited by Klossowski (note 30), p. 49: "Sur la montagne des Martyrs/Je mouds le rêve et l'harmonie/Je mouds l'or et les repentirs/Le rachat et l'ignominie/Je mouds un avenir meilleur."

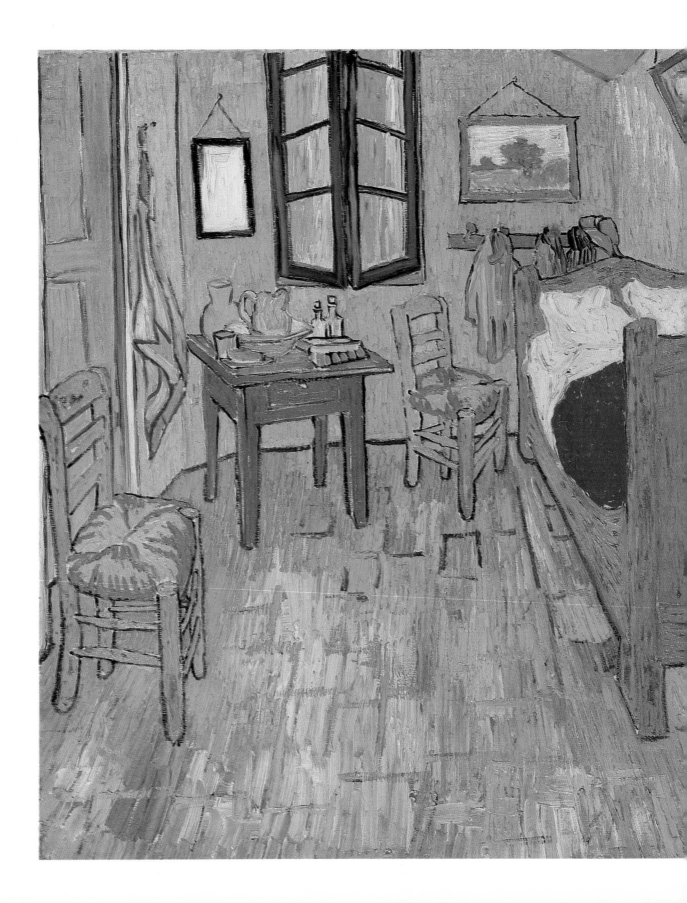

Van Gogh's Bedrooms at Arles: The Problem of Priority

RICHARD R. BRETTELL,
Searle Curator of European Painting

WHEN Vincent van Gogh's *Bedroom at Arles* (fig. 1) entered the collection of The Art Institute of Chicago in 1926, everyone assumed that it was done in 1888, the first or "premier" of the three versions of this famous composition. At that time, both other versions—one now in the Rijksmuseum-Vincent van Gogh, Amsterdam (fig. 2), and the other in the Musée d'Orsay, Paris (fig. 3)—were in private collections, inaccessible to most scholars, as well as to the general public. All the Art Institute literature issued since the painting's acquisition has insisted on its priority,[1] and countless museum lecturers have concurred. Thus, the general public of the Art Institute has simply assumed that "its" version of van Gogh's *Bedroom at Arles* is *the* version.

Scholars, however, have not been so ready to accept the museum's claims. Even by 1929, when the Art Institute painting was shown in the inaugural exhibition at The Museum of Modern Art, New York, the catalogue gave two dates—1888 or 1889—for Chicago's version and 1888 for Amsterdam's version.[2] Every recent exhibition catalogue, as well as the most important catalogue raisonné of van Gogh's oeuvre, maintains that the Chicago canvas was the second in the series and has assigned the preeminent position to the Rijksmuseum canvas.[3] This view was given its most recent affirmation in the

FIGURE 1 Vincent van Gogh (Dutch, 1853–1890). *Bedroom at Arles*, 1888. Oil on canvas; 73.6 × 92.3 cm. The Art Institute of Chicago, Helen Birch Bartlett Memorial Collection (1926.417).

137

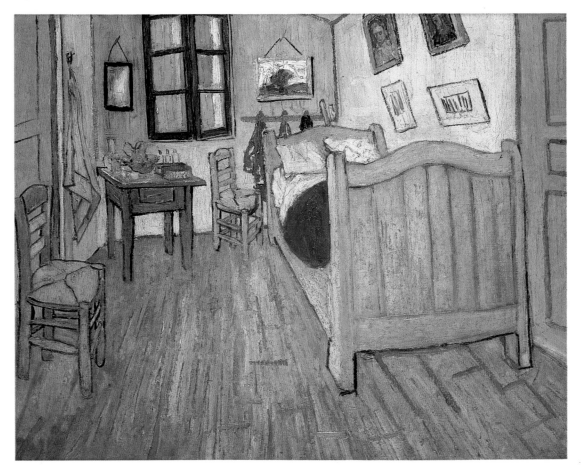

important exhibition at The Metropolitan Museum of Art, New York, "Van Gogh at Arles," where the Rijksmuseum painting occupied the place of honor in a gallery devoted to the paintings dating from October 1888 executed by van Gogh in Arles. No mention of the Art Institute version was made in either the wall label or the catalogue.[4]

It is the purpose of this essay to reexamine without prejudice the question of priority, and to use all available evidence before reaching a conclusion that will inevitably affect our interpretation of the painting. First, we will examine from van Gogh's vast correspondence the passages that relate specifically to the three compositions of the *Bedroom at Arles*, after which we will study the physical evidence of the paintings themselves before assigning priority to any particular version.

Van Gogh's Letters and the Bedroom at Arles

Van Gogh's letters from the summer and early autumn of 1888 are full of references to the furnishing of his newly rented studio in Arles, which he called the "Yellow House" or the "Studio of the South." It is clear from these letters that the artist's bedroom was perhaps the most important room in the house he occupied. As is usually the case with van Gogh, his own writing surpasses in quality and emotional intensity that of his commentators, and, for that reason, the following passages have been chosen and arranged in chronological order so that the reader can follow the artist's mind from the creation of the bedroom itself, to his first painting of it, and, finally, to the subsequent history of that first and the two versions that followed.

Van Gogh's desire for a permanent home and for companionship was paramount in his mind in the late summer of 1888 when he rented a tiny, four-room house on the Place Lamartine, just outside the old city of Arles. In a letter to his brother, Theo (undated, September 1/8), he expressed his new hope for a stable future embodied in a home:

How I'd like to settle down and have a home! I keep thinking that even if we had spent 500 francs on furniture at the start, we should already have recovered all of it and I should have the furniture and should already be delivered from the innkeepers. . . . Here there will always be artists coming and going, anxious to escape from the severity of the North. And I think myself that I shall always be one of

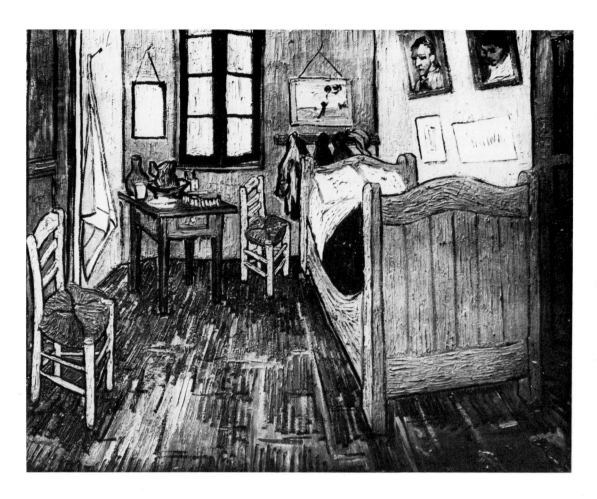

FIGURE 3 Vincent
van Gogh. *Bedroom
at Arles*, 1889. Oil
on canvas; 56.5 ×
74 cm. Paris, Musée
d'Orsay, Galerie
du Jeu de Paume.
Photo: Réunion des
Musées Nationaux.

them. . . . Once settled, we would stay there all our lives.
It's a poor way of doing things to wait till one is very rich,
and that is what I do not like about the de Goncourts, that
whatever the truth of it may be, they ended by buying their
home and their tranquility for 100,000 francs. But we'd have
it for at less than a thousand, so far as having a studio in the
South where we could give someone a bed goes./But if we
must make a fortune first . . . we shall be complete nervous
wrecks when we enter upon our rest. . . .[5]

From a somewhat later letter to Theo (undated, Sep-
tember 8/11), it is clear that the furnishing of the house
preoccupied van Gogh:

Well now, yesterday I was busy furnishing the house. Just as
the postman and his wife told me, the two beds, to be really
substantial, will come to 150 fr. apiece. I found everything
that they told me about prices was true. So I had to change
my tack, and this is what I have done. I have bought one
walnut bed and another in white deal which will be mine
and which I'll paint later./Then I got bedclothes for one of
the beds, and two mattresses./If Gauguin comes, or some-
one else, there is his bed ready in a minute. I wanted to
arrange the house from the start not for myself only, but so
as to be able to put someone else up too. Naturally this has
swallowed up the greater part of the money. With the rest I

have bought 12 chairs, a mirror and some small neces-
sities./For a visitor there will be the prettier room upstairs,
which I will try to make as much as possible like the
boudoir of a really artistic woman./Then there will be my
own bedroom, which I want extremely simple, but with
large, solid furniture, the bed, chairs and table all in white
deal./Downstairs will be the studio, and another room, a
studio too, but at the same time a kitchen./Someday or
other you will have a picture of the little house itself in
bright sunshine, or else with the window lit up, and a starry
sky./Henceforth you can feel that you have your country
house in Arles. For I am very anxious to arrange it so that
you will be pleased with it, and so that it will be a studio in
an absolutely individual style; that way, if I say a year from
now you come here and to Marseilles for your vacation, it
will be ready then, and the house, as I intend it, will be full
of pictures from top to bottom./The room you will have
then, or Gauguin if he comes, will have white walls with a
decoration of great yellow sunflowers./In the morning,
when you open the window, you will see the green of the
garden and the rising sun, and the road into the town. But
you will see these great pictures of sunflowers, 12 to 14 to
the bunch, crammed into this tiny boudoir with its pretty
bed and everything else dainty. It will not be com-
monplace./And the studio, the red tiles of the floor, the
walls and ceiling white, rustic chairs, white deal table, and I

139

hope a decoration of portraits. It will have a feeling of Daumier about it, and I think I dare predict it will not be commonplace. . . . There is not the slightest hurry, but I have my own plan. I want to make it really *an artists' house*—not precious, on the contrary nothing *precious*, but everything from the chairs to the pictures having character./About the beds, I have bought country beds, big double ones instead of iron ones. That gives an appearance of solidity, durability and quiet, and if it takes a little more bedding, so much the worse, but it must have character. . . . I don't feel any hesitation now about staying here, because ideas for my work are coming to me in abundance. I intend to buy something for the house every month. And with some patience the house will be worth something because of the furniture and the decorations.[6]

There is little doubt that this letter is crucial to an understanding of the Yellow House and of the only composition he did of its interior, *Bedroom at Arles*. He described each piece of furniture individually and in terms of its character. He used the words "solidity," "durability," and "quiet" to convey that character, and, in a slightly later letter, he expressed regret only that his happiness was solitary: "I am so happy in the house and in my work that I even dare to think that this happiness will not always be limited to one, but that you will have a share in it and good luck to go with it."[7] One remembers here his allusion to the Goncourt brothers, whose life together was so rich, and so brief.[8]

These themes are brought together in a letter to Theo written just after September 17:

I have just bought a dressing table with everything necessary, and my own little room is complete. The other one, Gauguin's or another lodger's, still needs a dressing table and a chest of drawers, and downstairs I shall need a big frying pan and a cupboard./There is no hurry for any of this, and already I can see myself earning enough to be safe for a long time to come./You cannot think what peace of mind it gives me, I am so set on making an artist's home, but one for practical use, and not the ordinary studio full of knick-knacks. . . . The sense of tranquility that the house has brought me mainly amounts to this—that from now on I feel that I am working to provide for the future, so that after me another painter will find a going concern. I shall need time, but I am obsessed with the idea of painting such decorations for the house as will be worth the money spent on me during the years in which I was unproductive.[9]

By the last weeks of September, van Gogh's Yellow House was essentially furnished, and the painter struggled to decorate it with his paintings. However, his efforts were so intense and produced such loneliness that by October 14 he was completely exhausted and collapsed in his bedroom, where he slept for sixteen hours.[10] *Bedroom at Arles* was made upon his recovery from this period of extreme mental and physical fatigue.

In a letter to Theo written on October 16, he first

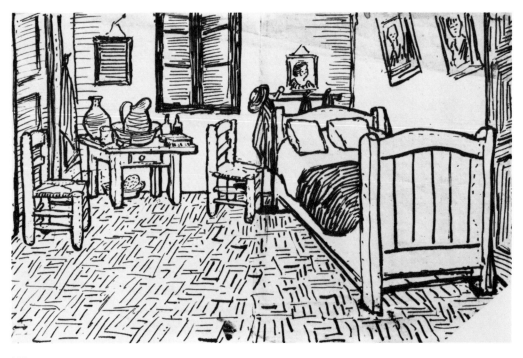

FIGURE 4 Vincent van Gogh. *First sketch of van Gogh's bedroom*, from letter 554, 1888. Pen and ink on paper; 13.2 × 20.5 cm. Amsterdam, Rijksmuseum Vincent van Gogh.

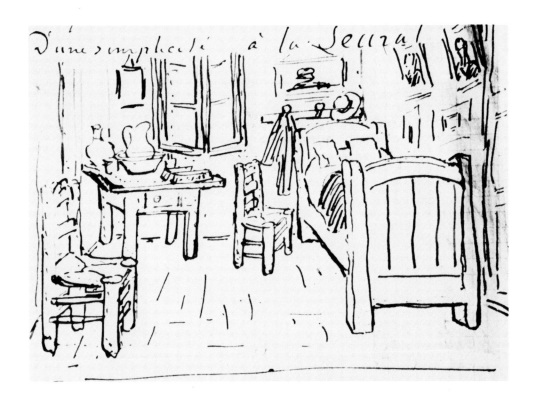

FIGURE 5 Vincent van Gogh. *Second sketch of van Gogh's bedroom*, from letter B22, 1888. Pen and ink on paper. Amsterdam, Rijksmuseum Vincent van Gogh. Photo: B. Zurcher, *Vincent van Gogh: Art, Life, and Letters* (New York, 1985), p. 189.

described the painting and sent his first sketch for it (fig. 4):

At last I can send you a little sketch to give you at least an idea of the way the work is shaping up. For today I am all right again. My eyes are still tired, but then I had a new idea in my head and here is the sketch of it. Another size 30 canvas. This time it's just simply my bedroom, only here color is to do everything, and giving by its simplification a grander style to things, is to be suggestive here of *rest* and of sleep in general. In a word, looking at the picture ought to rest the brain, or rather the imagination./The walls are pale violet. The floor is of red tiles./The wood of the bed and chairs is the yellow of fresh butter, the sheets and pillows very light greenish-citron./The coverlet scarlet. The window green./The toilet table orange, the basin blue./The doors lilac./And that is all—there is nothing in the room with its closed shutters./The broad outlines of the furniture again must express inviolable rest. Portraits on the walls, and a mirror and a towel and some clothes./The frame—as there is no white in the picture—will be white. . . . I shall work on it again all day, but you see how simple the conception is. The shadows and cast shadows are suppressed; it is painted in free flat tints like the Japanese prints. It is going to be a contrast to, for instance, the Tarascon diligence and the night café.[11]

The following day, he sent another letter to Theo about *Bedroom at Arles*: ". . . this afternoon I finished the canvas representing the bedroom. . . . The workmanship is . . . virile and simple. No stippling, no hatching, nothing, only flat colors in harmony."[12] The

brief description of the painting in this letter tallies well with his discussion of its "flat" facture in the letter of October 16.

However, in an undated letter to Paul Gauguin written at least one day later, the description and the drawing enclosed with it (fig. 5) are different in several significant ways. The most critical passages that vary from the letters to Theo have been italicized here for emphasis:

Listen, the other day I wrote you that my eyesight was strangely tired. All right, I rested for two and a half days, and then I set to work again, but without daring to go out into the open air yet. I have done, still for my decoration, a size 30 canvas of my bedroom with the white deal furniture that you know. Well, I enormously enjoyed doing this interior of nothing at all, of a Seurat-like simplicity; with *flat tints, but brushed on roughly, with a thick impasto*, the walls pale lilac, *the ground a faded broken red*, the chairs and the bed chrome yellow, the pillows and the sheet a very pale green-citron, *the [coverlet] blood red*, the washstand orange, the washbasin blue, the window green. By means of all these very diverse tones I have wanted to express an *absolute restfulness*, you see, and there is *no white in it at all except the little note produced by the mirror with its black frame* (in order to get the fourth pair of complementaries into it)./Well, you will see it along with the other things, and we will talk about it, for I often don't know what I am doing when I am working almost like a sleepwalker.[13]

On October 23, just days after van Gogh had completed the first version of *Bedroom at Arles*, Gauguin arrived in Arles for what was in the mind of each artist an indefi-

nite visit. All evidence suggests that Gauguin was ambivalent about the trip and made it essentially for economic reasons (he was promised support while in Arles from Theo van Gogh).[14] Van Gogh, who had anticipated the arrival of Gauguin for some months, seems to have been threatened by the actual presence of his friend, teacher, and rival. In a letter to Theo begun on October 22, van Gogh added the following postscript the day after Gauguin's arrival: "I do not know yet what Gauguin thinks of my decorations in general, I only know that there are already some studies which he really likes, like the sower, the sunflowers, and the bedroom."[15]

The failure of van Gogh's Studio of the South is well known. Gauguin and van Gogh clashed several times, their habits and characters perpetually opposed. Gauguin was a womanizer, van Gogh most probably impotent. Gauguin was neat and tidy in his personal habits, van Gogh sloppy and careless. Van Gogh worked in a kind of emotional frenzy; Gauguin was more careful and, one might say, intellectual about painting. Their mutually inspiring but stormy relationship ended in dis-

aster on December 23, when, after a violent quarrel, van Gogh performed a deliberate act of self-mutilation, which prompted Gauguin to flee from Arles.

So many attempts have been made by medical doctors, psychiatrists, historians, and amateurs to assign a name to van Gogh's malady that the van Gogh bibliography is overpadded with theories. In any case, the effect of this illness was enormous and, for the doomed artist, lasting, because he spent the remainder of his life haunted by his fear of madness. Not surprisingly, *Bedroom at Arles*, that painting about "inviolable rest," about "stability, durability, and quiet," played a role in the artist's failed attempts at recovery. In a letter to Theo, written after his return to the Yellow House from the hospital in Arles, van Gogh said he preferred the *Bedroom* to all his earlier canvases: "When I saw my canvases after my illness, the one that seemed best to me was the bedroom."[16]

This letter was written before the Yellow House was locked by the police and the painter essentially banished from Arles. It was also written before a spring flood of the Rhône River that badly damaged the paintings kept on the ground floor of van Gogh's sealed-up house. In a

FIGURE 6 Vincent van Gogh. *The Enclosed Field*, 1889. Oil on canvas, 70.5 × 88.5 cm. Copenhagen, Ny Carlsberg Glyptotek.

letter to Theo written on April 30, 1899, the painter described the damage:

Today I am busy packing a case of pictures and studies. One of them is flaking off, and I have stuck some newspapers on it; it is one of the best, and I think that when you look at it you will see better what my now shipwrecked studio might have been./This study, like some others, has got spoiled by moisture during my illness./The flood water came to within a few feet of the house, and on top of that, the house itself had no fires in it during my absence, so when I came back, the walls were oozing water and saltpeter.[17]

From this point, the story of *Bedroom at Arles* becomes confused. It was probably this painting that suffered from flaking as the direct result of the flood. In a letter from Theo to Vincent written on June 16, this fact seems confirmed: "I shall send you back the bedroom, but you must not think of retouching this canvas if you can repair the damage. Copy it, and then send back this one so that I can have it recanvased [lined]."[18]

However, even before Theo sent back the damaged *Bedroom*, Vincent was painting its pendant (fig. 6), presumably with only a memory of the earlier painting. His letter to Theo from early June makes this clear:

I am working on two landscapes (size 30 canvases), views taken in the hills, one is the country that I see from the window of my bedroom. In the foreground a field of wheat ruined and hurled to the ground by a storm. A boundary wall and beyond the gray foliage of a few olive trees, some huts and the hills. Then at the top of the canvas a great white and gray cloud floating in the azure./It is a landscape of extreme simplicity in coloring too. That will make a pendant to the study of the "Bedroom" which has got damaged.[19]

It was only in September that Vincent reported to his brother that he had made a copy of the *Bedroom*.

So I have gone over [redone] the canvas of my bedroom. That study [the original] is certainly one of the best—sooner or later it must [absolutely be lined]. It was painted so quickly and dried in such a way that the essence [spirit] evaporated at once, and so the paint is not firmly stuck to the canvas at all. That will be the case with other studies of mine too, which were painted very quickly and very thickly.[20]

In this letter, Vincent attributed the flake loss not to the flood, as he had earlier, but to his own method of painting. In all probability, he attributed the earlier damage to the flood before realizing that other paintings of his were behaving similarly, flood or no flood.

Finally, in a letter to Theo also dating from September 1889, Vincent reported that he had finished a small version of the *Bedroom*. This was sent to Theo along with small versions of other canvases to be an "oeuvre en miniature" for their mother.

The Letters as Evidence

What do we learn from these passages that can help us decide which of the versions was painted in October 1888, before the painter's first major illness? Obviously, the painting in the Musée d'Orsay (fig. 3), which is smaller than the other two, was clearly painted last. About the other two versions, the letters provide conflicting evidence. As is often the case with van Gogh, two letters, presumably written one or more days apart, can describe the same painting in some detail. Although the letters referring to the *Bedroom* agree substantially about the character of the painting, the differences between the two descriptions are crucial and make it difficult to use one or the other as final evidence.

In the October 16 letter to Theo, van Gogh said that he had applied the colors as "flat tints like the Japanese prints." While in the letter to Gauguin, van Gogh referred to "flat tints, but brushed on roughly, with a thick impasto." In one, the floor is referred to as "red tiles" and the coverlet "scarlet," while in the other the floor is described as "a faded, broken red" and the coverlet "blood red." And, if this is not enough, each of the drawings made to accompany the letters differs from the other not only in terms of proportion and finish, but also in several important details. The portrait over the headboard in the drawing sent to Theo was replaced in the drawing sent to Gauguin by a landscape like that in the painting, and the framed prints beneath the two portraits on the wall beside the bed are included only in the drawing sent to Gauguin. There are also differences in the positioning of the furniture, as well as in the hat and clothes behind the bed; in the drawing sent to Gauguin, van Gogh omitted the towel that hangs on the door frame near the wash table at the left of the painting.

All of this evidence, as well as the contents of the two letters, suggests that the letter to Theo was written when the painting was in its preliminary stages, before all aspects of its composition were fully resolved. At several points in the letter to Theo, van Gogh used either future or conditional verb tenses, and several sentences in the letter make it clear that van Gogh had only begun the canvas, and its sketch, that day. The letter to Gauguin was clearly written when the painting was finished. The alterations in the description as well as in the accompanying drawing therefore reflect van Gogh's actual work on the canvas.

Unfortunately, neither the Rijksmuseum nor the Art Institute versions of *Bedroom at Arles* can be assigned

priority on the basis of these letters and drawings. In each of them, the walls and doors are blue rather than the "lilac" mentioned in both letters, and the flatness of the tones in the Rijksmuseum version, which is often used to prove that it was the first version, does not accord well with van Gogh's description of the facture in his letter to Gauguin.

This quandary is not solved by an analysis of the several key differences between the paintings, particularly in the portraits on the wall beside the bed. In the Art Institute version, they are a self-portrait and a generic portrait of a young woman, while in the Rijksmuseum version, they are portraits of the Zouave Milliet and the painter Eugène Boch, each of which was made as the copy of a portrait already painted by van Gogh.[21] The fact that both of the latter portraits were made in Arles before October 1888 does not in itself prove that the Rijksmuseum version predates the Art Institute version. Indeed, neither portrait in the Art Institute version relates to an actual painting by van Gogh, and this scarcely seems surprising when one remembers that van Gogh described himself in his letter to Gauguin as "working almost like a sleepwalker." The careful copying in miniature of another painting does not accord well with such a trancelike state.

If the letters concerning the first of the three versions do not permit its precise identification, what about those relating to the second version? Unfortunately, this evidence is rather sketchy. We know that van Gogh was more pleased with the first *Bedroom* than with any of his other canvases painted before his "attack," that it was damaged in a flood, and that he made a replica of it not merely as an exercise, but because of the physical damage to the first version. Nowhere do we learn of any repair to or lining of the first version, although a lining is twice alluded to—once by Vincent, once by Theo. Clearly, the damaged first version was repaired or, at the very least, lined, as Theo suggested in his letter of June 16, but this act was not performed by van Gogh himself.

The Physical Evidence: The Paintings Themselves

Surely, if one version of the painting was damaged badly enough that it had to be lined and, perhaps, repainted, there should be evidence of that process today. Such physical evidence, if clear enough, can enable us to demonstrate conclusively the priority of one or the other version and then to proceed to more important matters of interpretation. The Art Institute canvas came to the museum in 1926 in its present physical state (the painting has not been treated for structural problems since its

acquisition). It has a very old—somewhat amateurish—glue lining, with irregular edges on both the original canvas and the lining canvas, and large areas of flake loss on the door at the right and throughout the back wall of the bedroom. Interestingly, the impasto has been crushed both as a result of the lining and from pressure exerted on the surface before it was lined.[22]

All of this suggests that the Art Institute *Bedroom at Arles* was the first version and that it was damaged, most probably as a result of improper working methods, and relined. The major areas of flake loss are confined to the door and the wall. Interestingly, and significantly, the underpainting is distinctly lilac in color, in contrast to the blue both of the final, thick layer of paint and of the walls and doors in the Amsterdam and Paris versions. Thus, the Art Institute painting did match the descriptions cited above, where the walls and doors are described as "lilac." Indeed, close examination of the surface reveals that the painting was quite thinly painted in most areas, that the floor was overpainted with pale green (perhaps reflecting the change in language from "red tiles" of the first letter to the "faded, broken red" of the second), and that walls and doors were originally lilac.

However, if one is to accept the Art Institute *Bedroom* as the first version, how does one explain that there are several obvious pentimental areas in the Rijksmuseum version and that, in certain color areas, this painting is more closely related to the descriptions in the letters than the Art Institute's? The area that is particularly troublesome, if one accepts the Rijksmuseum version as the copy, is the chair at the far left of the composition. There are clear indications that van Gogh experimented with the position of the chair in space and that he considered placing it nearer to the picture plane and turned toward the viewer. Clearly, a change of this sort is not in keeping with the idea of a strict copy. However, we know that, in doing copies, he made similar modifications to the original on many other occasions, and the mere fact of change does not prove priority.[23] The strongest evidence that it was the Art Institute *Bedroom* that van Gogh painted in October 1888 is the physical evidence of damage, together with the fact that similar damage was noted in four letters from Vincent to Theo and in one letter from Theo to Vincent.

We do not know exactly when and by whom the lining of the Art Institute's *Bedroom at Arles* was accomplished. Most probably, Theo had it done in Paris subsequent to September 1889, perhaps intending to return the painting to his brother to be repainted after lining. Unfortunately, we cannot know whether this took place. Surely, had van Gogh repainted the floor with the green, he would not have neglected the doors and walls. Rather,

the physical evidence suggests that the painting was re-lined and never retouched by the artist and that its current damage is what was referred to in the letters.

Priority and the Question of Meaning

Does it matter in any fundamental sense which of the two bedrooms was painted first? This question surely arises after such a persistent attempt to prove that one version was painted before another. The answer is yes. The Art Institute painting was made after a short period of illness perhaps brought on by exhaustion. It was, therefore, a "restful" painting in every sense, conceived in van Gogh's own mind to be the opposite of a painting about death and despair, *Night Café* (fig. 7), or one expressing movement and instability, *Tarascon Diligence*, both of which are of identical dimensions to the *Bedroom*. Clearly, van Gogh thought about this painting in the same way when he was in the sanitarium at St. Rémy and wanted to pair it with another canvas, this one about a bounded and storm-wrecked wheat field. Again, in any of the pairings, opposites abound: inside vs. outside, full-intensity hues vs. grayed hues, calm vs. stormy.

In almost every sense, the Rijksmuseum and the Art Institute versions would play identical roles in such oppositions, and the second version is surely as great a work of art as the first. And, one must not ignore the fact that van Gogh consistently referred to the painting as a study ("étude"). Although he often used this term to describe many of his efforts, its somewhat pejorative connotation was most likely intended. He was not absolutely convinced of the painting's perfection and, in repainting it, made changes to improve it.

The changes he did make are significant, particularly in the portraits. In the original painting, he included a self-portrait and the portrait of a blond woman. The self-portrait, though similar to several that he did paint, is identical with none and was probably painted directly from his imagination (with a possible glance in the mirror). That of the woman is so generalized as to be unidentifiable, and surely this is part of its meaning. We know, from all the evidence of the letters, that van Gogh longed for a perfect mate with whom to share his life, and that he designed the guest bedroom of his ideal, Yellow House to be like "the boudoir of a really artistic woman." In reality, he had difficulties with women, which prompted him at times to want to live like a monk and at others to share his life either with his brother or with other artist "brothers." Surely, the portrait in the Art Institute depicts the woman of his dreams. Both the self-portrait and that of the dream woman are painted in a harmony of yellow-orange and light blue, like sunflowers and all of van Gogh's images of happiness and concord.

The two portraits in the Rijksmuseum painting are copies within a copy, suggesting that they were made as part of a general enterprise of copying. But their inclusion has other significance as well: When van Gogh painted the copy, he was unable to feel and, therefore, to embody the hopeful dreams of his first version. In the place of his ideal couple, he put images of two actual friends, the Belgian painter Eugène Boch, whose portrait did hang in van Gogh's bedroom in early October 1888, and the Zouave soldier Paul Eugène Milliet. Both of these men knew van Gogh in Arles for very brief periods of time; Boch left in early September and Milliet in November of that year. Van Gogh had painted their portraits and kept them in his possession, along with many others. The portrait of Boch was framed in oak to hang in the Yellow House with a portrait of Patience Escalier. Nothing is known of the early display of the Milliet portrait. In any event, these two portraits of male friends, both with dark grounds—one green and the other deep, night blue—replaced the cheery yellow and pale blue of the "ideal" portraits of van Gogh's imagination.

All the other differences between the two versions, except perhaps one, are of less significance and probably have more to do with changes of mood or material than of meaning. The exception is the door at the left of the composition. We know from the disposition of the rooms in the Yellow House that the door to the right of the composition went, most likely, to the staircase that served both the Yellow House and its twin next door. The door to the left connected the bedroom with the corner guest room which was then being prepared for Gauguin. In the Art Institute version, that door is ajar. This is also true of the last version of the bedroom, painted for the artist's mother. However, because of the positioning of the chair and the omission of the nearest portion of the doorjamb in the Rijksmuseum version, it is not absolutely clear whether the door is closed or ajar. In the Chicago version, the chair sits out in the room, permitting passage through the door. In the Rijksmuseum version, it appears to block the door.

Admittedly, this is a subtle change, and one that might have been made unconsciously and, perhaps, for no reason. However, in view of the complex, and significant, place of this particular painting in the psychological history of the artist, one might be permitted to discuss the matter more fully. Indeed, the open or closed quality of a room is among its most potent psychological aspects. Van Gogh called his room an "interior of nothing at all," and in describing it mentioned only furniture and archi-

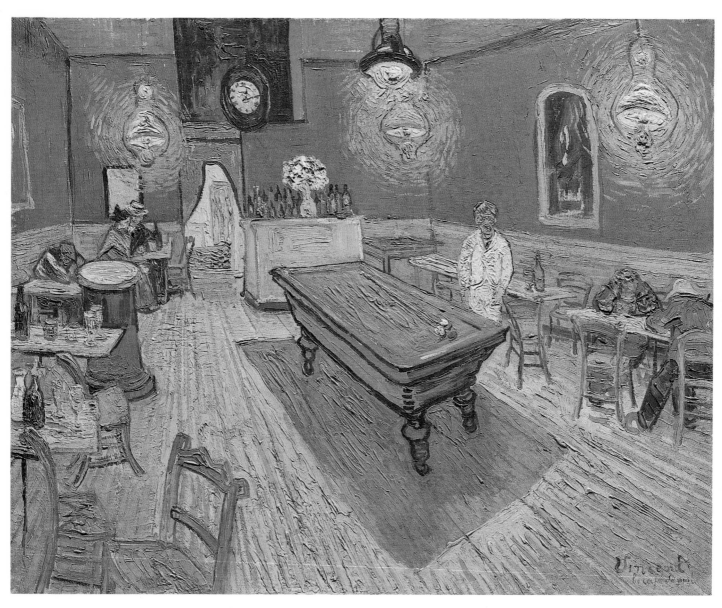

FIGURE 7 Vincent van Gogh. *Night Café*, 1888.
Oil on canvas; 72.4 × 92.1 cm. New Haven, Conn.,
Yale University Art Gallery, bequest of Stephen
Carlton Clark.

tecture. It was, for him, its emptiness, one might say its potential for being filled, that must have mattered.

Who can come into the room? Clearly, the painter and, by association, the viewer. Yet, with the door to another bedroom, or boudoir, ajar, there is potential for another human being to enter. When van Gogh painted *Bedroom at Arles*, there was no one in the Yellow House to use the door. Yet, once Gauguin arrived, the corner room had an occupant. We know from Gauguin's letters that van Gogh came into his guest room at night, if only to check on or to watch his friend sleeping. Van Gogh's behavior unnerved Gauguin immensely, and the threat it imposed upon his privacy was one of many reasons he decided to flee the Yellow House. If we accept all of this as true and if we assume that van Gogh painted the Rijksmuseum painting as the copy, his fussing with the position of the chair and his omission of the door jamb takes on significance. The door that had been ajar, that had once allowed admission, was now closed, making the emptiness of *Bedroom at Arles* even greater.

In all three versions of the *Bedroom*, the jamb of the door at the right is a bright blue, lighter than any other portion of the walls or doors. This is surely the effect of the light shining in from the corner room. This guest room was, in the painter's view, the better of the two rooms, the one reserved for the "other," whether brother, wife, or friend. It was illuminated by at least two windows and was, for that reason, brighter than the painter's bedroom. The bright light from this bedroom flooded through the door and, although it casts no shadow (shadows having been banished by van Gogh to make the painting look like a Japanese print), it reflects on the jamb and makes one think of light.

Usually, bedrooms are associated with darkness. Edgar Degas's *Interior* (fig. 8) and Edouard Vuillard's *Bedroom* of about 1890 (fig. 9) show bedrooms at night as the intimate setting for passion or sleep; this is the norm for countless representations of the bedroom in both eastern and western art. Strangely, van Gogh's *Bedroom at Arles* represents a bedroom not at night, but during the day. The green shutters have been closed, but the brilliant yellow light manages to seep around the thick, dark shutters. Yet, because of the total lack of shadows, the light in the bedroom is unreal, unspecific, and, in the end, unbelievable. It is as if light were everywhere equally, and only the hints of yellow at the window and white along the door tell us that it is day.

Bedroom at Arles is full of the light of hope and of reason. Because it is daytime, the difficulties of night are banished, and all is revealed. There is nothing closed or invisible. No wardrobe or cupboard is in sight, and one senses that there are no socks or shoes under the bed. It is difficult even to imagine what is in the little drawer of the night table, because all the necessaries are laid out on

Top
FIGURE 8 Edgar Degas (French, 1834–1917). *Interior*, 1875. Oil on canvas. Philadelphia, Henry P. McIlhenny Collection.

Bottom
FIGURE 9 Edouard Vuillard (French, 1868–1940). *Bedroom*, c. 1890. Oil on canvas; 74 × 92 cm. Paris, Musée d'art moderne. Photo: J. Salomon, *Vuillard* (Paris, 1968). p. 45.

its top as if for a ritual. Yet, there is the sense of another being in this empty room: there are two pillows, two chairs, two portraits, two doors, and two Japanese prints. Will another person come through the door? Will it be the "artistic" woman who stares into the room from inside her simple, oak frame?

Another detail, slight, but significant, adds to the sense of warmth and hope in the painting—the open window. Although van Gogh painted *Bedroom at Arles* in mid-October, he left the window open so that the fresh air of the day could enter his room. This image of warmth is juxtaposed with the easy, yellow-green harmonies of the landscape and the pure, empty whiteness of the mirror. Indeed, both a mirror and window—the two most powerful metaphors for a painting—are present and signify promise. The mirror can reflect anything, and the window can be flung open to reveal the light and warmth of the outside. Seen in this way, *Bedroom at Arles* is the opposite of *Night Café* (fig. 7). Where the mirror in the *Bedroom* reflects pure, white light, that in the *Café* seems to suggest an inferno. Where the window in the *Bedroom* can be opened onto the world of nature, the door in the *Café* reveals only another artificially lit interior. Yet, in both compositions, the viewer experiences a sense of being trapped. In the *Bedroom*, the shutters are closed and the door open only wide enough to suggest the existence, but not the nature, of the room on the left. We are allowed to know that there is an outside world and that it is warm, but we know nothing of what it is.

FIGURE 10 Edvard Munch (Norwegian, 1863–1944). *Death in the Sick Room*, 1896. Lithograph printed in black on Japan paper. The Art Institute of Chicago, gift of the Print and Drawing Club (1954.268).

In this hermetic space, the bed becomes almost terrifying. Indeed, its massive scale and looming volume so dominate the room that many commentators have doubted whether van Gogh's painting really does express the "inviolable rest" he sought to express in it. The bed is covered with a brilliant red ("blood red" in the letter to Gauguin) coverlet and is clearly made, ready, that is, to be slept in. There are no sleepers, only places for sleep. There are two chairs in which we can choose to sit. In one, we are a guardian, distant from the bed, positioned for action near the door; in the second, we are a protector, next to the bed as if to be a storyteller, nurse, or mother. In both, we are vigilant, turned to watch what will, or might, happen in the bed. Indeed, for a room populated with such guardians and protectors, one can look at many examples by Edvard Munch (see fig. 10). Van Gogh adopted a point of view from which the endboard completely blocks one half of the bed, thus keeping our attention on the relationship between the chairs, the door, and the "revealed" half of the bed.

It is interesting, in view of van Gogh's insistence that *Bedroom at Arles* is about rest, that he should have been so visually preoccupied with the evocation of another person in addition to himself in the room. Had the bedroom had one pillow (or even two stacked vertically), one chair, and one closed door, the viewer would not be led to speculate about the identity of van Gogh's companion. Clearly, the painting was, and is, intended as an embodiment of harmonious rest. Van Gogh's ideal rest was not to be experienced alone. We know already from his earliest letters about the house that he wanted it to be a home shared with others. He was never quite sure just who the others were to be. *Bedroom at Arles*, painted just before the arrival of Gauguin, is clearly an expression of his longings in the face of his miserable isolation. If *Night Café* was meant to represent a hell on earth, *Bedroom at Arles*, with its cleanliness, purity, and balance, was surely seen as heaven.

We know from many of van Gogh's letters that he lived a chaotic and disorderly life, often neglecting his own appearance. We also know from the letters Gauguin wrote from Arles that van Gogh lived almost like an animal and that Gauguin had to do all the cleaning and cooking. In van Gogh's ideal room, everything has its place, every coat a hook, every wall a door or decoration. The right half of the painting is devoted to rest and to art (there are no works of art at the left). The spacious half of the room at the left is dominated by the little dressing table with all its accouterments in order. It is easy to imagine a sleeper bounding out of bed, washing in the morning light (the window faced east), drying with the towel, combing his hair in the mirror, making up the bed, and going out into the day. Because of its

contrast with the actual life the painter led, the paintings can be read as an attempt at reform through picture making. Van Gogh had not left his bedroom for two days when he painted the first *Bedroom at Arles*, and his "remaking" of the room as picture surely prepared him to "re-enter" the world outside.

Yet, all van Gogh's harmony is undone by the floor of the Art Institute version. Unlike the later two versions, in which the floor is a faded, brownish red, that of the Chicago canvas is a veritable battleground between the faded red and a mint green. There is no real explanation for this in his correspondence. Yet, without stretching too far, one can find it in the descriptions of the painting van Gogh wrote to Theo and Gauguin. In the earlier letter, he called for a white frame for the painting because there was no white within. However, in the second letter, he mentioned Seurat and talked about the "pairs of complementaries."[24] There are four such pairs in the painting—the yellow and violet-blue of the walls and furniture, the orange and blue of the pitcher and table, the red and green of the window and coverlet, and the black and white of the mirror and frame. If, following Seurat's theories, van Gogh painted the floor as a broken, faded red, he would have been forced to include its compliment—mint green—in virtually equal quantity in order to achieve the balance and sense of restfulness he sought. Because van Gogh's obsession with Seurat lessened with time, he did not attempt to be so doctrinaire in the second or the third versions of the *Bedroom*.

Bedroom at Arles: Daydreams and Regression

Van Gogh was always searching for a home. Julius Meier-Graefe, his most eloquent biographer, wrote powerfully of his first attempt at creating a family home with the prostitute Sien and her illegitimate child (by another man) in 1882. Van Gogh worked

. . . to prepare their new home, a garret in a suburb of the Hague. He divided the garret by a wooden partition, and made a most comfortable studio. The studio had—as a studio ought to have—a cradle and a rocking chair, and there was another room next door as well as a charming and picturesque kitchen. In these surroundings, the workman's family was to start its new existence.[25]

The story continues with his account of van Gogh's decoration of his brother's rooms in Paris just before the painter's departure for Arles.

Vincent decorated their rooms on the last day while Theo was at the Gallery (he worked with Goupil). He scrubbed and polished everything for the first time in his life. He pulled out his rolled-up canvases from beneath his bed, flattened them out and nailed them up on the walls, so that Theo might feel his brother's presence about him. Then he fetched flowers and put them in the middle of the table.[26]

One wonders, of course, about Meier-Graefe's evidence for these picturesque stories. Yet, surely they must be true—at least, in spirit, for they seem so true when juxtaposed with yet another in a succession of van Gogh's temporary "homes" as reflected in *Bedroom at Arles*. In considering the painting today, we must not forget the magnitude of his failure to achieve in his life the harmony and rest that he attempted to convey in the *Bedroom*. How different this image is from the crooked and frantic patterns of his next "home," the hospital in Arles (fig. 11), where he lived in a ward, alone with others, or from his next "bedroom," described in words, but not pictured, at the asylum at St. Rémy:

I have a little room with greenish-gray paper and with two curtains of sea-green with a design of very pale roses, brightened by slight touches of blood-red./These curtains, probably the relics of some rich and ruined deceased, are very pretty in design. A very warm armchair probably comes from the same source; it is upholstered with tapestry splashed over like a Diaz or a Monticelli, with brown, red, pink, white, cream, black, forget-me-not blue, and bottle green. Through the iron-barred window I see a square field of wheat in an enclosure, a perspective like Van Goyen, above which I see the morning sun rising in all its glory.[27]

It was this view that van Gogh painted after a storm as the pendant to the damaged *Bedroom at Arles*. In the earlier bedroom, van Gogh was content and at rest in a harmonious environment of his own choosing; in the asylum room, surrounded by furniture that evoked thoughts of death, he looked obsessively out the window.

For van Gogh, *Bedroom at Arles* was *his* room in *his* home, and it is to the concept of "home" that one must turn for a fundamental understanding of this restorative or healing painting. While nineteenth-century texts about home, particularly man's dislocation from it, are plentiful, the text that, for this author, unlocks the deepest meanings of van Gogh's *Bedroom at Arles* is an essay by the twentieth-century phenomenologist Gaston Bachelard, who seems to have thought very little about van Gogh. In "The House from Cellar to Garret. The Significance of the Hut" from *The Poetics of Space*, Bachelard wrote:

The house is one of the greatest powers of integration for the thoughts, memories, and dreams of mankind. The binding principal in this integration is the daydream. Past, present, and future give the house different dynamisms, which often interfere, at times opposing, at others, stimulat-

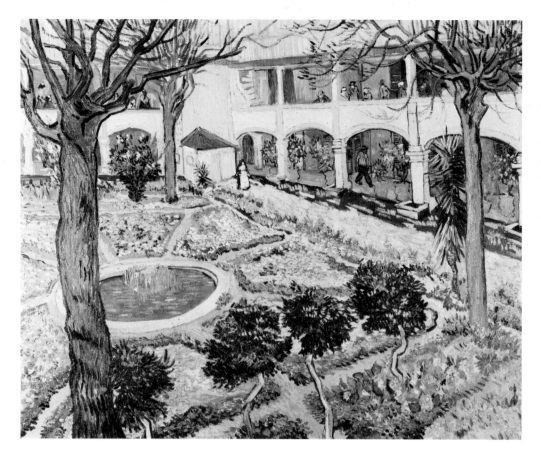

FIGURE 11 Vincent van Gogh. *The Garden of the Hospital at Arles*, 1889. Oil on canvas; 73 × 92 cm. Switzerland, Winterthur Museum, Oskar Reinhart Collection. Photo: B. Zurcher, *Vincent van Gogh: Art, Life, and Letters* (New York, 1985), p. 219.

ing one another. In the life of man, the house thrusts aside contingencies, its councils of continuity are unceasing. Without it, man would be a dispersed being.[28]

The powerful simplicity of van Gogh's painted *Bedroom*, its furnishings, and its manner of representation force the actual room upon us. The *Bedroom* is like an empty stage-set, with entrances at left and right. It is like a miniature room, so real does the furniture seem, so palpable the space. It thrusts out at us and recedes into the wall with equal conviction. It is what home is, a bounded universe, an infinity turned upon itself.

The real bedroom at Arles was never so clean, never so restful, and van Gogh's Yellow House, his Studio of the South, was fated to be temporary and imperfect. What one must remember in studying the *Bedroom* is that, for its maker, art integrated dreams and reality. And it is precisely in the concept of the daydream, as expressed by Bachelard in his article and by van Gogh in his painting, that one finds the source for this integration. The *Bedroom* was and is a bedroom of daydreams, not night dreams. The painting allows us into a clearly lit space, freeing our imagination just slightly from the reality in which we are all immersed. Nothing in the room bears close inspection; yet, the tactility of the paint allows us to feel in our minds the surface of each object. We revel in the emptiness of the room, and each of us fills it with

ourselves and our dreams. Thus, van Gogh's bedroom becomes our "home" as well. Even today, as we crowd into the museum to see it, we are alone in the bedroom both because it is empty and because it is so quintessentially private. Again, Bachelard says it best:

All the spaces of our past moments of solitude, the spaces in which we have suffered from solitude, enjoyed, desired, and compromised solitude, remain indelible within us, and precisely because the human being wants them to remain so. He knows instinctively that this space, identified with his own solitude, is creative; that even when it is forever expunged from the present, when, henceforth, it is alien to all the promises of the future, even when we no longer have the garret, when the attic room is lost and gone, there remains the fact that we once loved the garret, once lived in the attic. We return to them in our night dreams. These retreats have the value of a shell. And when we reach the very end of the labyrinths of sleep, when we attain to the regions of deep slumber, we may perhaps experience a type of repose that is pre-human; pre-human, in this case, approaching the immemorial. But in the daydream itself, when the recollection of moments of confined, simple, shut-in space are experiences of heartwarming space, of a space that does not seek to become extended, but would like above all to be possessed. In the past, the attic may have seemed small, it may have seemed cold in winter and hot in summer. Now, however, in memory captured through

daydreams, it is hard to say through what syncretism the attic is at once small and large, warm and cool, always comforting.[29]

Bedroom at Arles is such a memory, captured through daydreams in paint.

NOTES

1. R. M. F., "Van Gogh in Arles," *Bulletin of The Art Institute of Chicago* 20, 7 (1926), pp. 92–94; The Art Institute of Chicago, "Masterpiece of the Month" (June 1938), notes and bibliography, pp. 18–19; John Maxon, *The Art Institute of Chicago* (New York, 1970), pp. 93–94, 287.

2. New York, The Museum of Modern Art, *First Loan Exhibition: Cézanne, Gauguin, Seurat, Van Gogh*, exh. cat. (1929), p. 49, no. 79 (The Art Institute of Chicago): "Painted at Arles, 1888 or Saint Rémy, 1889 . . ."; and no. 80 (Rijksmuseum Vincent Van Gogh, Amsterdam): "Painted at Arles, 1888."

3. See, for example, Paris, Orangerie des Tuileries, *Vincent van Gogh: Collection du Musée National Vincent van Gogh à Amsterdam*, exh. cat. (1971), p. 60, no. 82; Bogomila Welsh-Ovcharov, *Vincent van Gogh and the Birth of Cloisonism*, exh. cat., Art Gallery of Ontario, Toronto, and Rijksmuseum Vincent van Gogh, Amsterdam (1981), p. 138, no. 26; Tokyo, The National Museum of Western Art, *Vincent van Gogh Exhibition* (1985), pp. 192–93, no. 67. See also the recent monograph on the artist by Bernard Zurcher, *Vincent Van Gogh: Art, Life, and Letters* (New York, 1985), p. 189, where he described the "original version in the Van Gogh Museum in Amsterdam" In the most comprehensive study of the artist's oeuvre, J. B. de la Faille, *The Works of Vincent van Gogh: His Paintings and Drawings* (Amsterdam, 1970), p. 218, The Art Institute *Bedroom* (F484) is described as having been executed at Arles and given to Theo *after* the Amsterdam museum version (F482).

4. Ronald Pickvance, *Van Gogh at Arles*, exh. cat., The Metropolitan Museum of Art (New York, 1984), cat. no. 113, pp. 190–91.

5. Vincent van Gogh, *The Complete Letters of Vincent Van Gogh*, 3 vols. (Greenwich, Conn., 1958), vol. 3, no. 532, p. 27.

6. Ibid., no. 534, pp. 30–31.

7. Ibid., no. 539, p. 43, datable to between September 8 and 16, 1888.

8. The careers of the brothers Edmond (1822–1896) and Jules (1830–1870) de Goncourt constituted a remarkable collaboration that produced novels, histories, and criticism of great sensitivity and vision. Their insightful criticism, in particular, focused on the eighteenth century, was pivotal in the revival of interest in this period. This fecund fraternal partnership, which was cut short by the death of Jules, served as an inspiration to Vincent and Theo van Gogh, who also sought to merge their creative energies and careers.

9. Van Gogh (note 5), no. 540, p. 46.

10. "I have been and still am nearly half dead from the past week's work. I cannot do any more yet, and besides, there is a very violent mistral that raises clouds of dust which whiten the trees on the plain from top to bottom. So I am forced to be quiet. I have just slept sixteen hours at a stretch, and it has restored me considerably." Ibid., no. 553, pp. 81–82.

11. Van Gogh (note 5), no. 554, p. 86.

12. Ibid., no. 555, p. 89.

13. Letter to Paul Gauguin; van Gogh (note 5), B22, p. 527.

14. For further discussion of the monetary agreement between Theo and Gauguin, see van Gogh (note 5), "Theo Van Gogh and Gauguin," T48, pp. 583–84.

15. Van Gogh (note 5), no. 558, p. 95.

16. Ibid., no. 573, p. 126.

17. Ibid., no. 588, p. 159.

18. Ibid., T10, p. 544.

19. Ibid., no. 594, p. 179.

20. Ibid., no. 604, p. 201.

21. See de la Faille (note 3), F462, *Portrait of Eugène Boch, a Belgian Painter* (Paris, Musée du Louvre), and F473, *Portrait of Milliet* (Otterlo, Rijksmuseum Kröller-Müller).

22. Examination by William Leisher, Executive Director of Conservation at the Art Institute, of the flattened impasto under high magnification revealed two distinctly different surfaces, each resulting from different mechanisms: 1) areas of impasto were imprinted with a fabric texture typical of the kind of imprint made by the contact of the back of one painting against the front of another when several paintings are stacked together in a bundle (as van Gogh was known to do); 2) other areas of flattened impasto were rounded, smooth, and depressed into the surface as is typical of too much pressure from a press used during the nineteenth century for glue linings.

23. For van Gogh's working methods, retouching of copies, and use of copies, see in particular Charles S. Chetham, *The Role of Vincent van Gogh's Copies in the Development of His Art*, Outstanding Dissertations in the Fine Arts, Garland Publishing Co. (New York, 1976).

24. Van Gogh (note 5), no. 554, p. 86.

25. Julius Meier-Graefe, *Vincent Van Gogh: A Biographical Study*, trans. John Holroyd-Reece (New York, 1933), pp. 41–42.

26. Ibid., p. 103.

27. Van Gogh (note 5), no. 592, p. 173.

28. Gaston Bachelard, *The Poetics of Space* (New York, 1964), pp. 6–7.

29. Ibid., p. 10.

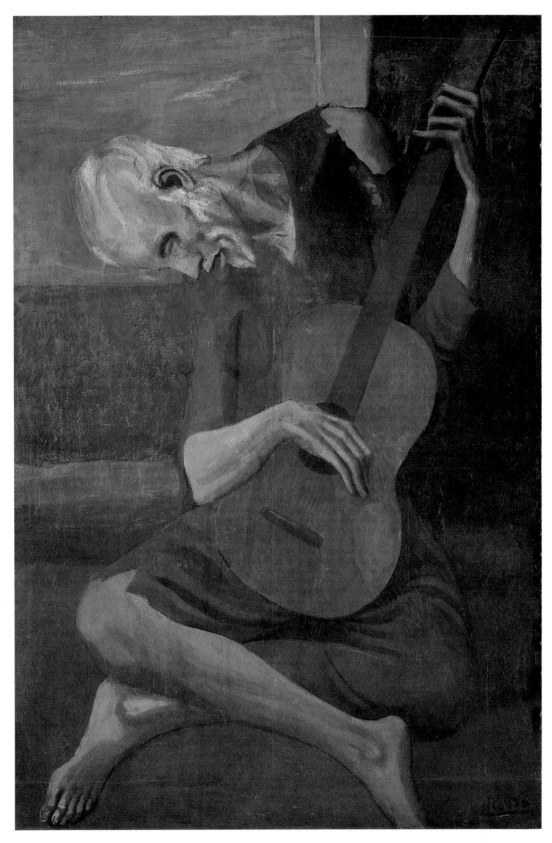

FIGURE 1 Pablo Picasso (Spanish, 1881–1973). *The Old Guitarist*, 1903/04. Oil on panel; 122.9 × 82.6 cm. The Art Institute of Chicago, Helen Birch Bartlett Memorial Collection (1926.253).

A Youthful Genius Confronts His Destiny: Picasso's *Old Guitarist* in The Art Institute of Chicago

MARY MATHEWS GEDO, *Chicago*

THE IMAGE of the blind minstrel has its origins deep in antiquity. According to tradition, it was the sightless Homer who carried the legends of the great Greek heroes from city to city, accompanying himself on his lyre as he sang their exploits. In Spanish art and literature, the figure of the itinerant bard gradually evolved into that of the blind guitarist; Pablo Picasso's great Spanish predecessor, Francisco Goya (1746-1828), was particularly fond of this motif and portrayed blind guitarists in a number of his paintings and prints. This theme was but one of several associated with Goya that the young Picasso would adopt and make his own.[1] He painted his masterful version, *The Old Guitarist* (fig. 1), now part of the Helen Birch Bartlett Memorial Collection of The Art Institute of Chicago, during the last weeks of 1903 or early in 1904, a time that simultaneously marked the climax and the closing phase of Picasso's blue period.

Picasso's Blue Period: A Brief History

The history of Picasso's blue style coincided with a period of restlessness in his young life, a time when he seemed almost as rootless as his itinerant guitarist. Between October 1900, when he celebrated his nineteenth birthday, and April 1904, he made four journeys from Barcelona, where he lived with his parents, to Paris, a city he evidently regarded as a kind of artistic mecca. He

created his first blue pictures during the course of his second and most extensive Paris stay, a visit that lasted from the late spring of 1901 until the following January. Although he had initiated this visit on a note of zestful productivity, he gradually became morosely preoccupied with the suicide of his friend Carlos Casagemas, an event that had occurred the previous February.[2]

Although Picasso had been far away when Casagemas killed himself and had not attended the funeral, the following autumn he painted a series of canvases portraying his friend's death, burial, and apotheosis. Their personal significance may be measured by the fact that Picasso kept several of them secreted in his own private collection, unpublished for over half a century.[3] His delayed reaction to Casagemas's death was probably related to Picasso's feelings about the death of his own younger sister, Concepcion, of diphtheria, in 1895, when the future artist was fourteen. Françoise Gilot believes that the artist never succeeded in eradicating his guilt over Concepcion's death; certainly, throughout his long lifetime, he remained prone to blame himself irrationally for the deaths of various friends.[4]

During the fall and winter of 1901 and 1902, Picasso gradually developed his full-blown blue style, abandoning the warmer colors of his palette to concentrate almost exclusively on shades of blue, enlivened by occasional touches of red or yellow-green. Concurrently, he renounced his rich, van Gogh-like brushwork to paint

153

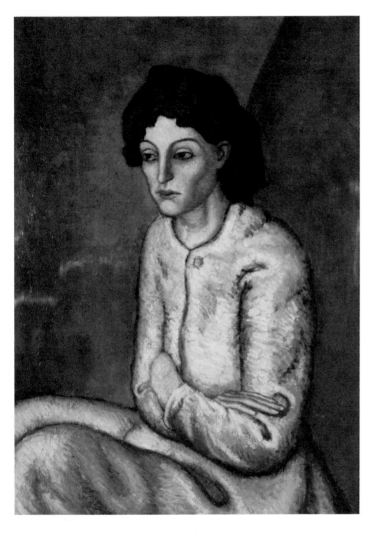

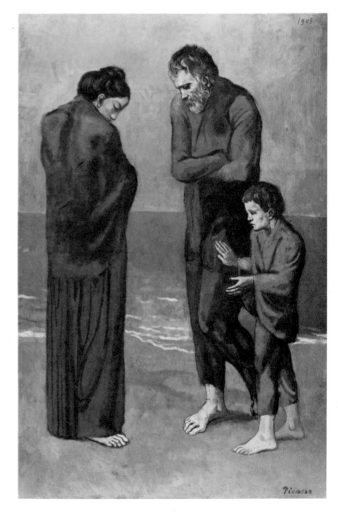

FIGURE 2 Pablo Picasso. *Woman with Folded Arms*, 1902. Oil on canvas; 79.4 × 57.8 cm. The Art Institute of Chicago, anonymous loan.

2), currently on loan to the Art Institute, admirably represents the canvases of this type. Alone in an empty universe, the figure dwells in bitter helplessness. Her reproachful expression recalls Josep Palau i Fabre's contention that the underlying motif of Picasso's entire blue-period production is one of accusation, as his protagonists berate us for being so prosperous and well-fed in the face of their abject poverty.[5]

In October 1902, Picasso returned to Paris for a third visit. This time he enjoyed none of the financial security that had made his first two trips more pleasant, and he

in thin, even strokes reminiscent of the technique of Paul Gauguin, who would become an important influence during Picasso's blue period. He peopled his new-style pictures with an entirely new cast of characters. Except for occasional portraits of himself or his friends, most of Picasso's 1901 and 1902 blue pictures feature destitute women—alcoholic outcasts or drooping madonnas whose seemingly boneless bodies almost fuse with those of the infants they hold. *Woman with Folded Arms* (fig.

FIGURE 3 Pablo Picasso. *The Tragedy*, 1903. Oil on panel; 105.4 × 69 cm. Washington, D.C., The National Gallery of Art, Chester Dale Collection.

lived a hand-to-mouth existence there until he finally earned the train fare back to Barcelona in January 1903.[6] On his return to Barcelona, he resolved to stay at least a year in order to create a significant body of work, a goal he had not accomplished during his relatively unproductive stay in Paris.

During the next fifteen months, Picasso's blue period reached its apex as he executed the most ambitious and memorable of these pictures. Early in 1903, the artist painted several canvases depicting mournful family groups. The most powerful of these, *The Tragedy* (fig. 3), represents a bereaved mother, father, and son standing by the seashore—a setting that recalls Corunna, the city where Picasso's sister died. Another group of multifigural compositions portrays young lovers. The most important of these, *La Vie* (fig. 4), the largest of all his blue paintings, is an enigmatic allegory that seemingly presents a confrontation between a pair of lovers and an older woman who clutches an infant to her breast. As already noted, Picasso depicted his dead friend Casagemas as the male lover (although x-rays of the picture reveal that Casagemas's image was painted over the artist's self-portrait).

The Art Institute's *Old Guitarist* forms part of yet another series Picasso painted during the fall and winter of 1903 representing pitiable male indigents. These half-naked beggars, nearly always depicted as blind or psychotic, appear to be more dramatic masculine counterparts to the female outcasts that Picasso had featured at the beginning of his blue period. Their elongated, angular physiques and slender, tapering fingers recall the similar anatomical anomalies of the final figurative style of El Greco, who had become a cult hero in the avant-garde artistic circle that Picasso frequented in Barcelona.[7] This physical type, to which *The Old Guitarist* belongs, characterizes Picasso's style throughout the closing phase of his blue period—a fact that corroborates other evidence suggesting that this picture was probably painted during the last weeks of 1903.[8] *The Old Guitarist*'s close formal links with one of the artist's other final blue paintings, *Woman with a Helmet of Hair (Head of the Acrobat's Wife)* (fig. 5), painted during the late spring or summer of 1904, can be observed firsthand by visitors to the Art Institute, where both pictures hang in adjoining galleries. The artist created the latter work in Paris, where the final chapter of the blue period was written. In April 1904, Picasso made his fourth journey to Paris; but this time it was for good, and he subsequently returned to Spain only as a visitor.

The Old Guitarist is unique among Picasso's blue-period works in showing the protagonist spiritually transported by his creative effort, rather than mired in hopeless passivity. This characteristic enhances the fig-

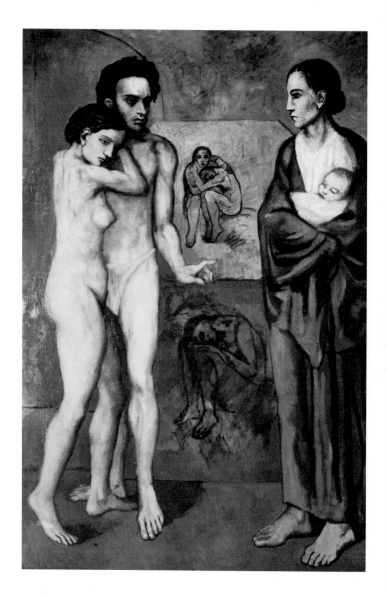

FIGURE 4 Pablo Picasso. *La Vie*, 1903. Oil on canvas; 196.5 × 129.2 cm. The Cleveland Museum of Art, gift of Hanna Fund.

FIGURE 5 Pablo Picasso. *Woman with a Helmet of Hair (Head of the Acrobat's Wife)*, 1904. Gouache on illustration board; 41.6 × 29.9 cm. The Art Institute of Chicago, bequest of Kate L. Brewster (1950.128).

The Old Guitarist and Its X-rays

In studying *The Old Guitarist,* the discerning viewer soon becomes aware of another presence behind the musician, the ghostly image of an earlier composition painted on the same panel (see fig. 7). Time has rendered the diguising layers of paint ever more transparent, and this earlier incarnation of the guitarist has become more and more visible. *The Old Guitarist* is but one of several pictures from Picasso's blue period known to have been painted on a reused support, a procedure dictated by economic necessity.[9] Nor did Picasso abandon this practice once the blue period had passed: A beautiful 1906 picture, *Nude with a Pitcher* (fig. 6), also in the Art Institute, demonstrates that Picasso continued this custom during his rose period as well. This idealized image began her painted existence as a full-length, rather than a three-quarter, representation and one readily perceives the bare feet of this earlier version right at the groin level of the extant figure.

The x-rays of *The Old Guitarist* and *Nude with a Pitcher* reveal that Picasso followed the same procedure in repainting both pictures. That is, he simply covered over the original figures with the new without bothering to turn his support 90 or 180 degrees, or even to interpose an obliterating layer of paint.[10] Picasso's ability to rework a picture in this manner without being distracted by his own earlier image reveals unusual powers of concentration. The most complex and fascinating reuse of such a support involves *La Vie* which, to this author's knowledge, is the only instance in which Picasso turned a painting before reusing it. Originally, as it was exhibited in 1900, the canvas showed a young priest at the bedside of a dying girl, an image most likely developed out of the artist's memories of his sister's death.[11] Before reusing it,

ure's effectiveness, while simultaneously relieving us of yet another of those reproachful encounters so many of Picasso's other blue-period characters seem to demand. The guitarist's creativity, like his blindness, encloses him in a protective cocoon: Transported by the beauty of his song, he dwells in a world apart, a state that surely mirrors the creative joy of the young artist himself. In order to emphasize the old man's self-containment and the power of his activity, Picasso has squeezed him into a pictorial format that seems too small to hold him. Should the guitarist ever unfold his legs or raise his head, he would burst the pictorial bounds that encase him. But like an obedient jack-in-the-box, he remains forever locked into the container in which his creator fitted him, conveying a sensation of compressed energy.

156

FIGURE 6 Pablo Picasso. *Nude with a Pitcher*, 1906. Oil on canvas; 100 × 81.4 cm. The Art Institute of Chicago, gift of Mary and Leigh Block (1981.14).

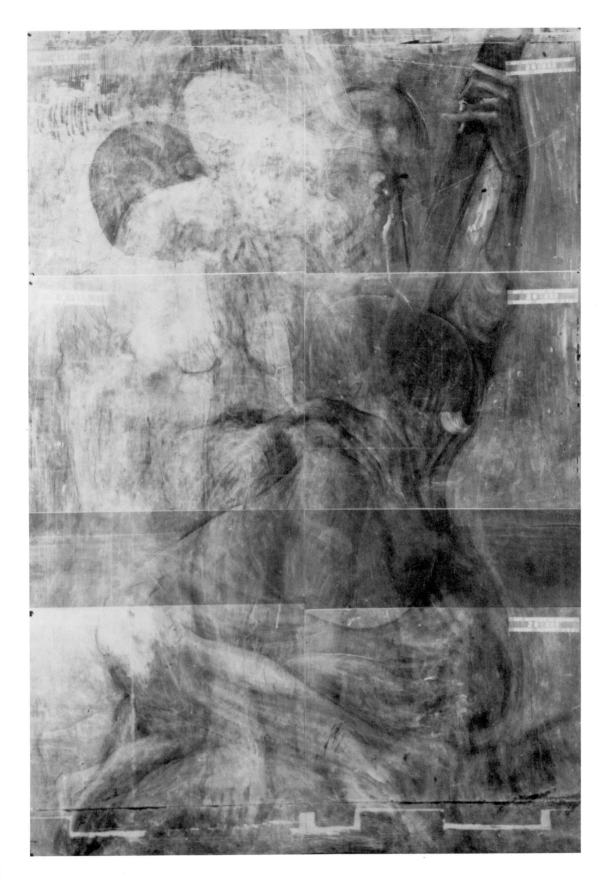

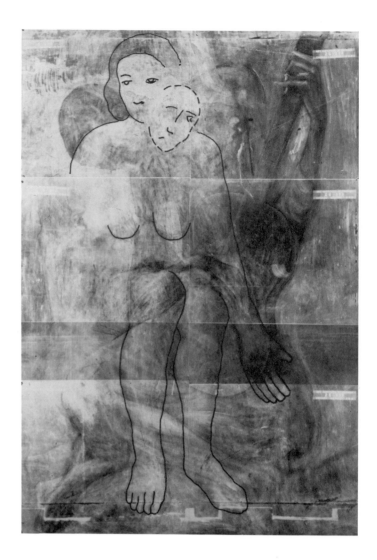

FIGURE 8 Author's reconstruction of figures beneath *The Old Guitarist* (fig. 1).

Picasso turned the canvas 90 degrees and then painted *La Vie* in a vertical format. The latter painting itself masks many pentimenti, among them Picasso's initial depiction of himself as the young male protagonist. It seems likely that the emotionally disturbing nature of the subject matter underlying *La Vie* determined this change in procedure.

While the x-rays of *Nude with a Pitcher* disclose the complete form of the underlying figure, those of the guitarist (see fig. 7) provide only fragmentary information about the nude submerged underneath. One readily perceives the young woman's head and shoulders, as well as her long, loose hair (see fig. 8). (In fact, these features can be observed without the aid of x-rays.) Her full, firm breasts can also be discerned, though less clearly. Below her head, and to her left, a second, more ghost-like female visage appears, her head seemingly bowed as though sunk into her chest. The radiograph also reveals an extended left arm, held palm upward, and two bare lower legs and feet, the latter firmly planted between the guitarist's own. It is not clear from this fragmentary evidence which female figure belongs to these limbs, nor which head Picasso executed first. The successive layers of paint masking the remainder of the torso(s) proved to be impervious to other laboratory techniques that were implemented.

Reconstructing a convincing pose for either of these submerged fragments that would explain the peculiar bodily proportions suggested by the x-rays seems difficult, especially because the figure's left hand appears below her knee level, suggesting that the woman had to be seated or crouching. A drawing, now in the Museo Picasso, Barcelona (fig. 9), shows a seated nude with her arms extended, duplicating perfectly the position of the feet and left hand of the figure beneath the guitarist.[12] This sketch represents an aging woman with sagging breasts; she looks down and to her left with a beseeching, troubled expression, so that one reads her open-armed gesture as one of entreaty. The pose of her head seems more congruent with that of the lower obliterated face than with that of the more upright, younger woman. However, neither the right shoulder nor the voluptuous breasts apparent in the x-rays match those of this aging personage. Perhaps remnants of two distinct figural compositions underlie the guitarist, one of them resembling the sorrowful woman of the drawing, the other closer in age and spirit to the model depicted in a surviving painting of a young woman, *Blue Nude* (fig. 10), whose sensuous form and provocative expression seem much closer to those of the younger woman who gazes out so boldly from beneath the guitarist.[13]

During late 1903, Picasso seemed quite preoccupied with portraying nudes who extended their arms in gestures similar to that of the submerged woman beneath the guitarist. Several of these personages seem to have been conceived as decorations for a fireplace,[14] toward which these pathetic figures stretched their arms; perhaps this was an unrealized commission of the period. Two other drawings feature quasi-mythical beings: in

159

FIGURE 9 Pablo Picasso. *Figure,
head, and guitar*, 1902/03. Pen and
ink on paper; 31.5 × 22.1 cm.
Barcelona, Museo Picasso.

FIGURE 10 Pablo Picasso. *Blue
Nude*, 1903. Oil on canvas; 62.2 ×
34 cm. Barcelona, Museo Picasso.

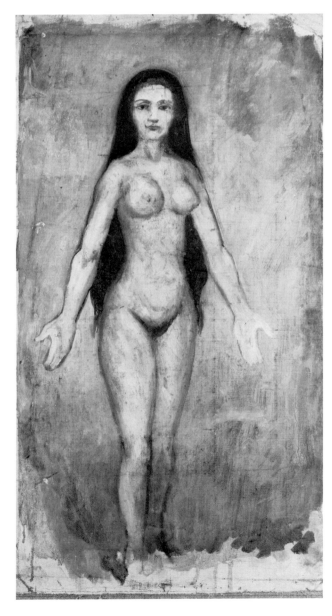

one case a nude winged man, in the other a similar female figure. In both instances, the winged persons seem to be making gestures of benediction or protection over a pair of nude lovers whose positions recall those of a couple that originally appeared in the area of *La Vie* now occupied by the nude in the lower background. This area originally showed a winged bird-man, with a feathered head and a human body, hovering over a reclining nude. The detail can be identified even in reproductions of the painting (see fig. 11). In this connection, it should be noted that a lost painting now known only from photographs, *Nude with Crossed Legs*, features the same young girl who probably posed for the figure beneath the guitarist and reads almost like a mirror image of the woman shown in the lower background of *La Vie*. The latter's bent head, in turn, echoes the pose of the guitarist himself. Such coincidences suggest that the two paintings probably share an underlying thematic relationship.

Thematic Interpretations of *The Old Guitarist*

In an important essay devoted to the symbolism in Picasso's *Old Guitarist*, R. W. Johnson posited a connection between that painting and *La Vie*, suggesting that their commonalities derive from the themes of love and death shared by both pictures. Specifically, he hypothesized a connection between the death of Casagemas and the initial appearance of the guitar in Picasso's oeuvre, noting, too, that members of the artist's intimate circle anthropomorphized the guitar, to which they ascribed not only a feminine form, but a feminine psychology.[15] The substitution of the old guitarist's image for that of the young woman followed, he believed, from that equation. In other words, Picasso's painting conveys the message that the artist has the same relation to his medium that characterizes that of other men to their sexual partners.

Johnson emphasized that the members of the Catalan artistic circle to which Picasso belonged were imbued with Nietzschean aesthetics.[16] Johnson believed that Nietzsche's *Birth of Tragedy from the Spirit of Music*, which connects the development of tragedy with the Dionysiac spirit as expressed in the Greek chorus, exercised a particularly strong influence on Picasso, who may have fused such ideas with the Spanish tradition of the *cante jondo,* or song of the Gypsies, a type of music that emphasized the tragic side of life and the heroic position of the victims of social injustice.[17]

There can be little doubt that Johnson correctly identified the programmatic determinants of Picasso's tragic view of life. The critic did not, however, address the reasons why certain aspects of the contemporary cul-

FIGURE 11 Pablo Picasso, *La Vie* (fig. 4), detail.

tural matrix exerted a much stronger pull on Picasso than on others. By the time that the artist's blue period had fully developed, the Symbolist style of painting to which these works belong had crested and begun to wane. For the only time in his career, then, Picasso hitched his wagon to a fading, rather than rising, star. Thereafter, he would take the lead in developing revolutionary new modes of art; yet, he ignored the proto-Fauve elements implicit in the oeuvre of Gauguin and other Post-Impressionists to whom he was exposed during his Paris sojourns, leaving the development of that new style to Henri Matisse and his peers.

The style and subject matter that Picasso pursued in his blue period surely reflected his personal experiences

and subjective attitudes as well as the impact of his cultural milieu. It was this potent combination of individual and communally shared factors that shaped his work of 1901 to 1904. Certainly, the artist himself repeatedly emphasized that his entire oeuvre possessed an explicitly autobiographical character. It seems plausible, then, that the young artist utilized his blue-period oeuvre as the forum in which he played out his conflicting feelings about his age-appropriate wish to assume a mature, independent sexual role, and his unresolved attachment to his family.[18] Certainly, separation had always posed difficult problems for Picasso. As a child, he suffered from a school phobia, a prime symptom of separation problems. To an unusual degree, he had relied on his parents, particularly his artist father, to organize his life and protect him, as well as to teach him the principles of the craft he would later practice with such dazzling mastery.

It is surely no coincidence, then, that Picasso initiated his blue period in Paris, where he was living independently without the emotional and financial support that his parents had provided. His earliest blue-period pictures, featuring the lonely female outcasts and impoverished mothers mentioned above, may be read as symbols of the artist's own mother, whom he may have imagined as psychologically impoverished by the threat of his nascent independence. Nor is it an accident that he terminated each of his first three Paris visits right around Christmas, or as soon thereafter as he could finance his return home. That the approach of the holiday season can exacerbate homesickness is too well known to require elaboration.[19]

As has already been stated, Casagemas's suicide had a strong effect on Picasso. The fact that Casagemas's death was connected to his unsuccessful attempt at a romantic relationship, and that his death triggered the death of his mother—who supposedly died of shock on learning of his demise—must have reinforced Picasso's baseless fears and feelings of guilt about the possible untoward effects of his efforts to separate himself from his parents. The artist's resolve to stay in Barcelona after he returned from his fruitless third Paris sojourn in January 1903 suggests an underlying awareness that he had to work his separation problems out on his home ground rather than through flights.

We may now be ready to draw the multiple levels of meaning encoded in *The Old Guitarist* together into a coherent statement. This picture, with its complex allusions, once again refers to the principal players in Picasso's domestic drama: his mother, his father, and himself. His aborted conception for this panel, the drawing in the Museo Picasso (fig. 9), portrayed not the sensuous young nude he eventually painted and then obliterated, but the figure of an older woman with sag-

ging breasts and a mournful expression. She extends her arms not in sexual supplication, but as if to entreat her lost child to return to her bosom. In contrast, the alternative image, that of the provocative nude, seems to have symbolized his simultaneous sexual longings and desire for an autonomous existence; eventually, he overlaid both images with that of the blind artist with which he concluded his work on this panel.[20] Once again, this figure, like the condensed images of a dream, represents not just the young Picasso himself, but his artist father as well and, by extension, all of his artistic progenitors. The image asserts the priority of Picasso's vocation over his obligations as a son.

The theme of blindness, too, possesses many ramifications. Blindness protects the sightless against many of the visual provocations that assail the rest of humanity; specifically, they do not—cannot—see beautiful temptresses like the alluring nude whom the artist painted out, protecting us, as well as himself, from this potential source of stimulation and focusing instead on his artistic activity. In this light, John Berger's hypothesis—that Picasso's preoccupation with the motif of blindness during this era probably stemmed from his fears that he would suffer venereally induced blindness as a punishment for his sexual transgressions—should not be ignored.[21] Blindness also refers to the fate of Picasso's father, an artist who allegedly gave up producing paintings of his own to live vicariously through his talented son. In this connection, it seems quite fascinating that the last painting Picasso completed before his definitive move from his parents' home to his own residence in Barcelona (where he stayed from January to April 1904), was *The Old Jew (Old Man and Child)* (fig. 12).[22] This canvas depicts another aged, emaciated beggar, probably based on the same model who posed for the guitarist. He hugs a small boy who sadly munches a crust of bread, evidently the only bit of food the pair possesses. Although the old man is scantily clothed and barefooted, the boy appears securely wrapped in a flowing cloak. The painting silently conveys the implicit message that the old man has sacrificed himself to save the boy—whatever meager food and clothing they possess belongs to the child. This theme reinforces those of other contemporaneous pictures, suggesting that in this, his last blue phase, the artist finally confronted his extreme dependency on his father and the dire implications that he perceived for his father's emotional prosperity following the young artist's imminent defection.

A preparatory drawing for *The Old Jew* strengthens the posited connection between this picture and *The Old Guitarist*. On a sketchbook sheet, Picasso depicted the model for the guitarist, this time sighted and staring intently to the left, where a drawing for the boy from *The Old Jew* appears. A wealth of lightly drawn female

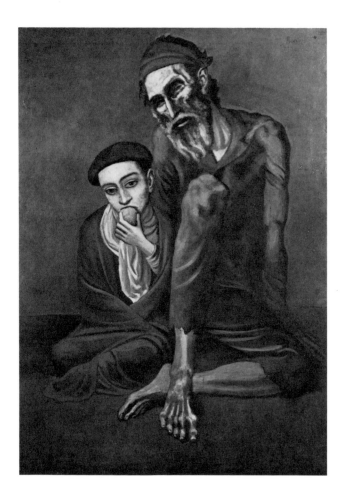

FIGURE 12 Pablo Picasso. *The Old Jew (Old Man and Child)*, 1903. Oil on canvas; 125 × 92 cm. Moscow, Pushkin State Museum of Fine Arts. Photo: J. Palau i Fabre, *Picasso: The Early Years, 1881–1907* (New York, 1981), p. 359.

nudes separates these two figures, including one who stands facing the lad, her arm extended palm outward in a gesture recalling that of the lost nude beneath *The Old Guitarist.* The drawing indicates that Picasso continued through the end of 1903 to struggle with his conflict between adult concerns and his lingering feelings of guilty loyalty toward his father. Moreover, this sketch, which shows a preliminary version of the guitarist, suggests that Picasso had not yet worked out the final configuration for this painting at the time that he completed *The Old Jew.*

Perhaps, then, *The Old Guitarist* was actually the final picture Picasso painted before he moved out of his parental home, or even the first that he executed in his new studio in 1904. Certainly, the self-contained pose of the guitarist, absorbed in his own creativity, symbolized the road that Picasso would soon follow, deliberately blinding himself to his family and his past to dedicate himself totally to his art and to his professional future. On another level, too, *The Old Guitarist* seems prophetic, for Picasso would live to become the great old master of twentieth-century painting. In his final self-portraits, the aged artist would show himself as a living death's head (see fig. 13), resembling that of the aged musician he had depicted so vividly seventy years earlier.

FIGURE 13 Pablo Picasso. *Self-Portrait*, 1972. Pencil and colored crayons on paper; 65.7 × 50.5 cm. Japan, private collection. Photo: The Solomon R. Guggenheim Museum, New York.

It is Picasso's own complete identification with his guitarist that ultimately makes this the most powerful and beloved of his blue-period pictures, and one of the greatest treasures of the Helen Birch Bartlett Memorial Collection.

NOTES

1. The prostitutes, procuresses, madmen, and beggars that Picasso painted between 1900 and 1904 have many counterparts in the art of Goya, as do the bullfight scenes later so intimately associated with the contemporary master. As an elderly artist, most markedly in his so-called "erotic engravings" of 1968, Picasso returned to many Goyesque themes.

2. Carlos Casagemas, a fellow artist and friend of Picasso's, accompanied him on the first trip to Paris. There, Casagemas fell in love with a young woman variously known as Germanine Gorgallo and Germaine Pichot; although she saw Casagemas, she did not return his love. He began to brood and to drink heavily, alarming Picasso, who proposed that when they returned to Barcelona for the Christmas holidays, Casagemas join his family and himself on their annual holiday pilgrimage to their native Malaga. This change of scene failed to improve Casagemas's spirits, and Picasso's new Bohemianism inflamed his family and relatives. After accompanying Casagemas on a drunken round of Malaguenan fleshpots, Picasso abandoned his friend to his fate and fled alone to Madrid. Casagemas later returned to Paris, where he killed himself in his beloved's presence on February 17, 1901. During his second Paris sojourn, Picasso himself had a brief affair with this promiscuous young woman. That Picasso's preoccupation with Casagemas's fate evolved out of conversations about him with Germaine is suggested by Josep Palau i Fabre in *Picasso: The Early Years, 1881–1907*, trans. Kenneth Lyons (New York, 1981), pp. 269–70.

3. Picasso revealed this fact to Pierre Daix and Georges Boudaille, who included reproductions of two of these hitherto unpublished pictures in their catalogue raisonné of Picasso's paintings from 1900 to 1906, *Picasso: The Blue and Rose Periods*, comp. with Joan Rosselet; trans. Phoebe Pool (Greenwich, Conn., 1967), cat. 6, nos. 5, 6.

4. Author's personal communication with Françoise Gilot, September 3, 1977. During the course of this interview, this author made Gilot aware of the fact that Picasso had distorted the chronology of his sister's illness and death, which he always attributed to 1891, when they arrived in Corunna, rather than to the actual date of January 5, 1895, during their last winter in the Atlantic coast city. See also M. M. Gedo, "The Archaeology of a Painting: A Visit to the City of the Dead Beneath Picasso's *La Vie*," *Arts Magazine* 56 (Nov. 1981), pp. 116–29.

5. Palau i Fabre (note 2), p. 336.

6. Picasso earned the fare back to Barcelona by hawking *The Mistletoe Seller* (Paris, private collection), a painting that strangely anticipates his subject matter of nearly a year later.

The picture shows an extremely emaciated, bearded (and presumably blind) beggar accompanied by a small boy helper or guide whom the old man treats with tender consideration. Both the protagonists and the style prefigure such works of late 1903 as *The Old Jew* (see fig. 12, p. 163). For reproductions of these and other works from this period, see Daix and Boudaille (note 3), cat. 8, nos. 4, 5; cat. 9, nos. 29–34.

7. Alfred H. Barr, Jr. was one of the first critics to point out Picasso's early debt to El Greco. See his *Picasso: Fifty Years of His Art* (New York, 1966), pp. 29, 48, and passim. Barr and others have also emphasized the importance of medieval sculpture as a source for Picasso's exaggerated anatomical depictions of the blue period. In this connection, it is interesting to compare *The Old Guitarist* with sculptures such as the representation of David on the south porch of the great Spanish pilgrimage church at Santiago de Compostela, for their similar elongations and cross-limbed postures.

8. Palau i Fabre (note 2), p. 352, noted that a sketchbook from October 1903 shows in embryonic form the artist's subject matter during the autumn and early winter; it included various sketches of blind men and blind singers. A drawing that Picasso sent to a friend in Paris on November 30, 1903, shows the model who later appeared as *The Old Guitarist*. See also note 22.

9. Although Picasso did not actually suffer physical deprivation during the blue period, except perhaps during his brief third stay in Paris, he did not have much ready cash either, so such a creative reuse of materials was important.

10. This author is especially grateful to Timothy Lennon, Art Institute Conservator, who discussed the x-rays on several occasions during the summer of 1985. In addition, William R. Leisher, Executive Director of Conservation, Neal Benezra, Associate Curator of Twentieth-Century Painting and Sculpture, and Courtney G. Donnell, Assistant Curator in that department, all provided helpful observations and input.

11. See Gedo (note 4).

12. The tiny rendition of a guitar that the artist later appended to the left margin of the Barcelona sketch seems especially provocative, suggesting that, on some preconscious level, Picasso had already associated this female figure with the image of a guitar. For a translation of the poem also inscribed on this sketchbook sheet, see R. W. Johnson, "Picasso's Old Guitarist and the Symbolist Sensibility," *Artforum* 13 (Dec. 1974), pp. 56–62, esp. p. 59.

13. Several other paintings from the same period also seem to portray this model, though sometimes depicted as a more morose figure than in *Blue Nude*. See Daix and Boudaille (note 3), cat. 9, nos. 16, 18, and 19, for pictures not reproduced here.

14. Juan Eduardo Cirlot identified these works as "sketches for the decoration of a fireplace." Since these drawings were all made in Barcelona, the unrealized commission apparently originated there. See Cirlot's *Picasso: Birth of a Genius*, trans. Paul Elek Ltd. (New York, 1972), p. 140. Cirlot's identifications of works reflect those of the Museo Picasso, whose staff cooperated with him to produce this book.

15. See Johnson (note 12), pp. 58–59, for extensive quotations from an essay devoted to this idea that appeared in *Arte Joven* in 1901, an ephemeral journal for which Picasso served as art editor.

16. See Johnson (note 12), pp. 61–62. Anthony Blunt and Phoebe Pool, *Picasso: The Formative Years: A Study of His Sources* (Greenwich, Conn., 1962), p. 6, also noted that interest in Nietzsche was in the air, but suggested that Picasso probably got his information secondhand from others.

17. Nietzsche's implicit conception of the artist as prophet, best exemplified by his *Zarathustra*, must have strongly appealed to the adolescent Picasso and buttressed him in his struggle to justify leaving his family.

18. See M. M. Gedo, *Picasso—Art as Autobiography* (Chicago, 1980), pp. 27–56.

19. To add to Picasso's emotional distress around the holiday season, he associated it with the birth of his sister next in age, Dolores. Although Dolores was actually born on December 15, 1884, Picasso mistakenly remembered her birth as occurring during the night of December 25. Also, Concepcion's death on January 5, 1895, indicates that she must have been severely ill throughout that Christmas season.

20. This kind of fluidity in developing his images occurred in many of Picasso's early paintings. For a discussion of the complex instances of this type involved in the evolution of *La Vie*, see Gedo (note 4), pp. 120–22.

21. John Berger, *The Success and Failure of Picasso* (Harmondsworth, Middlesex, England, 1965), pp. 43–44.

22. An inscription on the back of this painting indicates that it was completed in Picasso's family home, not in his studio; Palau i Fabre (note 2) suggested that the artist painted this at the very end of 1903, while waiting to move into his own studio. The sketch—showing the boy who appears in *The Old Jew*, along with another sketch of the model for *The Old Guitarist*, still not in his definitive pose—suggests that *The Old Guitarist* may have been painted later still. The close resemblance between the pose of the guitarist and that assumed by the figure in *Woman Ironing*, 1904 (New York, Solomon R. Guggenheim Museum), adds to this impression. The latter is one of Picasso's last blue-period pictures.

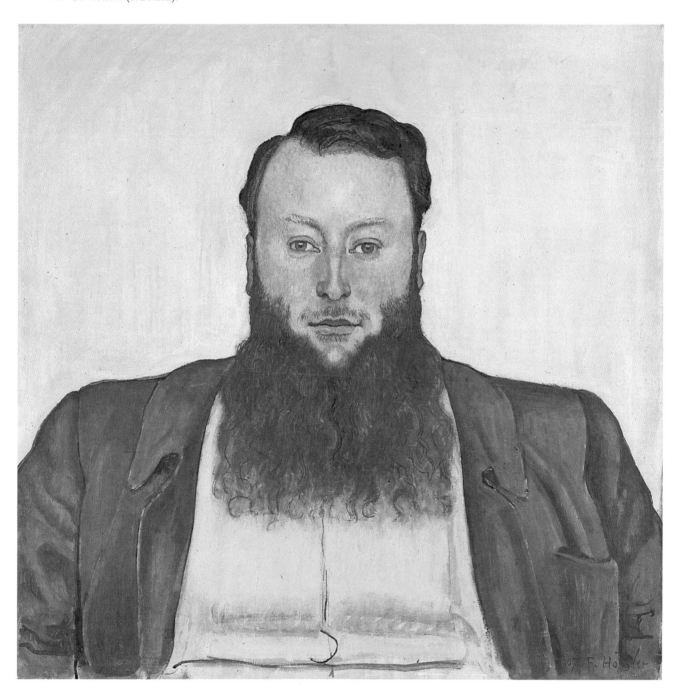

Ferdinand Hodler:
A Unique Note in the
Birch Bartlett Collection

REINHOLD HELLER, *Professor of Art and
Germanic Languages and Literature, The University of Chicago*

*I*n the May 21, 1918, issue of the *New York Times*, a two-line item appeared, datelined Bern, Switzerland: "Ferdinand Hodler, a leading Swiss painter, is dead here at age 65." It was the most extensive American notice given his death then, as well as the most attention Hodler had received here up to that time. There had been no exhibitions of his paintings, nor would there be any until over fifty years later, in 1972;[1] and his work was not included in American private collections or museums. In contrast, in Europe he was praised as one of the greatest artists of the time. In Switzerland, France, Austria, and Germany, the invention of his portraits and landscapes was compared in numerous books, articles, and exhibitions to that of Cézanne, while his monumental scenes of Swiss history were seen as inaugurating a new and grand modern style of mural painting. Even if Switzerland had no other artists, one critic wrote, in Hodler alone the country has a great national school of painting; another summarized Hodler's historical significance by seeing in him the realization of "our era's deep yearning for greatness and immortality."[2]

In the United States, Hodler remains virtually unknown, unseen, and uncollected. There was, and is, but one exception. During the summer and fall of 1924, after a visit to Switzerland, the Chicago collector Frederic Clay Bartlett purchased three Hodler paintings, the last additions to an extensive collection of Post-Impressionist art prior to its donation to The Art Institute of Chicago beginning in 1926. The three paintings—a portrait of the Swiss sculptor James Vibert, painted in 1907 (fig. 1); an Alpine landscape representing the mountain chain of the Grand Muveran, of 1912 (fig. 2); and an oil study of a soldier's head for Hodler's last, unfinished history painting, *The Battle of Murten*, from 1915/17 (fig. 3)—represent the three major areas of Hodler's European fame at the time of their purchase. They constitute the only group of Hodler paintings in any American museum today.

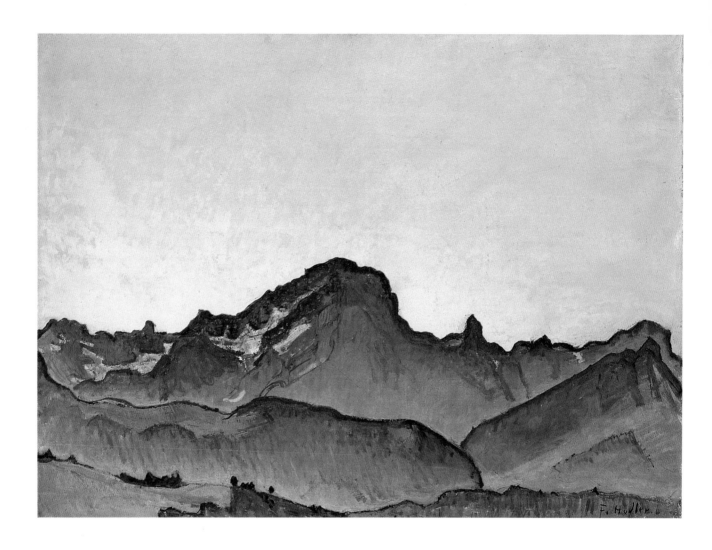

FIGURE 2 Ferdinand Hodler. *The Grand Muveran*, 1912. Oil on canvas; 70.8 × 95.5 cm. The Art Institute of Chicago, Helen Birch Bartlett Memorial Collection (1926.211).

Although in Europe Hodler was celebrated and successful at the time of his death in 1918, he spent much of his life in relative deprivation.[3] Born on March 14, 1853, in the city of Bern's most impoverished quarter, Ferdinand Hodler was the oldest of six children, the son of a carpenter who would die of tuberculosis seven years later on Christmas Eve, a few months after having been forced into bankruptcy. Death, poverty, and insecurity came to mark the future artist's entire childhood.

His mother, Margareta Hodler, remarried a few months after her first husband's death, adding to her family of four surviving children the five of her new husband, Gottlieb Schüpbach, a decorative painter who would be the first to instruct the young Ferdinand in art. Six years later, Margareta died, like her first husband, of tuberculosis, after having given birth to three more children. Her sudden death, while working in a field, was not the last in the family: by 1885, all of Ferdinand Hodler's sisters and brothers were dead of the same disease that killed their parents. "In my family," Hodler later said, "there was a constant dying, and it seemed only right to me that there would always be a corpse in the house."[4] These early experiences of loss and instability established

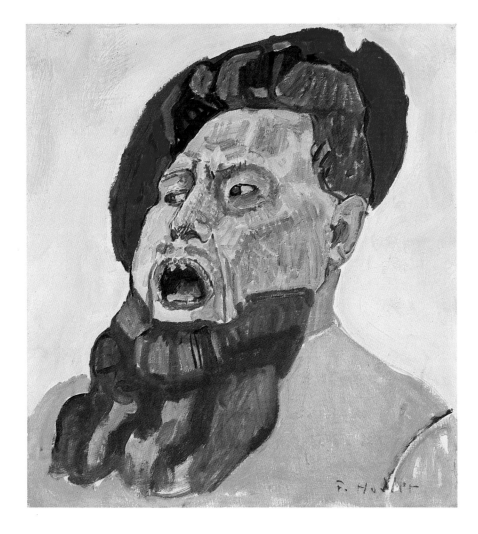

FIGURE 3 Ferdinand Hodler. *Head of a Soldier (Study for "The Battle of Murten")*, 1915/17. Oil on canvas; 46.7 × 43.3 cm. The Art Institute of Chicago, Helen Birch Bartlett Memorial Collection (1926.213).

in him a fundamental need for permanence, for an existence and sense of self that would counteract the persistence of change and fear of death. This demand, which formed an essential characteristic of Hodler's psyche, was met by Hodler largely through his art. Imposing the impermeability of his own ego ideal onto the flux and change that surrounded him, he created in his paintings a new world of harmonious unity and inalterable stability.[5]

Hodler began the formal study of art when he entered the Geneva School of Design in 1872 at the recommendation of Barthélémy Menn. A student of J. A. D. Ingres's and a friend of Camille Corot's, Menn attempted to fuse the demands of his teacher's classicism with the concerns of Romantic naturalism in both his teaching and his art (see fig. 4). His teaching emphasized the consolidation of an established, universal theory with temporal observation; he advised his students to fuse Euclid's laws of geometry and Albrecht Dürer's fundamentals of human proportion with a constant process of sketching from life. Hodler, searching for the stasis only a constant theory could provide, absorbed Menn's principles and transformed them into a personal list of essential rules which he committed to memory and later jokingly identified as his

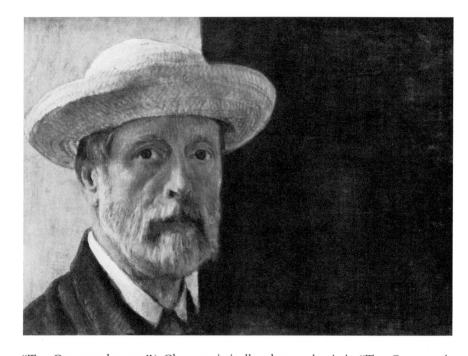

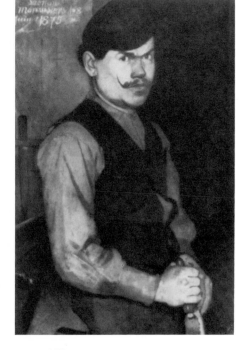

"Ten Commandments."[6] Characteristically, these aphoristic "Ten Commandments," written while he was a student, remained stable principles that guided for life Hodler's practice of art. Through them and their reflection of Menn's authority, he could replace the shaky realms of existence with universal laws and inalterable processes. In changeability, he discovered permanence:

The measure of all things visible is the eye. The painter must accustom himself to seeing nature in terms of a flat surface.

In a sensitive and reflective manner, he must subdivide that segment of flat surface he wishes to represent into geometric planes, using the precision of mathematics as it is available to him.

After he has subdivided his surface in this way, he should draw as precisely and sharply as possible the contour of his object.

In and of itself, the contour constitutes an element of expression and beauty. It serves as the foundation of all further work, and consequently that it be precise and powerful is important. . . .[7]

Hodler applied his guiding principles to his art with an obsessive consistency. They aided his capacity to withstand the attacks of an imperfect world, for through them he could confront critical rejection and condemnation with an independence and certainty supported by universal laws. The strength of his self-image gained in the recognition of other artists, exhibition prizes, and public commissions throughout the 1880s and 1890s, as colleagues rallied to his defense. One, for example, seeing Hodler's first exhibited works, had advised Hodler to "study the great masters" and cease creating "undeniably ugly painting . . . [whose figures reveal] a gaze that lacks expression, a pose that is forced, a body . . . that is too small and incorrectly drawn, a hand . . . that is crippled: one involuntarily thinks of those pitiable beggars who show us their deformities to arouse our sympathy."[8] The works provoking such distaste and rejection early in Hodler's career were highly realistic, highly detailed portraits (see fig. 5), which fellow artists, in opposition to Swiss art critics, lauded as revealing "an intense effort to remain sincere and naive on the basis of true talent and a temperament that is through and through that of an artist, who justifiably gives rise to hopes for a great future."[9] For his portraits and land-

scapes, "painted after nature exactly as the artist saw it,"[10] as well as for paintings of scenes from the history of Geneva, Hodler received prizes but little income. Seeking cheaper living accommodations, he moved to Madrid during 1878–79, and, after returning to Geneva, received rent-free housing with another artist in exchange for doing the housework.

This depressing standard of living changed somewhat after Hodler was able to rent his own studio in 1881, when he received the commission to paint a mural for an army barracks and became an assistant to the successful panorama painter E. Castres. During this period, Hodler continued to paint portraits and landscapes. He also produced depictions of rural workers—carpenters, farmers, and shoemakers—based on the popular works of François Millet and Albert Anker, as well as realistic renderings of scenes from Geneva's history. Continuing to receive major prizes, he gained the confidence to have his first one-man exhibition in 1885. While the exhibition was not successful, it did bring Hodler the public support of a group of Genevese poets who published the periodical *La Revue de Genève*, which championed a new idealist literature modeled on the French Symbolist lyrics of Mallarmé and Verlaine. Under the tutelage of poets Louis Duchosal and Mathias Morhardt, Hodler began to ". . . make use of Naturalism to create the Ideal"[11] in paintings such as *View into Eternity* (fig. 6), which depicts with veristic detail an aged carpenter, with a

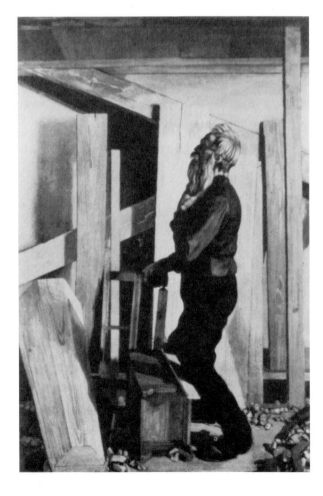

FIGURE 6 Ferdinand Hodler. *View into Eternity*, 1885. Oil on canvas; 245.5 × 168.5 cm. Bern, Kunstmuseum. Photo: S. L. Hirsh, *Ferdinand Hodler* (New York, 1982), p. 15.

FIGURE 7 Ferdinand Hodler. *Night*,
1890. Oil on canvas; 116 × 229 cm,
Bern, Kunstmuseum. Photo:
S. L. Hirsh, *Ferdinand Hodler*
(New York, 1982), pp. 76–77.

beard and features not unlike those of Michelangelo's *Moses*, pausing contemplatively in his task of constructing a child's coffin.

Hodler's process of transforming Naturalism into Symbolism culminated in 1890 in *Night* (fig. 7), in which the evocatively draped black form of the phantom of death crouches on the naked body of a terrified man who reclines in an ethereally illuminated landscape in the center of a group of peacefully sleeping women and men. Created at a time when Hodler was plagued by fears of his own death, following that of his sister, the painting must have functioned to fix and allay those anxieties. The central male figure even bears Hodler's own features, but in accordance with Symbolism's demands for the mystical, the full significance of the painting defies clarification in its mixture of the traditional and personal, the naturalistic and the abstracted.[12] With its nude and seminude male and female figures, the painting attracted the animus of the Geneva city president, who refused to permit its inclusion in the annual city art exhibition, although the painting had already been accepted by its jury. An embittered Hodler responded that "my painting exists on a plane of thought totally superior to the intentions attributed to it. I conceived of *Night* as the great symbol of death and attempted to depict this by means of figures presented and draped in a fashion demanded by the logic of the picture's content."[13] He exhibited the painting independently in Geneva, then sent it to the Salon du Champ de Mars in Paris, where it was praised by Puvis de Chavannes and received extensive critical praise, causing Hodler to exult: "Soon I shall be famous in Paris!"[14] He was invited to join the Rose et Croix Esthétique and to participate in the salons of the Société Nationale des Artistes Français, and so returned to Geneva

vindicated. Invitations to exhibit in Antwerp, Brussels, Munich, and Berlin followed as Hodler's international reputation became established, while in Geneva he became the embodiment of art's newest tendencies.

Swiss acceptance of his work seemed finally assured when, in 1896, Hodler won the competition for murals for the Weapons Hall of the new Landesmuseum in Zurich. The motif of the murals was the Swiss Battle of Marignano, and Hodler created full-scale cartoons for the three arched fields reserved for the commission at the museum (see fig. 8). Reduced to either a single figure or small groups of isolated figures, the monumental compositions depicted warriors, but not in heroic combat. They failed to meet the museum director's traditional expectations for descriptive anecdote, and he inaugurated a vehement campaign against Hodler's paintings:

We, on our side, testify that the composition is less than nothing at all: this is not the retreat from Marignano, this is not even a lively scuffle, it is nothing more than an incomprehensible, raw studio conception that hurts the eye. In addition we testify that the design leaves much to be desired everywhere, as does the amount of historical accuracy.[15]

Hodler was defended, in turn, by the Society of Swiss Artists, and the debate between them, the prize committee, the museum commission, critics, and even the Swiss parliament, raged for three years as Hodler repeatedly submitted new full-sized cartoons of his paintings. He was finally permitted to paint his works between 1900 and 1902; soon thereafter, the museum director resigned.

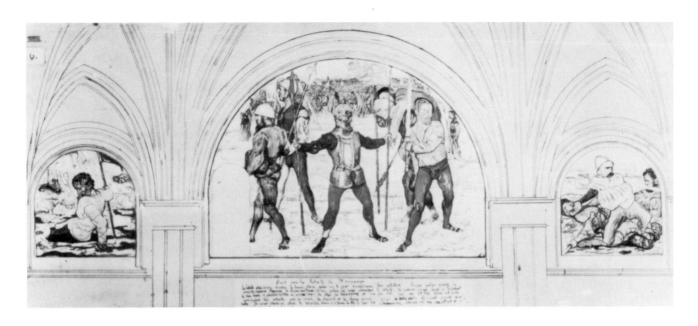

FIGURE 8 Ferdinand Hodler. *Competition Design for*
"The Retreat from Marignano," 1896. Pencil, crayon,
tusche, and tempera on paper; 50 × 117.5 cm. Zurich,
Kunsthaus, deposit of the Schweizerische
Eidgenossenschaft. Photo: *Ferdinand Hodler*
1853–1918 (Paris, 1983), p. 110.

Throughout this period of controversy, Hodler continued to receive foreign
honors, including gold medals at the Munich International Art Exhibition of
1897 and the Paris Exposition Universelle in 1900; at both, fellow artists served
as judges. He was similarly honored in 1904, when the artists of the Vienna
Secession invited him to exhibit with them as the prophet of "the noble severity
and strong simplicity of a reborn monumental style."[16] The self-assurance of
the student composing his own "commandments" was finally rewarded in the
victory of the fifty-year-old painter's art; the stability of his ego ideal finally
conquered the shifting attacks of an external world.

The critical acclaim in Austria, Belgium, France, and Germany made Hodler
a fashionable artist in Switzerland as well. Museums and private collectors vied
to obtain examples of his art. Among the most encompassing collections was
that formed by Willy Russ, director of the Suchard chocolate factory in Ser-
rières-Neuchâtel.[17] Identifying himself as "an art collector who makes choco-
late in his spare time," Russ was portrayed by Hodler in 1911 (see fig. 9). His
collection of Hodler's art consisted of ninety-two paintings and seventy-five
drawings and was a remarkable selection of major works from every phase and
every genre of the artist's career. Russ sold much of his collection during the
1920s and 1930s, and donated the remainder to the Neuchâtel Musée d'art et
d'histoire in 1940, when he was named the museum's curator. Among the early
purchasers of objects from the collection was Frederic Bartlett who, in 1924,
selected two of his Hodler paintings at the Lucerne gallery of T. Fischer and the
third one through a Chicago dealer.[18] With them, in a highly concentrated
fashion, Bartlett could represent Hodler's achievement as a portraitist, land-
scapist, and history painter—but not as a Symbolist painter of personal meta-
physical allegories which, in the 1920s, had ceased to be admired or fashion-
able. This unique American collection of Hodler's work, therefore, also
reflected the critical vagaries of the artist's posthumous reputation.

Hodler was in demand as a portraitist throughout his career, but after his success in Vienna he limited himself almost exclusively to portraying friends and a few special patrons. Hodler's portraits functioned as a means of tribute to those who had supported him and defended his art, but the act of homage for Hodler was also one of appropriation: The portraits were a means of absorbing the sitter's person into his own ego, of supplanting the fragility and instability of human relationships in a narcissistic act of artistic creation. Thus, in his portrait of James Vibert (fig. 1), the subject becomes a perfected extension of Hodler himself.

A sculptor who studied briefly with Auguste Rodin, Vibert was with Hodler in Paris during *Night's* triumphant exhibition in 1891. Vibert's association with

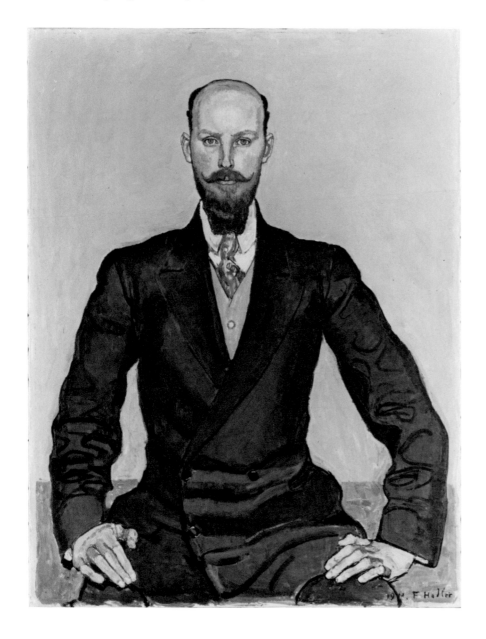

Hodler's critical and financial success was reinforced when he returned to
Geneva in 1903 to accept a professorship at the Ecole des Beaux-Arts, just at the
same time as Hodler received his invitation to be the guest of honor of the
Vienna Secessionists. A talisman of success, Vibert became one of Hodler's
closest friends, capping the friendship in 1918 when he created a portrait bust of
the dying painter (see fig. 10). Hodler, in turn, portrayed the sculptor nine
times.[19] The earliest and most significant of these, with an almost-square for-
mat, depicts Vibert life-sized, in a harsh frontal view. Signed and dated 1907,
this painting was the first of Frederic Bartlett's Hodler purchases in 1924.

Carl A. Loosli, the Swiss art historian who worked closely with Hodler and
compiled what is still the most extensive monograph on the painter, must have
been reflecting Hodler's own evaluation when he repeatedly identified the 1907
portrait of Vibert as "a classic, fundamental example of Hodler's perception of
portraits":

In his external appearance this old friend of Hodler had the build of an athlete, not
overly tall but broad. He had a sunny disposition, [was] kind as a child but also
quite intelligent with his wide, bright red beard and boyishly blue eyes. Hodler
captured all this with amazing certainty in this portrait, and in terms of his concepts
of art, he has gone as far here as is possible while retaining a sense of actual
physiognomy. Particularly characteristic of Vibert are his broad shoulders and his
expansive chest. Hodler accented them in the painting to such a degree that he came
within a hair's breadth of a caricature, but since he stayed within the norms of the
possible and imaginable, Hodler achieved an effect of power and conviction.[20]

As Loosli suggested, Hodler saw the portrait less as a study of physiological or
psychological uniqueness than as a means for representing universality within
individuality. "There is unity as well as diversity in a human existence," Hodler
wrote in one of his notebooks. "We differ one from the other, but we are like
each other even more. What unifies us is greater and more powerful than what
divides us."[21] While the Vibert portrait captures the sitter's likeness, the sense
that it represents a certain physiological type is overpowering. Hodler sought
to depict universal, idealized, and abstracted features or principles largely

through an iconic presentation. Bereft of any sense of movement and severely symmetrical, the painting is constructed so that a center line would run directly down the middle of Vibert's forehead, nose, mouth, and almost-rectangular beard. Indeed, if one were to fold the painting in half, Vibert's shoulders, jacket lapels, and sleeve seams would almost exactly cover one another. Hodler introduced slight variations and irregularities between minor details of the left and the right side: Vibert's part, the folds and pocket of the jacket, and the button line of the shirt front. These serve to enhance and enforce, rather than disrupt, the painting's overarching symmetry. In the colors, too, Hodler achieved a kind of symmetry, not only by repeating tones throughout both halves of the image equally, but also by utilizing the interaction of complementary colors, such as the yellow of the background and the violet of the jacket or the blue-white shirt front and the red-orange beard.

"Obviously, Hodler was very much concerned here with rigorously demonstrating the excellence of his principle of Parallelism," Loosli wrote. "Therefore, this portrait can be considered a prime example of the parallelistic effect." Hodler's theory of Parallelism, developed from the Menn-like principles of his "Ten Commandments" of the 1870s, was articulated by him in 1897 for the Société des Amis des Arts in Freiburg.[22] "I understand Parallelism to be every kind of repetition," he wrote:

Now, if in my mind I compare the dominant aspects of things that have made a strong impression on me, and whose general effect seemed most satisfying in terms of an imposing sense of unity, then every time I discover the identical principle of beauty existing: Parallelism. . . . Parallelism always results in a greater unity. . . . [Through its use] the work of art will reveal a newly perceived order in the world and will ennoble in the idea of unity emanating from it. . . . [The artist] shows us nature exalted, simplified, liberated of all detail . . . , the eternal element of nature . . . , her essential beauty.[23]

Parallelism signified more than a principle of harmony in art for Hodler: He contended that "Parallelism is a law that extends beyond art, since it governs life. . . . This law is the necessary premise of every event in nature, of every sensation, of every birth and death in every area of existence."[24] Through the

FIGURE 11 Albrecht Dürer (German, 1471–1528). *The Dürer plane*, 1525. Photo: Albrecht Dürer, *The Painter's Manual*, trans. Walter L. Strauss (New York, 1977), p. 390.

177

practice of his art, Hodler developed a personal metaphysics and science of nature, "a world law of universal validity" whose significance and truth it would be the task of twentieth-century philosophy and science to verify, according to Hodler. To Loosli, he passionately contended, "Parallelism is something so fundamental and significant that one simply can no longer ignore it. . . . I was the first to formulate [it] as a law and to apply it to art; that is why I am significant; that is why I am not only a painter among other painters, but an historic event!"[25]

Underlying this egomaniacal proclamation were, of course, the anxieties it was intended to cover. Parallelism structured with absolute certainty the artist's creations, granting them continuous and predictable artistic success while countering the validity of any criticism. The resulting "immortality" of art supplanted, in Hodler's mind, the tragedies of death and loss that characterized his youth, and it rejected as unenlightened those who would deny the quality of his paintings. Hodler's own mortality and fear of change thus emerge as his fundamental psychological justifications for his theory of Parallelism.

In making his first sketches of Vibert, to guarantee the veracity of his likeness, Hodler probably used a device called the *Dürerscheibe*, or Dürer plane (see fig. 11). The device was illustrated by the German Renaissance painter Albrecht Dürer in his 1528 study entitled *Four Books on Human Proportions*, which Menn had advised his students to use in their own work. A Dürer plane consists of a rectangular pane of glass mounted into a simple supporting frame, which is attached to a moveable arm that holds a card. In the center of the card is a small hole through which the painter may peer at his subject. The distance from the peephole and the model to the pane of glass determines the size of the image seen on the glass. Similar in its functions to the perspective frame Vincent van Gogh constructed,[26] the Dürer plane used by Hodler was a means of translating the three-dimensional world into the two-dimensional realm of painting.

Looking through his peephole onto the flat surface of the glass, Hodler quickly and accurately sketched onto the glass (where a grid of lines had been etched) a sitter's silhouette and major features. He then traced the image on the glass onto transparent paper. The traced drawing served Hodler as the source for a multitude of additional variations of the image prior to transferring it in its final resolution onto canvas.[27] In the Vibert portrait, Hodler used a finely woven, unprimed canvas which he had carefully inscribed with a rectangular grid, identifying the various interstices with numbers and letters to facilitate the transfer from drawing to painting. Onto this geometric substructure of the portrait image, Hodler brushed the form and major features of Vibert. The process was essentially one of moving from a methodically determined representation of reality to an evermore abstract and subjective one dependent on the artist's reworking of his drawings: a process, for Hodler, of decreasing dependence on external fact to a revelation of intra-artistic, universalized principles. As he worked further on such paintings, Hodler would often require the presence of the model again to test his art's ideal product against the limitations of material reality.

Around the brushed-in silhouette of Vibert, Hodler applied a coat of zinc white in the area of the canvas that would become the background. While still wet, the zinc white was covered by the flat but thickly painted background tone of chrome yellow. The sharply silhouetted head of the sculptor was rendered with a Pointillist-like brushstroke that breaks down the local colors of the face into fine, varied dots of nondescriptive color tones. Vibert's beard was created with yet again different patterns of brushstrokes and paint thicknesses: long,

undulating linear emulations of strands of hair. The jacket and shirt front areas represent still other methods of paint application. By altering textures and patterns of paint to correspond to the varying visual aspects of reality, Hodler simultaneously achieved two goals. Most obviously, the painted image reflects by various means the multiplicity of the external world. More significantly for Hodler, however, the altering textures and patterns serve to make a viewer highly aware of the painting as a constructed image, not simply an illusion. It was, in Hodler's own words, initially formulated in one of his "Ten Commandments," "seeing nature in terms of a flat surface."[28]

"Viewing nature in the relationship of her volumes to a flat surface"[29] became for Hodler a means of identifying the various aspects of nature in a unified context; as all elements shared in the process of translation into planar surfaces, the ultimate aim of Hodler's Parallelism, his "doctrine of the unities of existence," was made visible. The awkward combination of a mechanical search for objectivity and an effort to introduce subjectivity through the execution of repeated sketches—in Hodler's formulation a combination of "eye, reason, heart"—were the components of a constant practice verified in repetition. The portrait of Vibert, therefore, functioned far more as a demonstration for Hodler of the truth of his system of Parallelism than as an explanation of his sitter's psychology or physiological appearance. It reveals a system of thought and through it the person of the artist. Using mechanical drawing aids and geometric grids, he desperately sought systematic and inalterable certainty as the compensations of his ego ideal for the uncertainty and deprivations of his youth.

About the same time that the Art Institute's portrait of Vibert was executed, Hodler evolved, during summers spent in the Alps, a new vision of landscape. Foresaking the traditional subdivisions of foreground, middleground, and background, as other nineteenth-century artists (notably the Impressionists) had already done, he created flattened, unified scenes that isolated the peaks of the mountains against a broad expanse of sky. Following this compositional formulation during the summer of 1912, Hodler painted the Alpine mountain chain of the Grand Muveran, in which the form of the central peak is echoed repeatedly by lesser ones, a total of seven times as he saw it from the town of Chesières.[30] On the back of the stretcher of the painting now in the Art Institute (fig. 2) is inscribed the title: *Chain of the Grand Muveran, morning impression.*[31] The "morning impression" is apparent in the yellow sky with its slight tinge of pink, the entire effect recalling an intensely bright dawn. Hodler achieved this with a palette knife, rather than the brush he more commonly used. The remainder of the scene consists of variations on violet and yellow-ocher with touches of white (snow) and green. The orchestration of colors closely approximates that of the Vibert portrait with its contrasting yellows and violets, its tints of green, and its rose and yellow flesh tones.

The general composition, too, recalls the Vibert portrait. The peak of the mountain is set in the center of the canvas, rising slightly above the horizontal midline—as Vibert's head rises in the center of the painting from massive shoulders that slope to the very edges of the canvas—while the vertical midline passes through the slight indentation of the mountain peak. Like the face-to-face presentation of Vibert, the image of the Grand Muveran directly confronts the viewer, who is raised to the mountain's height and seems to gaze down onto the echoing forms of lesser peaks and valleys. Just as the profile of Vibert's hair shares its configuration with that of the shoulders, so the mountain's profile continues to find sympathetic reverberations in the lesser peaks to its left and right. To enhance the effect of form mirroring form, as well as to ensure the

Grand Muveran's dominance at the center of the composition, Hodler manipulated his image. Having painted his mountain's "portrait," he significantly shifted the profiles of the receding peaks to the left and right of the central peak. The lesser peaks have been lowered from a now-obliterated horizon line that was as much as half an inch higher than the one seen here. This results in the narrowing and raising of the Grand Muveran, making it less squat than it actually is and granting it a greater sense of isolation and lonely grandeur as it rules over the realm of mountains surrounding it.[32]

Through this alteration, Hodler created in the mountain the compositional echo of Vibert's portrait: in their formal outlines, mountain and sculptor were equated. Both the practice and metaphysics of Parallelism demanded such equations. As all objects and substances were unified in their parallelistic identities, they were submitted to ideal, inalterable laws of compositional and formal organization. In the linear rhythms that define the silhouettes of their forms, landscapes and portraits ceased to be distinguishable in any essential manner, except for the accidents of external appearance. Hodler's insistence on the essential unity of all of nature, whether it be a human being or a mountain, that manifested itself in a process of repetition is apparent when he speaks of the Parallelism he saw in a landscape:

An impression of melancholy grandeur . . . overcomes us when we find ourselves on a mountain top in the Alps. All the innumerable mountain peaks that surround us give rise to that feeling of attraction that results from the repetition of similar forms. . . . When I look up to the vast expanse of the cloudless sky, then this great

FIGURE 12 Caspar David Friedrich (German, 1774–1840). *Wanderer Over a Sea of Mists*, c. 1818. Oil on canvas; 74.8 × 94.8 cm. Hamburg, Kunsthalle. Photo: H. Börsch-Supan and K.W. Jähnig, *Caspar David Friedrich* (Munich, 1973), p. 349.

FIGURE 13 Caspar David Friedrich. *The Watzmann Mountain*, c. 1824/25. Oil on canvas; 133 × 170 cm. Berlin, National-galerie. Photo: W. Vaughan, H. Börsch-Supan, H.J. Neidhardt, *Caspar David Friedrich 1774–1840: Romantic Landscape Painting in Dresden* (London, 1972), p. 32.

undivided flatness, this great unity inspires a sense of wonder in me. . . . Every molecule of air is identical in appearance to the other, [they are] parallel, and the sum of these individual effects is determined by the great, clear overpowering unity.[33]

Hodler's recognition of a world unity in which a single principle underlies all existence, whether animate or inanimate, is closely linked to the panentheistic teachings of Romanticism. Hodler's emotional metaphysical recognition in the peaks of the Alps thus closely approximates the poetic outburst of the German Romantic painter Philipp Otto Runge:

When the sky above me teems with innumerable stars, when through the vastness of space the winds blow, and the wave breaks noisily in the immensity of night; when above the forest the ether blushes red and the sun illuminates the world; when the valley streams and I fling myself into the grass among glistening drops of dew; when every leaf and every blade of grass teems with life as the earth lives and moves beneath me and everything harmonizes in one great accord: then my soul rejoices and soars in the immeasurable space around me. There no longer is an above or a below, no beginning and no end.[34]

For Runge, as for other Romantics, nature was the source of emotive sensations and moods that mankind registered—"this feeling of the unity of the entire universe with us"[35]—and this emphasis on human perception caused Romantic painters to overtly or implicitly include human figures in their landscapes.

Caspar David Friedrich is perhaps the supreme example of this Romantic approach to landscape which called for "a representation of a certain mood of the emotions through a re-presentation of a corresponding mood in nature,"[36] a process that animated nature and demanded from the viewer of a landscape scene an empathetic response. Nature was the determinant; man responded, as

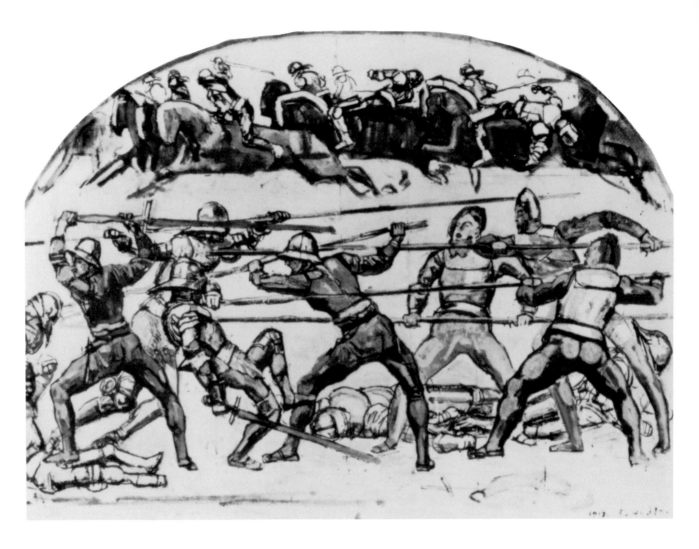

FIGURE 14 Ferdinand Hodler. *Study for "The Battle of Murten"* (detail), 1917. Oil on canvas; 88 × 120 cm. Glarus, Switzerland, Kunsthaus. Photo: *Ferdinand Hodler 1853–1918* (Paris, 1983), p. 248.

in Friedrich's *Wanderer Over a Sea of Mists* of about 1818 (fig. 12). For the Friedrich painting, accordingly, the illusions of transversible depth and the infinite expanse of an atmospheric sky were necessary to induce in a viewer the almost ethereal sense of nature's majesty, the reflection of God's glory. In this, the differences and distinctions between Hodler and the Romantics, despite all their similarities, become apparent.

While Hodler's *Grand Muveran* exhibits a compositional orientation not unlike some of Friedrich's landscapes of nearly a century earlier (see fig. 13), as both artists focused on the monumental peaks of mountain chains, the sense fundamental to Friedrich's pictorial conception of a landscape's vast expanse, which draws the viewer into it to experience vicariously an empathetic recognition of the landscape's mood, is lacking totally in Hodler. Instead, as in the portrait of Vibert, the materiality of paint, mountain, and sky proffers itself as ultimate reality fixed in the Parallelist system. Just as the iconic composition of the portrait prevents any access to the viewer and denies surrounding space, so, too, the images of Alpine peaks symmetrically arranged and extending from edge to edge of the canvas share a physical presence with sky rather than being surrounded by traversable space or penetrable atmosphere. With air, rock, and plant equally dense in their matter, Hodler's landscape becomes inaccessible to human life. They form a constructed grand unity, totally removed, everlastingly silent, inalterable, and eternal in their grandeur. Hodler did not depict, as Friedrich did, the emotional impact of nature on him; instead, he

182

depicted his own intellectual impact on nature: the imposition onto landscape of his own iron will. With principles he himself formulated, he transformed nature into the abstract and ideally structured world of his ego ideal—a willful, majestic, and monumental self-absorbed existence. Hodler's vision, not nature, was supreme.

Hodler's concern for one form echoing another and for the total unity of a composition achieved through parallel constructions lent itself particularly well to imposing monumental, multifigured scenes. Such allegorical and history paintings were the basis of his critical reputation, particularly after the 1904 Viennese Secession exhibition, which was devoted to such works. Repeatedly, Hodler was called upon to provide mural paintings for large museum halls, for university ceremonial halls, and for meeting rooms in city halls in Switzerland and Germany. The last of these was initiated in 1910, when he was commissioned to paint the companion image to his earlier, controversial murals in the Weapons Hall of the Zurich Landesmuseum. For the desired scene, Hodler selected a battle that took place on June 22, 1476, near the town of Murten (or Morat, the town's French name) during the 1474–76 war of the Swiss Confederation against Burgundy's Charles the Bold.[37] Hodler submitted the first of his sketches for this fresco in 1915 and completed two compositional cartoons in 1917. The images are divided vertically into two areas: the lower portion depicts foot soldiers, with spears, advancing from right to left as they push the defeated Burgundians toward Lake Murten: and, in the arch-shape of the upper half of the mural, the Burgundian cavalry retreats after being routed by the Bernese citizen soldiery (see figs. 14, 15). The foreground line of lances and the arching shapes of horses and riders in the background became the organizational elements around which the composition evolved. The oil sketch now in the Art Institute's Birch Bartlett Collection (fig. 3) is a study for one of the soldiers in the arched portion of the mural.

In the midst of World War I, despite Swiss neutrality, Hodler recognized the

FIGURE 15 Félix Vibert, Georges Navazza, and Ferdinand Hodler in front of incomplete cartoon for *The Battle of Murten*, summer 1916. Photo: courtesy Sharon L. Hirsh.

kinship of his own theme with the slaughter then being carried out on European battlefields. He told Loosli:

I analyzed that state of fury and brutal bestiality endlessly and without respite, until I reached a point of being similarly enraged myself! All this poisonous, ruthless rage had to find expression at least in one of the soldier figures. But I could find neither the soldier nor his pose, and felt that if I did not succeed in finding them the entire painting would fail. Then one night I dreamed that I saw our friend Félix confront a violent street demonstration. He was in the dress of a fifteenth-century warrior and armed with a long spear. First with an extraordinarily powerful voice he ordered the approaching mob to disband in peace, but then he was attacked, and I saw how he lowered his spear, prepared for the thrust, and then crashed into the nearest attacker with beastly power. I saw it all as clearly as if I had been awake: how his face turned red, became horribly distorted; I heard him scream like a wounded steer, saw the spearpoint as it bored into the very center of his attacker's face, and even heard the bones of his skull crunch and break, watched as a mighty stream of blood spouted forth to run along the entire length of the spear. Then I woke up.

The image of the dream was still so powerful and alive in me, that I turned on the light immediately and was able to sketch the scene as if the figures actually stood in front of me. Now I had what I wanted; this was what I had been looking for.[38]

Again, Hodler imposed his own sense of structure onto the model he found. "Friend Félix" was Félix Vibert, brother of the sculptor Hodler portrayed in 1907 and, like him, of a powerful and athletic build (see fig. 15). Unlike Hodler's representation of him, however, Félix Vibert was inclined neither toward rage nor violence; as he sat for Hodler, he was transformed into the terrorized, and terrorizing, personification of warfare.[39] As was his practice, Hodler again made repeated sketches of the enraged soldier in pencil and pastels before turning to oils for yet further studies of the head. The Art Institute painting fits into this series of oil sketches; drawn first with absolute surety onto the canvas in pencil, it also functioned as a completed work in itself as it displays the broad brushwork of Hodler's last years and his concern then with rendering volume in terms of broad planes of color.

Stylistically, by the time of this painting, Hodler had undergone yet another shift in his work. Having moved earlier from veristic Naturalism to Symbolism, he now made use of intense color and heavy brushstrokes such as might be related to Expressionism, the art movement based in Germany and Austria from about 1905 to 1920 and tracing its lineage to Vincent van Gogh and Edvard Munch. Hodler never attached himself to any of the Expressionist groups of artists, but his numerous exhibitions in Germany and Austria, as well as in Switzerland, contributed to the formation of an Expressionist aesthetic that emphasized the direct interaction of the painter with his motif and the rendering of this subjective interrelationship in the construction of the painted image. Hodler's seemingly mechanistic process of using the *Dürerscheibe* and almost pathologically repeating an image in innumerable pencil, watercolor, and oil studies was also a means of absorbing the subject into Hodler's own person, making an almost unconscious and thus intuitive presentation of it possible. Repetition brought control, but also, ironically, it made greater improvisation in color and brushwork possible. "Everything before this was only a beginning and experiment," Hodler told a critic in 1917. "Now I know what matters: more than ever, the color not only accompanies the form, but rather the form lives and moves through color."[40] In the head of the soldier from Murten, color becomes dominant and subordinates all else to itself to achieve the anxiety-ridden image, as in neither of the other two Hodler paintings in the Art In-

stitute. Set off against a white background, the soldier's head stands out forcefully, defined in primary red and yellow, browns, flesh tones, greens, and blues brushed on with a sensuous bravura similarly absent from the others. All the colors are static as they merge into the expansive form of the warrior whose vehement violence Hodler captured. In this way, the small study condenses the entire content of the Battle of Murten mural project, Hodler's last public commission.

The Battle of Murten murals were never completed, and the head of Félix Vibert, in a sense, forms a concentrated substitute for Hodler's final vision. In his sixties, Hodler continued in his experimentation to express self-doubt, and in carrying out the experiment in style continued to seek the fixity of his ego ideal. Repeated illness weakened him physically and the death Hodler had attempted to elude through his art could no longer be avoided, even though he painted almost to the very hour of dying, creating self-portraits and rendering the landscape seen through the window of his deathroom. In death, Hodler's striving for stability and impermeability found its conclusion. "If you accept death," Hodler observed resignedly, but also with a sense of triumph as he now found in death a new tool for his art, "into your consciousness, into your will, then great works will result! And there is only this one life in which to achieve something. This orders our entire life, . . . grants it an entirely different rhythm! To know this transforms the thought of death into a totally new power."[41] Soon after his death, obituaries, reminiscences, biographies, and exhibitions proliferated in Europe, granting Hodler the parallelistic postmortal construction of immortality he had shaped himself. In the immortality of his fame, his ego ideal received its final manifestation, concretized in the United States in three paintings that together synthesize Hodler's strivings toward an immutable ideal.

NOTES

I am deeply indebted to Professor Sharon L. Hirsh of Dickinson College for sharing her extensive knowledge of Ferdinand Hodler and his work.

1. The first Hodler exhibition in the United States took place in 1972 at the University Art Museum, The University of California, Berkeley.

2. Hodler's critical reception was reviewed by Jura Brüschweiler, *Ferdinand Hodler im Spiegel der zeitgenössischen Kritik* (Lausanne, 1970). A bibliography of Hodler publications is included in Carl Albert Loosli, *Ferdinand Hodler: Leben, Werk, und Nachlass* (Bern, 1921–24), vol. 4, pp. 347–80.

3. Unless otherwise indicated, all biographical information is derived from Sharon L. Hirsh, *Ferdinand Hodler* (New York, 1982); and Jura Brüschweiler, "Ferdinand Hodler (Bern 1853–Genf 1918), Chronologische Uebersicht: Biografie, Werk, Rezensionen," in Berlin, Nationalgalerie, *Ferdinand Hodler*, exh. cat. (Berlin, 1983), pp. 43–169.

4. Hodler, as quoted by Hans Mühlestein and Georg Schmidt, *Ferdinand Hodler, 1853–1918, Sein Leben und sein Werk* (Zurich, 1942), p. 5.

5. Hodler's "ego ideal" and its role in his creative process were discussed by Hartmut Kraft in "Objektverlust und Kreativität—eine Darstellung anhand Ferdinand Hodlers Werkzyklus über Valentine Godé-Darel," in Hartmut Kraft, comp., *Psychoanalyse, Kunst und Kreativität heute: Die Entwicklung der analytischen Kunstpsychologie seit Freud* (Cologne, 1984), pp. 306–23.

6. Loosli (note 3), vol. 1, pp. 227–28. The manuscript of these "Ten Commandments" is lost; Loosli indicated that he copied from the manuscript Hodler showed him and also

took down Hodler's recitation of the text. In an intriguing example of art-historical invention, Brüschweiler (note 3), p. 49, transformed Hodler's "joking identification" of ten commandments into a manuscript that he "entitled in all seriousness 'The Ten Commandments of the Painter Ferdinand Hodler.'"

7. Loosli (note 2), vol. 1, pp. 227–28.

8. G. F. [Georges Favon], in *Journal de Genève*, Apr. 12, 1876, as cited by Brüschweiler (note 2), p. 20.

9. B. in *Petit Genevois*, Apr. 15, 1876, as cited in Brüschweiler (note 2), p. 21.

10. A. V. in *Le Genevois*, Dec. 15, 1885, as cited by Brüschweiler (note 2), p. 30.

11. "Mysti . . ." [Louis Montchal], "Phantasie über ein Gemälde von Ferdinand Hodler," *La Revue de Genève* (Sept. 25, 1885), as cited by Brüschweiler (note 2), p. 34.

12. Extensive and insightful discussion of Hodler and Symbolism is provided by Sharon L. Hirsh, *Ferdinand Hodler's Symbolist Themes* (Ann Arbor, Mich., 1983).

13. Hirsh (note 3), p. 74.

14. Ferdinand Hodler, in a letter to Louis Duchosal, Apr. 15, 1891, in Arnold Kohler, "Hodler parle: Lettres à Louis Duchosal," *Club des Arts-Musées Suisses* 1, 9 (May 1953), p. 6.

15. Heinrich Angst, in *Neue Zürcher Zeitung*, Feb. 24, 1897, as cited by Brüschweiler (note 2), p. 66.

16. Franz Servaes, "Secession (Der Monumentalmaler Ferdinand Hodler)," *Neue Freie Presse*, no. 14152 (Jan. 19, 1904), as cited by Loosli (note 2), vol. 1, pp. 237–43.

17. The collection was catalogued by Johannes Widmer, *Les Hodler de la Collection Russ-Young à Serrières-Neuchâtel* (Geneva, 1923). For information concerning Willy Russ, see Jura Brüschweiler, *Ferdinand Hodler porträtiert General Wille* (Zurich, 1975), pp. 9–11. It is likely that Russ began selling portions of his collection once the catalogue had been published, although it is currently not known if the gallery of T. Fischer, where Bartlett purchased the three Art Institute paintings, also had available other works from the Russ Collection. Russ sold some sixty paintings in 1939 to the city of Geneva for its museum, then donated the remainder of his collection to the Neuchâtel museum.

18. The gallery was located at Heldenstrasse 17 in Lucerne. Bartlett purchased the portrait of Vibert and the study for the soldier's head in July; the landscape painting was purchased from a Chicago dealer, George F. Porter, in November of the same year.

19. Loosli (note 2), vol. 4, pp. 140–41, nos. 2136-44.

20. Ibid., vol. 2, pp. 71–72.

21. Hodler, as cited by Hirsh (note 3), p. 21.

22. Loosli (note 2), vol. 4, pp. 249–306, published the French-language manuscript of the lecture. Later variations of the section on Parallelism appear in vol. 1, pp. 76–81.

23. Ibid., vol. 4, pp. 249–50.

24. Ibid., p. 306.

25. Ibid., p. 249.

26. Van Gogh explained his perspective frame in a letter to his brother Theo, dated around August 5 or 6, 1882; see Vincent van Gogh, *The Complete Letters of Vincent Van Gogh*, 3 vols. (Greenwich, Conn., 1958), vol. 1, no. 223.

27. Judging from Hodler's manner of working, sketches for the Vibert portrait must exist, but they have not yet been located. The process of creating a portrait was discussed by Brüschweiler (note 2), pp. 405–10.

28. Loosli (note 2), vol. 1, p. 227.

29. Ibid., vol. 4, p. 306.

30. Ibid., p. 88.

31. In its entirety, the inscription reads: "*Châne du Grand Muveran/u.d. Vaud/ Suisse/effet du* [sic] *Matin.*" Tempting as it is to believe the inscription on the frame to be Hodler's own, it is unlikely since the location of the Grand Muveran is not in the province of Vaud, as the inscription states, but in Valais. However, the identity as "effet de matin" or "Morgenstimmung" is one already recorded by Loosli ([note 2], vol. 4, p. 88, no. 867) and likely to be Hodler's own.

32. The on-canvas alterations of the painting suggest that Hodler did not filter the Alpine scene through his process of multiple sketches and studies, as he did his portraits, but rather painted either directly from the scene or from a preliminary sketch. However, the Art Institute painting does appear much like a refinement of an almost identical composition in a private collection in Zurich.

33. Loosli (note 2), vol. 1, p. 77.

34. Philipp Otto Runge, *Hinterlassene Schriften* (Hamburg, 1840), vol. 1, p. 9.

35. Ibid., p. 11.

36. Carl Gustav Carus, *Neun Briefe über Landschaftsmalerei* (Leipzig, 1835), pp. 41–43.

37. When, during the summer of 1476, Charles besieged the town of Murten while marching towards Bern and Lausanne, his force of 25,000 soldiers was met by Bernese and allied Confederation troops, who gained victory after annihilating over one-third of the Burgundian troops.

38. Loosli (note 2), vol. 3, pp. 178–79.

39. According to Loosli (ibid.), Félix Vibert was an extraordinarily kind and gentle man. By profession, he was the police commissioner of Geneva.

40. Ferdinand Hodler to Johannes Widmer (Oct. 1917), as cited by Brüschweiler, *Ferdinand Hodler: Selbstbildnisse als Selbstbiographie*, exh. cat., Kunstmuseum Basel (Basel, 1979), p. 158.

41. Mühlestein and Schmidt (note 4), p. 521.

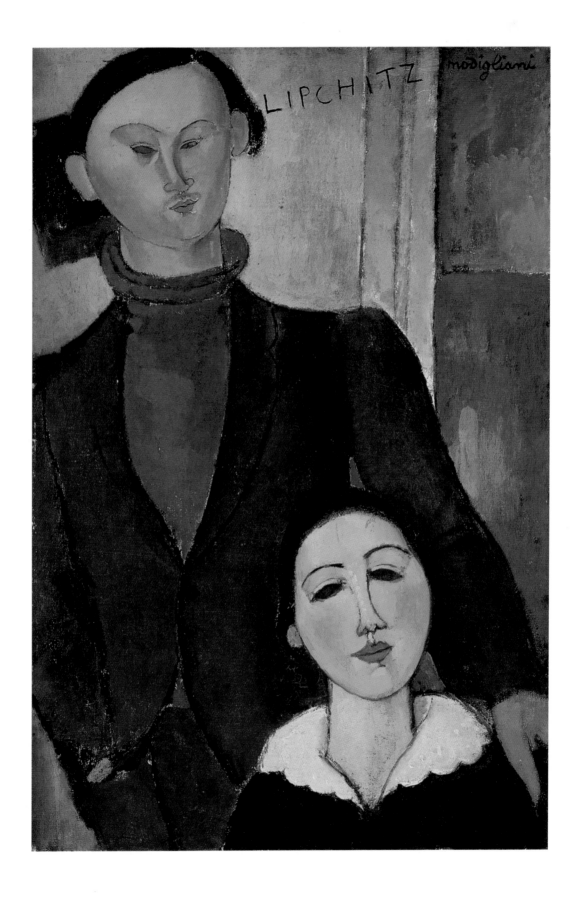

A Study in Irony: Modigliani's *Jacques and Berthe Lipchitz*

NEAL BENEZRA, *Associate Curator,*
Twentieth-Century Painting and Sculpture

In 1916, having just signed a contract with Léonce Rosenberg, the dealer, I had a little money. I was also newly married, and my wife and I decided to ask Modigliani to make our portrait. "My price is ten francs a sitting and a little alcohol" he replied when I asked him to do it.

JACQUES LIPCHITZ[1]

THE SCULPTOR Jacques Lipchitz's words describe the genesis of Amedeo Modigliani's 1916 portrait *Jacques and Berthe Lipchitz* (fig. 1), a painting acquired by Frederic Clay and Helen Birch Bartlett in 1922 and given to The Art Institute of Chicago four years later. Beyond offering the circumstances of the painting's commission, Lipchitz's words allude to the differing paths that each artist's life had taken after each had immigrated to Paris: Lipchitz, a model of artistic industry and traditional values, and Modigliani, the stereotypical *peintre maudit* (damned painter), tragically doomed by his own vices. One of only two double portraits ever painted by Modigliani, *Jacques and Berthe Lipchitz* is both a complex and fascinating work and an ironic commentary on the personal lives and professional careers of these two immigrant artists.

In the wedding portrait, the Lithuanian-born sculptor and his recent bride, a Russian poet named Berthe Kitrosser, are portrayed in their flat at 54 rue du Montparnasse, the former residence of the artist Constantin Brancusi. Set against Modigliani's characteristic backdrop of interior architectural forms are two distinctly different individuals. Smartly attired, Lipchitz stands casually, one hand at his wife's shoulder, the other thrust into his pants pocket. If the sculptor's pose is comfortable, the expression Modigliani assigned to Lipchitz is proud, even haughty. Indeed, Modigliani's portrait virtually assaults Lipchitz: the large ears, small pursed lips, narrow squinting eyes, and, in particular, the wickedly twisted nose, all combine to aggressively caricature the sculptor.

The unflattering nature of this image is particularly evident when compared with Modigliani's portrayal of Berthe Kitrosser. Hers is obviously the more endearing likeness, as the gentle, eloquent lines of her face emerge gracefully from her husband's coat. In contrast to the eccentric delineation of Lipchitz's face, Madame Lipchitz is characterized by a harmonious weave of contrasting curves, one echoing and balancing another. In her large downturned eyes, elegantly elongated nose, large fleshy lips, and long graceful neck, she radiates a sensuality that is absent from Modigliani's image of her husband.

Perhaps because Modigliani produced only two portraits of couples—the other is *Bride and Groom* of 1915/16 (fig. 2), which, ironically, Frederic Clay Bartlett also owned and gave to The Museum of Modern Art in 1942—the contrast between his depiction and characterization of men and women is seldom so obvious as it

FIGURE 1 Amedeo Modigliani (Italian, 1884–1920). *Jacques and Berthe Lipchitz*, 1916. Oil on canvas; 80.7 × 54 cm. The Art Institute of Chicago, Helen Birch Bartlett Memorial Collection (1926.221).

Below
FIGURE 2 Amedeo Modigliani. *Bride and Groom*, 1915/16.
Oil on canvas; 55.2 × 46.2 cm. New York, The Museum of
Modern Art, gift of Frederick Clay Bartlett.

Right
FIGURE 3 Amedeo Modigliani. *Anna Zborowska*, 1917.
Oil on canvas; 130 × 81 cm. New York, The Museum of
Modern Art, Lillie P. Bliss Collection.

Facing page, left
FIGURE 4 Amedeo Modigliani. *Juan Gris*, 1915. Oil on
canvas; 55.5 × 38 cm. New York, The Metropolitan Mu-
seum of Art, bequest of Miss Adelaide Milton deGroot.

Facing page, right
FIGURE 5 Amedeo Modigliani. *Paul Guillaume*, 1916. Oil on
canvas; 81 × 54 cm. Milan, Galleria Civica d'Arte
Contemporanea.

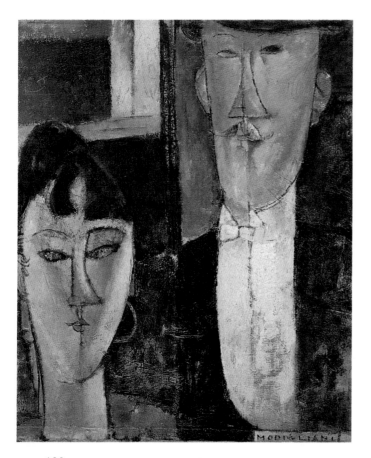

is in the Chicago canvas. Modigliani had a well-known
preference for nude women as subjects, and his images
of anonymous, reclining women are overtly sensual.
While his portraits of specific women, such as those of
Anna Zborowska (fig. 3), or Lunia Czechowska, are less
sexual, they never fail to flatter. In contrast, Modigliani's
portraits of men are generally more critical characteriza-
tions, and many, like the image of Lipchitz, approach
satire. His rather disparaging depiction of Juan Gris (fig.
4), for example, typifies this attitude, and each of his
three portraits of the dealer Paul Guillaume, who han-
dled his work in 1915–16, is replete with cynicism (see
fig. 5). The brilliance of Modigliani's portrait style re-
sides in his ability to depict men and women—person-
ally or impersonally, decorously or indecorously—
while working within a narrowly defined vocabulary of
painted forms. In the case of the Lipchitz portrait, it is
ultimately Modigliani's unflattering depiction of the
sculptor that both intrigues us and holds the meaning of

the painting. Moreover, the disagreeable nature of the likeness eventually contributed to its purchase by the Bartletts in 1922, only six years after the painting had been completed.

According to Lipchitz, Modigliani initially spent only two days working on the portrait, one devoted to preparatory studies on paper, the other to the actual painting:

He came the next day and made perhaps twenty preparatory drawings very quickly, beginning with the eyes and then continuing without any hesitation. I had a photograph made by a well-known photographer which I intended to send to my parents, so he used the pose of this. The next day he came with an old canvas and began to paint at one o'clock. From time to time he would take a drink and stand back and look at it; then around five o'clock he said that it was ready.[2]

Although Lipchitz recalled around twenty preliminary drawings, only nine have been documented.[3] Most of these depict the sitters separately (see figs. 6–8), as Modigliani sought to familiarize himself with his subjects individually prior to establishing a relationship between them. There is little to distinguish Berthe's countenance in the drawings from that of the painting; in all of them, she is seated and, by virtue of her facial expression and the various gestures of her hands, she is a model of warmth and domesticity. In contrast, Lipchitz apparently presented greater difficulties for Modigliani. He is seen both sitting and standing; on occasion, he reclines in a chair; in one instance, he sits formally, hands clasped before him. There are anatomical and expressive changes as well: At times, Modigliani emphasized the barrel-chested, broad-shouldered aspect of the sculptor; in other sketches, he appears rather slight of build. The lone study of both figures is the final one (fig. 9), in which Modigliani established the position of his subjects and their relation to one another. Here, the sculptor

191

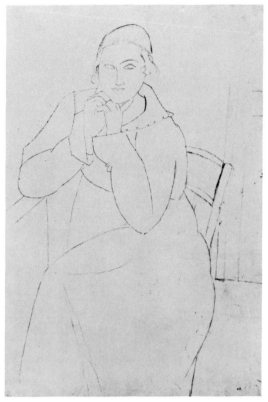

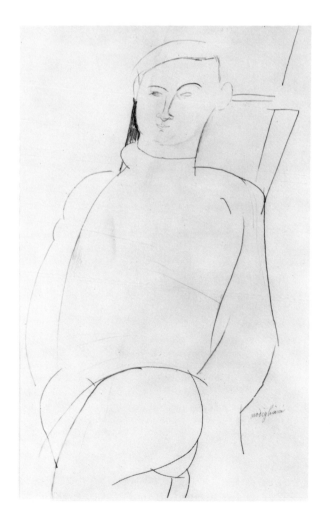

Left
FIGURE 6 Amedeo Modigliani. *Portrait of Berthe Lipchitz*, 1916. Pencil on paper; 54.6 × 38.1 cm. New York, collection of Yulla Lipchitz. Photo: *Modigliani: Paintings and Drawings* (Los Angeles, 1961), p. 67.

Bottom left
FIGURE 7 Amedeo Modigliani. *Portrait of Jacques Lipchitz*, 1916. Pencil on paper; 43.2 × 26.7 cm. New York, collection of Lolya Lipchitz. Photo: *Modigliani: Paintings and Drawings* (Los Angeles, 1961), p. 67.

Below
FIGURE 8 Amedeo Modigliani. *Portrait of Jacques Lipchitz*, 1916. Pencil on paper; 49.5 × 31.8 cm. London, Marlborough Fine Arts, Ltd.

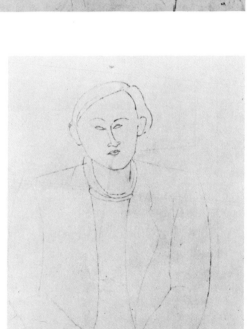

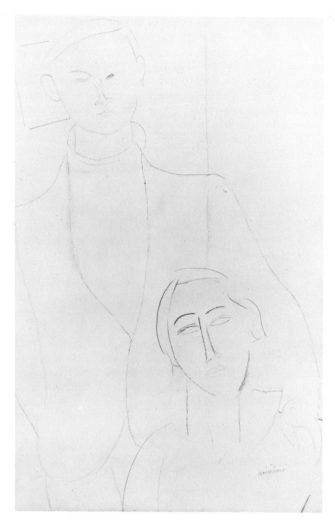

FIGURE 9 Amedeo Modigliani. *Portrait of Berthe and Jacques Lipchitz*, 1916. Pencil on paper; 48 × 31.5 cm. France, Public Collections, Masurel donation. Photo: Georges Routhier, Studio Lourmel, Paris.

terization is explained by Lipchitz's desire to send the finished work to his parents in Lithuania, whom he had not seen since he had left his native country for Paris four years before.

Born in Druskieniki, Lithuania, in 1891, Lipchitz attended school in Bialystok and Vilna, where he was fascinated by the plaster casts from which he learned to draw.[4] He developed an interest in sculpture at a very early age, despite being encouraged to study engineering

FIGURE 10 Anonymous. Wedding photograph of Jacques and Berthe Lipchitz, 1916. Photo: I. Patai, *Encounter: The Life of Jacques Lipchitz* (New York, 1961), fig. 5.

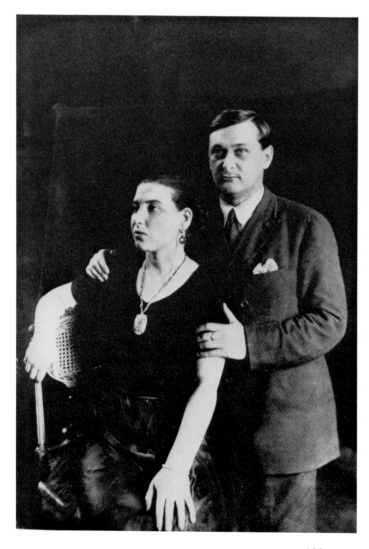

stands in front and just to the left of a doorway and his wife is wedged comfortably beneath his shoulder, directly in line with the doorjamb behind them.

As Lipchitz noted, the pose of this final study and that of the resulting painting was derived, albeit in reverse, from that of a portrait photograph he had commissioned (fig. 10). As a result, in comparison with many of Modigliani's other portraits, the final study and the painting itself speak with a certain formality, as the sitters appear psychologically detached from one another. The decorous and even somewhat awkward charac-

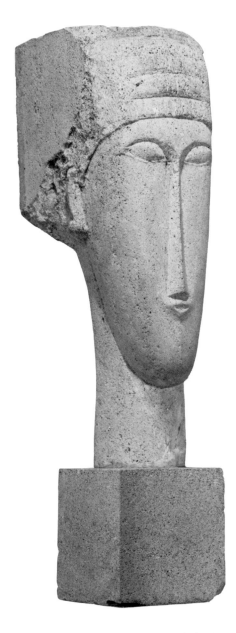

FIGURE 11 Amedeo Modigliani. *Head*, 1911/13. Stone; h. 64 cm. New York, The Solomon R. Guggenheim Museum. Photo: Robert E. Mates.

and architecture by his father, a successful building contractor. Lipchitz benefitted from a supportive mother, whose financial assistance enabled him to study sculpture in Paris against his father's will. Upon his arrival in 1909, Lipchitz entered the Ecole des Beaux-Arts and then the Académie Julian, where he attended courses in drawing, anatomy, and art history, as well as in sculpture. In 1911, Lipchitz learned that his parents were experiencing financial difficulties and he returned to Druskieniki for several months. Returning to Paris the following year, Lipchitz knew he had to support himself largely through the sale of his work. He did this initially by executing commissioned portraits. By 1916, when he joined Picasso among the stable of dealer Léonce Rosenberg, he was in a position to commission from Modigliani the portrait of himself and his wife. He apparently intended to send it to his parents as a proud indication of his success.

Modigliani's background was remarkably similar to that of Lipchitz. Born in Livorno, Italy, in 1884, Modigliani came from an eccentric Jewish family involved for generations in a variety of commercial ventures.[5] In his youth, Modigliani was particularly devoted to his mother, an energetic and talented woman who dominated the family while working as a translator and as the director of a school for privileged children. Like Lipchitz's mother, she encouraged Modigliani's interest in art, and with her financial and psychological backing he attended in 1902–03, albeit sporadically, the academies in Florence and Venice, where he studied painting. She also facilitated his move to Paris in 1906.

It is not surprising, then, that the two artists had developed a close friendship by the time Lipchitz engaged Modigliani to paint the Art Institute portrait. Although they were introduced by the poet Max Jacob as early as 1912, their contact was minimal at that time, as Lipchitz spent nearly two years traveling in Mallorca and Spain with the Mexican painter Diego Rivera. When they resumed their acquaintance in 1915 in Paris, Modigliani held Lipchitz to an earlier promise to introduce him to the inhabitants of "La Ruche," a building south of Montmartre that housed numerous Jewish artists of Slavic descent, among them Marc Chagall, Moise Kisling, Ossip Zadkine, and Chaim Soutine, who later would become Modigliani's devoted protégé.

Between the time of his arrival in Paris in 1906 and his execution of the Lipchitz double portrait of 1916, Modigliani had evolved a unique and highly expressive method of depicting the human form. During his first years in Paris, Modigliani tried his hand at a variety of portrait styles. Ranging from watercolors executed in a manner owing to Toulouse-Lautrec to fashionable likenesses that resemble the work of John Singer Sargent,

these portraits hardly resemble the products of Modigliani's mature style, which he arrived at through his work as a sculptor.

Around 1910, Modigliani had moved to a first-floor studio in the Cité Falguière, next door to the Romanian sculptor Constantin Brancusi. Although his only practical experience with sculpture had occurred in 1902, during a visit to the quarries at Pietrasanta and Carrara, Modigliani learned to carve in Paris under Brancusi's influence. Like Brancusi, Modigliani rejected the prac-

FIGURE 13 Amedeo Modigliani. *Portrait of Diego Rivera*, c. 1914. Pen and ink on paper; 26 × 20.3 cm. The Art Institute of Chicago, gift of Mr. and Mrs. Wesley M. Dixon, Jr. (1967.35)

FIGURE 12 Amedeo Modigliani. *Caryatid*, 1913. Watercolor over pencil on paper; 53.5 × 41 cm. The Art Institute of Chicago, gift of Amy McCormick (1942.462).

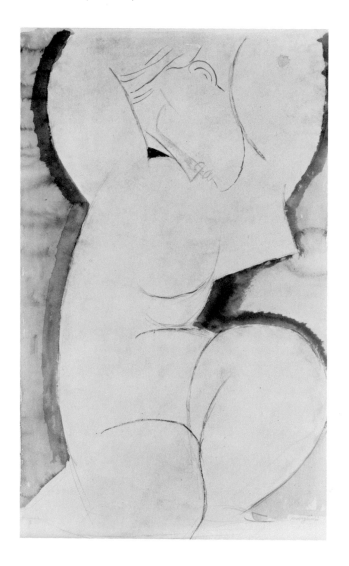

tice of modeling, preferring to carve directly in stone. Some twenty-five sculptures—mostly limestone heads characterized by simplified forms and smooth, elegant surfaces—survive from the pre-World War I period (see fig. 11). They readily betray the impact of Brancusi's example, as well as that of the Italian and non-Western sculpture Modigliani loved. Although they were only casual friends at this time, Lipchitz knew Modigliani's sculpture and often visited his studio. In contrast to Lipchitz, who had an abiding admiration for classical sculpture and for Auguste Rodin, Modigliani believed Rodin's method of modeling to be outmoded. He preferred instead the primitive directness and elegant yet expressive linearity he could achieve through carving.[6]

While Modigliani generally eschewed classicism, there is one group of very noteworthy exceptions: his 1913 sketches of caryatids. These are remarkable pencil and watercolor studies in which the artist transformed the sturdy, load-bearing maidens of Greek architecture into

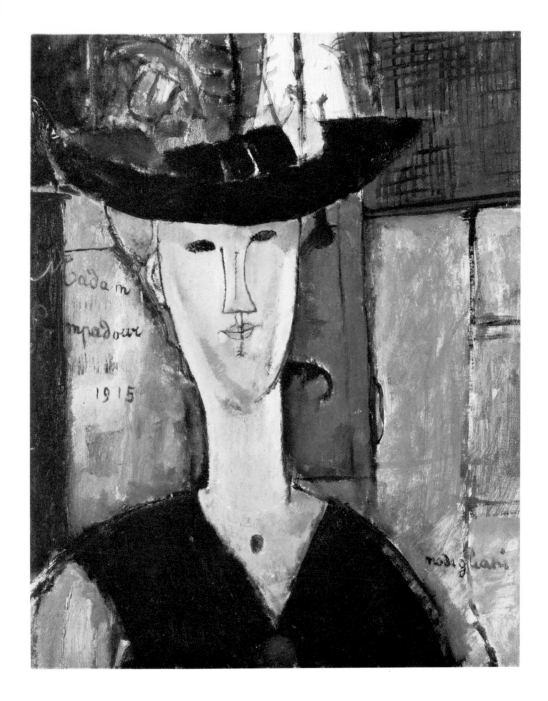

FIGURE 14 Amedeo Modigliani. *Beatrice Hastings as Madam Pompadour*, 1915. Oil on canvas; 61.1 × 50.2 cm. The Art Institute of Chicago, Joseph Winterbotham Collection (1938.217).

sinuously curved and quite seductive nudes (see fig. 12). These works were of essential importance for Modigliani, since they translated the curvilinear manner of his sculpture into drawings and ultimately led to the paintings that characterize his later career. The transition was fortuitous, for while Modigliani matured first as a sculptor, achieving a vocabulary of carved forms of lyrical beauty, he was a draftsman by temperament, attuned to the life of the café and lacking the sustained discipline required of a sculptor.

Yet the shift from sculpture back to drawing and painting was neither as immediate nor as smooth as the quality of the caryatid drawings might indicate. As his drawing of 1914 for a portrait of Diego Rivera (fig. 13) demonstrates, Modigliani was familiar with and learned from the innovations of the Cubists. In the drawing of Rivera, Modigliani delineated the Mexican painter with a variety of lines. As was then his habit, Modigliani began slowly, with a tentative and rather thoughtful pattern of dots and dashes that gives form to Rivera's eyes, nose,

and mouth. As the drawing progressed, these dots evolved into longer, more rapidly executed lines in the area of the torso, shoulders, and the outline of the head. Influenced by the then-widespread use of typography by the Cubists and Futurists, Modigliani integrated Rivera's name, as well as his own signature, into the overall linear pattern.

The artist's debt to Picasso is not only apparent in his use of typography, but also in his activation of the space around his figures, such as in *Beatrice Hastings as Madam Pompadour* (fig. 14) of 1915, which is also in the collection of the Art Institute. Hastings, an English critic with whom Modigliani had a sustained affair and whom he painted on thirteen other occasions, is depicted with the elongated face and neck of his earlier sculpture. Here, however, Modigliani sought to balance the facial type he had established in stone with the structuring precepts of Cubism. While the face is boldly realized, the rest of the figure and the ground merge, especially in the treatment of the hat, and the architectural elements of the background serve to structure the surrounding space.

Modigliani always worked indoors, and his tendency to manipulate architectural lines in the positioning of his figures was particularly strong in *Bride and Groom* (fig. 2). Here, the two figures and the studio architecture are locked into a controlled compositional grid. Dramatically cropped by the frame, Modigliani's subjects are rendered expressionless by the discipline of their depiction. This is the artist's most rigorously formal painting and yet, by the time of the Lipchitz portrait less than a year later, Modigliani had abandoned the monochromatic tones and structural concerns of the Cubists, returning instead to his earlier explorations of the expressive possibilities of the figure. Ultimately, therefore, Modigliani's great quality as a painter of the human figure derived not from his brief flirtation with Cubism. Rather, it was his relationship to Brancusi and the experience of carving in stone that provided him with a rigorously circumscribed vocabulary of forms. When he again began to paint, Modigliani was able to transform what was, in the 1910s, an essentially conservative, realist portrait manner into a vehicle for potent psychological interpretation.

In many ways, therefore, Modigliani was a perfectly logical choice to paint the Lipchitz wedding portrait. Beyond the friendship between the two artists, and the fact that both were immigrants and Jews, Modigliani had achieved an effective figurative style that, although stylized, still synthesized elements of Cubism without sacrificing either realism or expression.

Although by 1916 Modigliani had attracted a devoted dealer in the person of Leopold Zborowski, he was nevertheless on the verge of indigence. No market would develop for his work until after his death in 1920 at the age of thirty-six. In 1917, Zborowski organized an exhibit at the respected Berthe Weill Gallery; yet, when Modigliani's nudes were shown in the gallery's storefront window, the police closed the exhibition because of the alleged "pornographic" nature of the paintings. The artist's private life was equally unsettled: his relationship with Beatrice Hastings was characterized by violent interludes and their mutual penchant for hashish and alcohol sapped Modigliani's energy as well as his meager finances. Modigliani met Jeanne Hebuterne in 1917 and fathered a son with her the following year, but his erratic behavior continued until his death. Anecdotes such as the following one, an account by Lipchitz of being awakened by Modigliani in the middle of the night, were all too common:

It was Modigliani, obviously quite drunk. In a shaky voice he tried to tell me he remembered seeing on my shelf a volume of poetry by François Villon and he said he would like to have it. . . . This scene is still vivid in my mind: the small room, the darkness of the middle of the night interrupted only by the flickering, mysterious light of the kerosene lamp, Modigliani, drunk, sitting like a phantom in the armchair, completely undisturbed, reciting Villon, his voice growing louder and louder. . . .[7]

Lipchitz was keenly aware of Modigliani's unfortunate circumstances and was extremely sympathetic:

Many artists at this period . . . tried to help others who were in real need. . . . With Modigliani you could never give him anything directly, since he was too proud and would not have tolerated it; so I would invite him to have lunch with me at some restaurant where I had a credit and this he would accept.[8]

Lipchitz's subtle patronage of Modigliani accounts for the circumstances of the wedding portrait. As noted earlier, Lipchitz agreed to Modigliani's fee of ten francs per sitting with the assumption that the portrait would require a number of sessions. He was subsequently bewildered when the painter completed the portrait in one afternoon:

I felt some scruples at having the painting at the modest price of ten francs; it had not occurred to me that he could do two portraits on one canvas in a single session. So I asked him if he could not continue to work a bit more on the canvas, inventing excuses for additional sittings. . . . As I recall it, it took him almost two weeks to finish our portrait, probably the longest time he ever devoted to working on one painting.[9]

ily's collection, Lipchitz, according to one source, "did not care too much for the portrait and kept it in a closet."[12]

In 1920, after Modigliani died, Lipchitz traded the painting to Léonce Rosenberg for two of his own early sculptures with which he had become dissatisfied and which he immediately destroyed. Thus, the final irony of the painting lies in the distaste for the portrait felt by the man who had commissioned it. Had the relationship between Lipchitz and Modigliani been less complex and the Italian's depiction of the Lithuanian more sympathetic, the painting certainly would not have been put on the market so soon after its completion. Purchased two years later by Helen and Frederic Bartlett, the painting has become a prized possession of The Art Institute of Chicago.

NOTES

I am indebted to Maria Makela, to my colleague Courtney Donnell for her preliminary research on this painting, and to Robert V. Sharp for his editorial suggestions.

1. This painting was formerly titled *Jacques Lipchitz and His Wife*. Lipchitz's most complete record of the events surrounding the creation of this painting are included in his *Amedeo Modigliani* (New York, 1952).

2. Lipchitz with H. H. Arnason, *My Life in Sculpture* (New York, 1972), p. 30.

3. J. Lanthemann, in his *Modigliani: Catalogue Raisonné* (Barcelona, 1970), accounted for six: no. 808, *Portrait of Jacques Lipchitz* (bust portrait), pencil on paper, 40 × 37.3 cm, Grenoble, Musée de Peinture et de Sculpture; no. 809, *Portrait of Jacques Lipchitz* (seated with hands folded), pencil on paper, dimensions and present location unknown; no. 810, *Portrait of Jacques Lipchitz* (seated with hands on his thighs), pencil on paper, 43.2 × 26.7 cm, New York, Lolya Lipchitz Collection; no. 811, *Portrait of Berthe and Jacques Lipchitz*, pencil on paper, 48.1 × 31.6 cm, France, Public Collections, Masurel donation (inv. 979.4.153); no. 812, *Portrait of Berthe Lipchitz* (seated with hands in her lap), pencil on paper, 48.1 × 31.6 cm, present location unknown; no. 813, *Portrait of Berthe Lipchitz*, (seated with hands beneath her chin), pencil on paper, 55 × 38.1 cm, New York, Yulla Lipchitz Collection.

Despite their friendship, Lipchitz and Modigliani inhabited very different worlds. In contrast to the flamboyant behavior of Modigliani, Lipchitz was well known even then for his moderation and unstinting devotion to work. "Waking at six o'clock in the morning no matter how late [he] stayed up the previous night,"[10] Lipchitz sacrificed everything for his sculpture. His traditional principles demanded that an artist work hard and be reimbursed both for his genius and for his time and effort: hence, Lipchitz's guilt regarding Modigliani's small fee. The sculptor's industry brought him rewards: in 1916, his association with Léonce Rosenberg enabled him to hire a studio assistant for the first time. The fact that Lipchitz intended the double portrait for his parents, as a tangible symbol of his personal happiness and growing artistic success in Paris, was an irony that could not have been lost on either artist.

Although he was a leading Cubist sculptor, Lipchitz always considered portraiture "rooted in [his] observation and impression of a specific individual."[11] Lipchitz's own 1922 portrait of Berthe (fig. 15) exemplifies the sculptor's essentially conservative, realist view of portraiture. While the Modigliani portrait fits well within this approach, there can be little doubt that it was the likeness of Lipchitz himself, and not that of his wife, which troubled the sculptor. While he liked Modigliani's preparatory studies, three of which remain in his fam-

198

There are three additional drawings, not included by Lanthemann: *Portrait of Jacques Lipchitz* (seated with hands in pockets), pencil on paper, 31.8 × 49.5 cm, London, Marlborough Fine Arts, Ltd. (illustrated in Paris, Musée d'art moderne de la ville de Paris, *Amedeo Modigliani*, exh. cat. [1981], p. 207, no. 186); *Portrait of Jacques Lipchitz* (seated with hands folded between his legs), pencil on paper, 43.2 × 26.7 cm, New York, Lolya Lipchitz Collection (illustrated in Boston, Museum of Fine Arts, and Los Angeles County Museum, *Modigliani: Paintings & Drawings* [1961], no. 55); *Portrait of Jacques Lipchitz* (seated with hands folded and legs crossed), medium, dimensions, and location unknown (illustrated in André Salmon, *Modigliani: A Memoir* [New York, 1961], p. 8).

4. For biographical information on the sculptor, see Lipchitz (note 2); Irene Patai, *Encounter: The Life of Jacques Lipchitz* (New York, 1961); and A. M. Hammacher, *Jacques Lipchitz: His Sculpture* (New York, 1960).

5. In addition to Lipchitz's own writings on Modigliani, noted above, the painter's career and the often disputed details of his biography are chronicled in: Jeanne Modigliani, *Modigliani: Man and Myth* (New York, 1958); Salmon (note 3); Carol Mann, *Modigliani* (London, 1980); and Douglas Hall, *Modigliani* (Oxford, 1984).

6. Lipchitz (note 1) described Modigliani's attitude toward sculpture in the 1910s in these terms:

Modigliani, like some others at this time, was very taken with the notion that sculpture was sick, that it had become very sick with Rodin and his influence. There was too much modeling in clay, "too much mud." The only way to save sculpture was to start carving again, direct carving in stone (n. pag.).

7. Lipchitz (note 1), n. pag.

8. Lipchitz (note 2), pp. 30–31.

9. Lipchitz (note 1), n. pag.

10. Lipchitz (note 2), p. 32.

11. Ibid, p. 11. Lipchitz's words are as follows:

All my life, with a few intervals, I have done portraits. I love to do them, and no matter what else I am working on I find them an excellent discipline and even relaxation. I have never believed in the idea of abstract or cubist portraits. . . . To me the portrait is rooted in my observation and impression of a specific individual, and, although it is necessary to transform that individual into a work of sculpture, the subject can never be lost sight of [pp. 10–11].

12. Ibid, p. 30. It should be noted that in another account of these events (note 1), Lipchitz claimed that the painting remained on view in his house until he traded it:

This painting had been hanging on my wall for a long time until one day I wanted my dealer to return to me some sculptures in stone which I no longer felt were representative. He asked me more money than I could afford, and the only thing I could do was to offer as an exchange the portrait by Modigliani—who by that time was already dead. My dealer accepted, and as soon as I had my stones back I destroyed them. And that's how it happens that this portrait came finally to be in the collection of The Art Institute of Chicago [n. pag.].

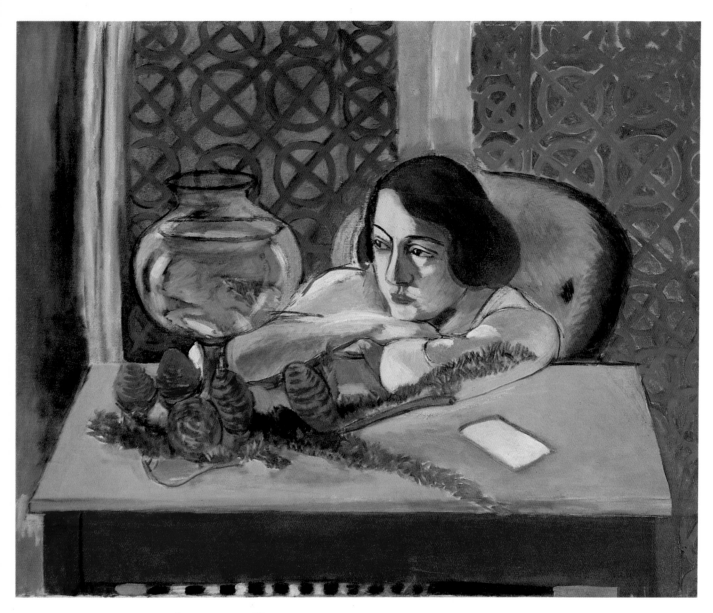

FIGURE 1 Henri Matisse (French, 1869–1954). *Woman Before an Aquarium*, 1923. Oil on canvas; 80.7 × 100 cm. The Art Institute of Chicago, Helen Birch Bartlett Memorial Collection (1926.220).

Woman Before an Aquarium and Woman on a Rose Divan: Matisse in the Helen Birch Bartlett Memorial Collection

CATHERINE C. BOCK, *Professor, Department of Art History and Criticism, The School of The Art Institute of Chicago*

There are so many things in art, beginning with art itself, that one doesn't understand. A painter doesn't see everything he has put in his painting. It is other people who find these treasures in it, one by one, and the richer a painting is in surprises of this sort, in treasures, the greater its author.

HENRI MATISSE[1]

THE TWO PAINTINGS by Henri Matisse in the Helen Birch Bartlett Memorial Collection of The Art Institute of Chicago, *Woman Before an Aquarium* (fig. 1) and *Woman on a Rose Divan* (fig. 2), provide, along with the Art Institute's *Interior at Nice* (fig. 19) and *The Green Sash* (fig. 3), a surprisingly complete demonstration of the character of the artist's early Nice period.[2] Taken together, the four works are a summary of the themes, motifs, and styles of a decade, from 1918 to 1928, which has been for the most part critically neglected since the artist's death in 1954. Overshadowed by Matisse's late works, namely the paper cut-outs, the decorative commissions, and the Dominican Chapel at Vence, the work of the 1920s has seemed modest and unadventurous. Compared to the boldly constructed abstract canvases that preceded them and the chromatically intense neo-Fauve painting that followed in the 1930s, the Nice period works have seemed, like a woman of easy virtue, all too accessible.[3]

The two paintings from the Birch Bartlett Collection argue otherwise. They immediately challenge any facile generalizations about Matisse's sumptuous and self-satisfied odalisques and the vacuous anonymity of his contemporary women.[4] In fact, Matisse's costumed model in *Woman on a Rose Divan* seems lumpish and ill-at-ease in her harem costume; the girl gazing into the fishbowl in *Woman Before an Aquarium* appears at once introspective and shrewd. These two canvases underscore the chronological fluidity of the first and sec-

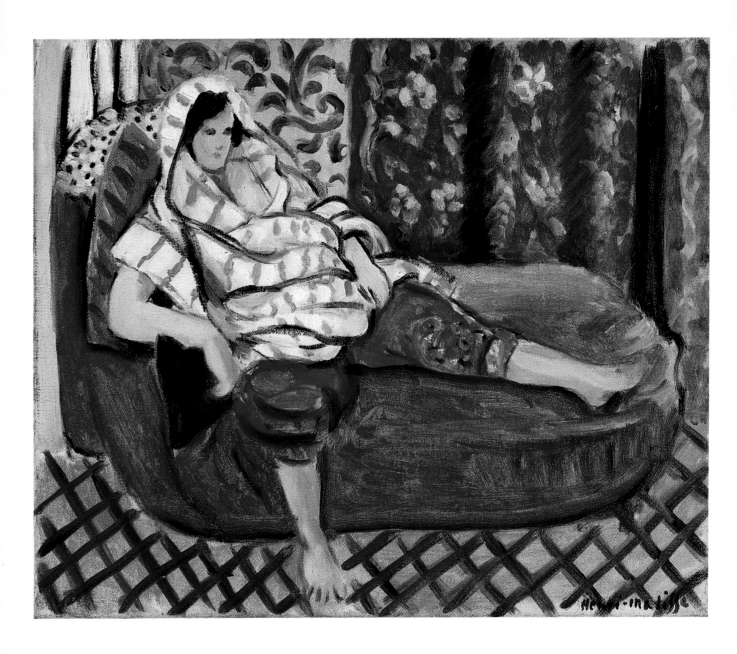

FIGURE 2 Henri Matisse. *Woman on a Rose Divan*, 1921. Oil on canvas: 38.4 × 46.4 cm. The Art Institute of Chicago, Helen Birch Bartlett Memorial Collection (1926.219).

ond parts of the Nice decade. The slightly later painting, *Woman Before an Aquarium* of 1923, looks back to the previous five years, when contemporary figures predominated in paintings whose mood was often febrile and anxious. The earlier *Woman on a Rose Divan* of 1921 looks forward to the suites of odalisques, that is, nudes in harem settings and costumes, which marked what Matisse termed the "sublimated voluptuousness" of the later Nice period. Neither work under discussion is really characteristic, however, of the type that it represents. The *Woman Before an Aquarium* has resolved, with a grave and elegiac monumentality, the theme of the solitary contemporary woman in a hotel-like room. In contrast, *Woman on a Rose Divan* barely sets forth the terms, as it were, of the exotic theater of the Middle East that was to be enacted with such opulent artifice from about 1923 onward. Both canvases, therefore, manage to be at once typical and idiosyncratic—which is characteristic of the work of Matisse's entire Nice period.

The "Nice period" denotes a chronological period in Matisse's work, a more or less homogeneous style, and a persistent subject: women in interiors. Chronologically, the period is said to have begun in 1917, when the artist spent his first winter in the south of France; stylistically, in 1918, when a shift in style became inescapably evident; or in 1919, when Matisse made Nice his primary place of residence and became obsessed with the southern light and atmosphere as filtered through French windows. The end of the Nice period, around 1931, is defined by another shift in style, although Matisse continued to reside in or near Nice until his death.

When Matisse first chose to absent himself from Paris and his home in suburban Issy-les-Moulineaux for seven months of the year, the artist was already nearly fifty years old. He was internationally recognized as the leader of French expressionist painting and as a continuing innovator in modern art. His somewhat gradual retreat from the French capital occurred at the height of his powers and at the culmination of his most ambitious endeavors. Behind him lay the works of heightened impressionist color (1904–08), of large-scale decorative expressionism (1909–12), and of sparely constructed near-abstractions (1913–17). None of these manners had succeeded its predecessor by way of rupture; at each new stage in the development of his painting style, Matisse utilized and extended his mastery of the particular elements of painting achieved in the previous mode. In the Fauve paintings, Matisse liberated color from its descriptive function and from traditional modeling, while retaining the intimacy with and dependence upon natural objects characteristic of his earliest works. The Art Institute's *Still Life with Geranium Plant and Fruit* of 1906 exemplifies this manner. In his decorative style, culminating in the great panels *Music* and *Dance* (The Hermitage, Leningrad) of 1910, Matisse exploited his newly liberated color in large-scale, imaginative compositions that use arabesques and patterns as major elements. In them, he substituted monumentality for intimacy. His final pre-Nice period effort was to synthesize this knowledge of color and surface expansion with the exploration of the "modern methods of [pictorial] construction," as Matisse put it, pioneered by the Cubists. The Art Institute's *Apples* of 1916 and *Bathers by a River*, also of 1916, are superb examples of the period that has been characterized as one of austerity and abstract experimentation.[5]

The shock of Matisse's admirers was therefore great when they found that, in his first major postwar exhibition at his dealer Bernheim-Jeune in Paris in 1919, the painter appeared to have resumed an earlier style, that of impressionist realism. The paintings are small, sketchily painted, of a blond tonality that evokes light and atmosphere, and depict women in spatially plausible interiors. They were not hard to enjoy, but difficult to respect as an advance over his previous achievement. They reintroduced, moreover, the elements that Matisse had left out of his preceding innovative paintings, which had successively explored color, surface, and construction. The new paintings and drawings reinstated modeling, spatial depth, light and atmosphere, richness of specific detail, and the manipulation of materials through a more gestural, painterly handling. We may say that painting as architecture was replaced by painting as writing (*écriture*)—a fluent, calligraphic manner. But, as Matisse himself insisted, the new works only "*seem* impressionist, made by chance and in haste"[Matisse's emphasis]. In fact, he was attempting a marriage of the "left-out" elements of his earliest impressionist style and the hard-won achievements of his most recent advanced style. Not the least of what Matisse wanted to reinstate was what he termed the "human element" in painting.[6]

Far from being *retardataire* or reactionary, the paintings of the Nice period

are the result of Matisse's enormously ambitious attempt at a grand synthesis of two roughly thirteen-year periods of previous work. By his own admission, Matisse did not attempt to fulfill this ambition in every painting. Through Bernheim-Jeune, he yearly exhibited drawings and studies from the model along with more and less important oils, offering his public a large group of works so that they could see what he was attempting and how well he was succeeding. In 1920, he brought out privately an album of fifty recent drawings, which are somewhat uneven in quality. He could have said of these works what he remarked of another group of transitional, small-scale paintings in 1905: "I was glad to exhibit, for my things may not be very important, but they have the merit of expressing my feelings in a very pure way." Matisse expected his viewers to be interested in the quality of his sensibility and his mind, as one is with a favorite writer whose minor work, even, is read with interest. With a mature artist, no part of his work is without interest or fails to illuminate the whole. "Cézanne ceaselessly redid the same picture," Matisse remarked in 1925, at the heart of the Nice period, "but don't we come upon each new Cézanne with the greatest of curiosity?"[7]

Woman Before an Aquarium, as we have said, is the more definitive of the two Birch Bartlett Collection works in its synthesis and resolution of motifs and themes. The motif of the goldfish in a glass bowl and of meditation in front of it was not new for Matisse. Six important paintings between 1911 and 1915 bring together a goldfish bowl, flowers, and a "human" presence (in all but one instance, the terracotta colored statuettes of a female nude; in the other, *Goldfish* [The Museum of Modern Art, New York], an almost totally effaced portrait of the artist himself). Four of these include a window as background for the glass bowl. Two Moroccan paintings, *Arab Café* (The Hermitage, Leningrad) of 1912 and *Zorah on the Terrace* (fig. 4) of 1912/13, also feature the goldfish motif as an object of contemplation; in the former by a group of male Arabs, in the latter by a single Arab woman. Both are set outdoors. Finally, there is the Art Institute's *Woman Before an Aquarium* and its companion study, the quite similar *Woman Regarding Fishbowl* (fig. 5) in The Barnes Foundation collection.[8]

Although just half of the goldfish paintings include an attentive observer, in every case the aquatic animals are presented for contemplation. With flora and human (or substitute sculptural) presence, the goldfish complete the hierarchy of creatures by providing the category of fauna. When pictured with the window, the glass container of the goldfish bowl provides an analogue to the transparency of the glass window/plane that permits inner and outer worlds to meet. As a vehicle of specular activity, the goldfish bowl mimics the eye's orb as well as the circle of the universe. In this latter sense, the bowl signifies a complete and self-contained world, framed for viewing. "By this equation," as Kate Linker observed in her subtle and penetrating article on the topic, "the contents

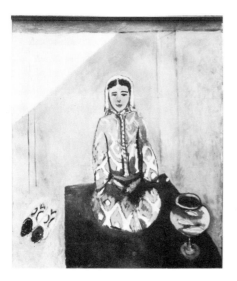

FIGURE 3 Henri Matisse. *The Green Sash*, 1919. Oil on canvas; 49.1 × 43.3 cm. The Art Institute of Chicago, Charles H. and Mary F. S. Worcester Collection (1947.91).

FIGURE 4 Henri Matisse. *Zorah on the Terrace*, 1912/13. Oil on canvas; 115 × 100 cm. Moscow, Pushkin State Museum of Fine Arts.

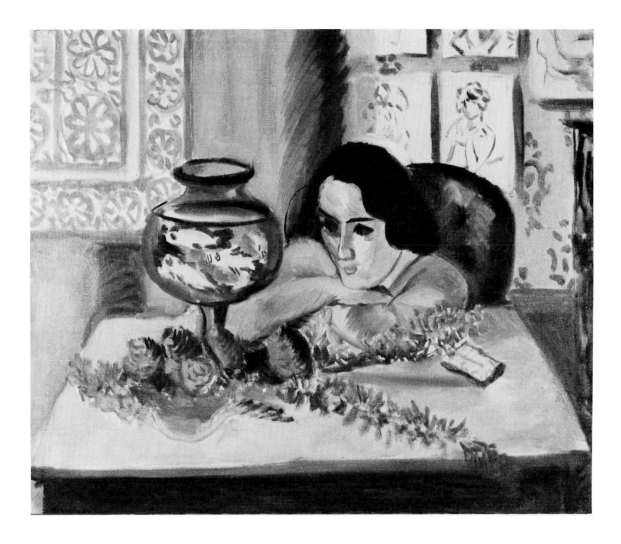

of the spaces are aligned: the space of the fish is compared to the space of the room, the room's extent to the pictorial field and that field, implicitly, to the external sphere from which we, intently, observe."[9]

Rich in symbolist allusion and metaphoric echoes, the goldfish paintings preceding the two created in the Nice period belong, however, to a different formal endeavor. The Chicago painting has some elements in common with the earlier works, but it is striking as well for its differences. An examination of these reveals it to be both the culmination of the earlier versions (Matisse never painted the subject again) and a unique work that is pivotal for the whole Nice decade.

Matisse's daughter, the late Madame Marguerite Duthuit, stated in a letter of 1976 that The Barnes Foundation version of the woman and goldfish was painted in 1921, two years before Matisse took up the theme again in the Birch Bartlett version of 1923.[10] The earlier version has the character of a spontaneous study, the latter of a deliberated composition. The major elements are nearly identical (woman, table and chair, bowl, and pine cones) but the background of the Barnes version is busier in incident, pattern, and color. The dominant tonality of soft browns and warm apple-greens is broken only by the vivid reds of the patterned tapestry in the upper left corner and the lips of the woman, on which the hint of an amused smile plays. Everything in The Barnes Foundation's version trembles on the edge of mobility: the woman's expression is

FIGURE 5 Henri Matisse. *Woman Regarding Fishbowl*, 1921. Merion Station, Penn., The Barnes Foundation.

205

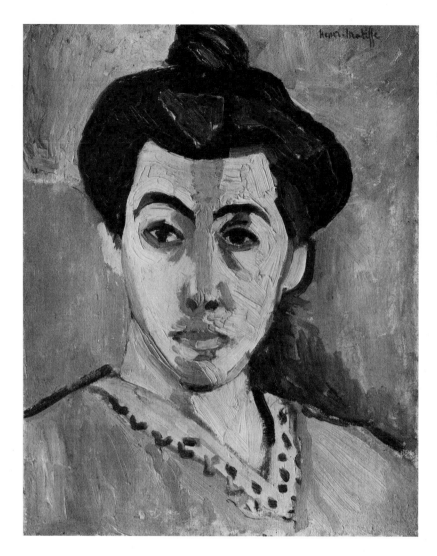

FIGURE 6 Henri Matisse. *Woman with a Green Stripe (Portrait of Mme. Matisse)*, 1905. Oil on canvas; 40.6 × 32.4 cm. Copenhagen, Statens Museum für Kunst.

fleeting, the fish thrash and turn, the pine needles quiver, the little notebook buckles, even the drawings seem to lift away from the wall, their images in restless motion. Thinly worked in discrete strokes and washes, the painting is more graphic than painterly. The charm of the work lies in its volatile, exploratory character that embodies the vibratory nuances of light, movement, and instantaneity.[11]

In contrast, nearly all movement is stilled in the Birch Bartlett *Woman Before an Aquarium*: the motif is concentrated and stabilized. The background has been subdued to a regular, unobtrusive pattern. The two-paneled screen that nearly fills the upper ground provides pillarlike verticals that frame the still life and emphasize the figure. These verticals are reinforced by continuation in the table legs and by the flickering black-and-white alternation of a striped skirt below the table across the lower frame.

Plastically rendered by the light, the woman is at the same time pressed forward between the background plane of the patterned screen and the foreground plane of the tipped table, between an illusionistic space and Cubist planarity. Like Cézanne, Matisse outlined opposite corners of the table (lower left, foreground, and upper right, middleground) to underscore the pine branches' diagonal movement across the table, while flattening the table surface

with the same device. At the right edge of the table, the ghost of a rejected diagonal remains to act as a "shadow" as well as to pull the background up to the picture plane. Also, to suggest space behind the dark hair on the far side of the woman's face, Matisse scraped away paint to reveal the light tan of the chair; what is exposed is the weave of the canvas, which asserts the material flatness of the support and destroys illusionism. This subtle warp of planes and shift of space keep the composition alive in spite of the stasis of its subject.

The color is local and used to model form, while at the same time being artificially manipulated to refer back to the surface plane. Subdued brown, tan, and mauve tones are played off against their complementary colors of blue and blue-green. A pale, fluorescent pink light enters from an unseen window at the left and bathes the tans, turning them lavender, and the blues, turning them gray. The light changes from a silvery twilight warmth on the left of the painting, the side nearest the light source, to a colder pink-lavender on the right which reflects from the table to the underside of the woman's left arm and shoulder. The pink on her right shoulder lies on the same plane as the pink tabletop.

The grays do the same subtle work as the pink tones, both declaring and denying space. For example, the background screen panels seem to stand at angles to one another because of a nuanced shift of values in the left and the right panels. This near-reversal of light and dark in the patterns suggests that the left panel is backlit and the right panel is lit from the front, which could only happen if they did indeed stand at different angles in relation to the (off-stage) window at the left. The screen also acts to immerse the woman in a pulsating blue ambiance, parallel to that of the fish.

Only the clear turquoise vertical behind the woman's head takes a stand against the invasion of iridescent pink-lilac light. The blue-green vertical performs the same function that the green stripe does on the face of Madame Matisse in the famous portrait *Woman with a Green Stripe* (fig. 6) of 1905. In the latter, it provides an "armature" for the face and calls attention to salience (the projecting nose) without recourse to traditional modeling. In the Birch Bartlett painting, the left edge of the turquoise vertical is implicitly aligned with the side of the model's nose and runs directly through the tip of her left elbow at its most projective point. The right edge of the blue-green joins the swelling contour of the chair-back and finally rejoins the line of the arm and evergreens in the foreground, thus joining the farthest plane to the nearest and giving a centripetal, ingathering impulse to the figure and still life.[12]

Theodore Reff rightly noted "the remarkable . . . concentration" of the figure, and remarked upon the "screen whose pattern of intersecting diamonds and circles . . . suggests intellectual activity."[13] Since the painting lacks a specific setting—clues to either studio or luxury apartment being absent—the woman is less apt to be read narratively. In combination with the other motifs—goldfish, pine branch, and empty tablet—she invites a symbolic reading. The painting becomes the culmination of a series of goldfish paintings whose theme is the profound contemplation of free, yet contained, natural beauty. The goldfish, englobed, represent a closed yet transparent world that yields its secrets to the attentive observer, a metaphor for art as process and as product. Both the artist and the viewer enter into an aesthetic realm through meditation—the former into the realm of nature; the latter into the realm of the work of art. The fishbowl is a metaphor for the artwork itself, which, in a closed system, traps and transmutes nature into an ideal aesthetic world.

But *Woman Before an Aquarium* also comes at the end of a series of paintings of and about young women alone in interiors. Matisse's earliest pictorial treat-

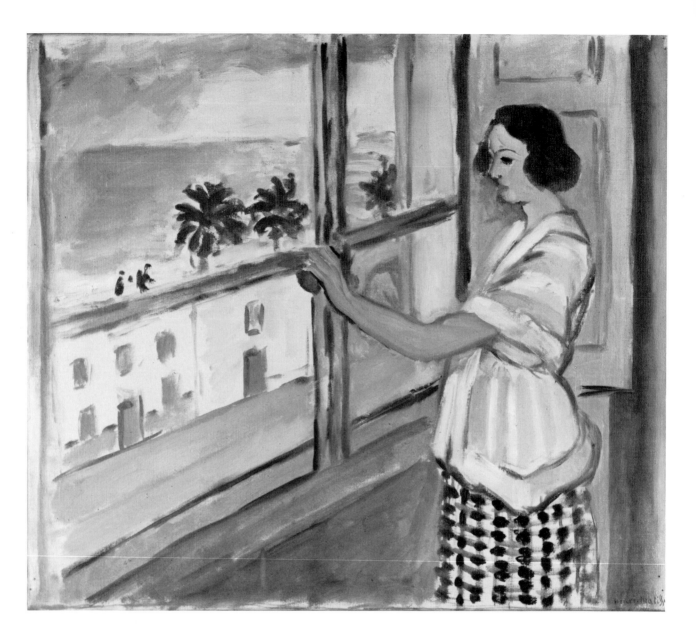

FIGURE 7 Henri Matisse. *Young Woman at the Window, Sunset*, 1921. Oil on canvas; 52.4 × 60.3 cm. The Baltimore Museum of Art, Cone Collection.

ment of women is of two types: 1) women engaged in "useful" activity within serene domestic settings; and 2) idealized nude female figures, idyllically dancing or dallying in arcadian nature. The modern young woman in a hotel room, the early Nice subject matter, mediates between the entirely role-oriented domestic woman (*femme de ménage*) and the totally emancipated archetypal nude. The young woman habitually presented in Matisse's Nice paintings is devoid of social role: she is neither wife, mother, servant, mistress, nor even model (except where the painter gives specific clues to the last-named role). Yet, she is not unconditionally free like the nudes in nature. In spite of its window onto the natural world, the room she inhabits functions as a real enclosure. Contemporary clothing and hairstyle bind her to a specific milieu and moment in time, as in *Young Woman at the Window, Sunset* (fig. 7). The hotel room setting—intimate but temporary—suggests a provisional situation, not an ideal permanent state.

The Nice paintings of women followed a powerful series of portraits of

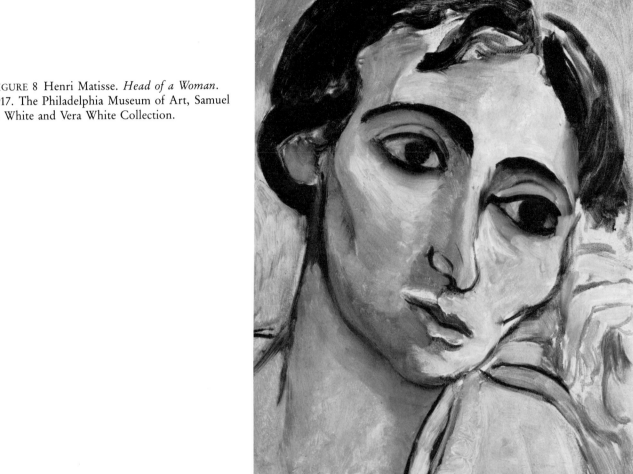

FIGURE 8 Henri Matisse. *Head of a Woman.*
1917. The Philadelphia Museum of Art, Samuel
S. White and Vera White Collection.

women that Matisse painted just before and during World War I. Through the
study of particular—and often notable—women, the artist deepened his "al-
most religious feeling" toward the character of his models and prepared himself
for the psychological empathy with his subject that characterizes the postwar
work. A remarkable series of portraits of his model Laurette, for example, in
Head of a Woman (fig. 8), conveys this sympathetic acuity.[14] In spite of his own
freedom and prosperity in the 1920s, Matisse conveyed in his Nice paintings
something of the mood of anomie and loss in postwar France, whose victory
was after all somewhat Pyrrhic—her industrial provinces were ravaged and she
was estranged from her former allies on the question of reparations.[15]

In these Nice "portraits" of a handful of models, he recorded the restless
anxiety of women gazing at the sea, pining at open windows, neither dressed
nor nude, going nowhere, twisting in their chairs, inert on their couches with
unread books and unplayed instruments in their hands, never facing themselves
in the omnipresent mirrored vanity table, indifferent to bouquets, absorbed in

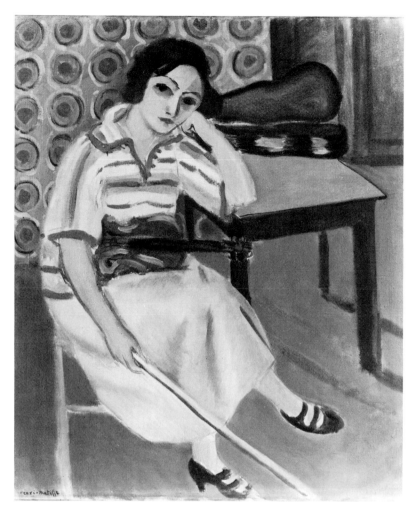

FIGURE 9 Henri Matisse. *Woman with a Violin*, c. 1918. Paris, Orangerie des Tuileries, collection of Walter P. Guillaume. Photo: Réunion des Musées Nationaux.

FIGURE 10 Henri Matisse. *Breakfast (Le Petit Dejeuner)*, 1921. Oil on canvas; 64.1 × 74 cm. The Philadelphia Museum of Art, Samuel S. White and Vera White Collection.

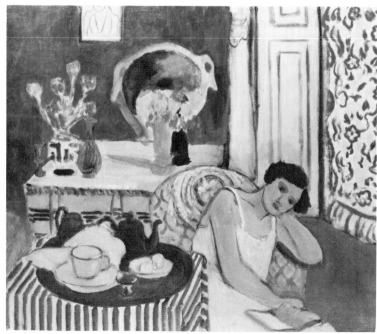

their own mute presences (see figs. 9, 10). Matisse directed a silent cinema of particular stars—Antoinette, Henriette, Marguerite, and unnamed but recognizable others—playing out the role of the sometimes-cosseted but confined woman, the rootless modern female of the period who lived by her wits with little satisfying precedent to guide her. These are the women one finds in postwar novels, the women described by Jean Rhys or Paul Morand, available, bored in their self-absorption, and adrift.[16]

Woman before an Aquarium sets itself apart from these images, though it shares with them certain features. The woman in this painting was once thought to be the artist's daughter, Marguerite, but is, rather, his model Henriette Darricarrère. Still, the solemn attentiveness and intelligent concentration of the woman in the painting are typically found in portraits of Marguerite, who often sat for her father. Matisse in fact sometimes used Henriette as a stand-in for Marguerite, as in the family scenes of Henriette and her two younger brothers which restaged earlier paintings of the Matisse children—Marguerite, with her brothers, Jean and Pierre. Further, this subject of the woman and goldfish was taken up again in 1923—the year of Marguerite's marriage to art historian Georges Duthuit.[17]

It is not inconceivable, therefore, that the artist painted the remarkable *Woman Before an Aquarium* with his daughter, more or less consciously, in mind. His understanding of his daughter may well have been the key to his sensitivity toward the theme of the twentieth-century woman at this time, at liberty but not yet free, that is, not yet independent and self-determining. In the Birch Bartlett canvas, however, the young woman has achieved an equilibrium in rapt absorption. Her reverie is neither blissful nor transcendent, however, but judicious and wary. It does not take her out of herself, but into herself. No longer merely the object of our viewing, she is the prime viewer. We identify with her and her sober reverie induces ours.

The unflinching and unsentimental gravity of the image is further conveyed by the cool, dry handling of color and by the orchestration of the composition toward a single effect—that of the absorptive gaze—as much as through the expression of sagacious brooding on the woman's face. The painting thus also relates to the realism and extreme sobriety of the European (especially German and Italian) style of the 1920s known as the New Objectivity (*Die Neue Sachlichkeit*). This movement, a reaction to expressionism and abstraction, is characterized by a stern, detailed realism—precise to the point of unreality—of everyday subjects often frozen in an uneasy stasis. Jean Clay, a French writer on art, has suggested that work of this type often exhibits the theme of melancholy, a state of intense awareness of spiritual malaise. He pointed out the similarity among certain inter-war images, often of women, that recall Renaissance depictions of the brooding allegorical figure of *Malinconia* (see fig. 11). The figure alludes to both the artist and thinker and embodies self-awareness coming to grips with the limits of knowledge and freedom. Matisse's *Woman Before an Aquarium* conveys something of this melancholy and is consonant with this postwar mood.[18]

Woman Before an Aquarium and *Woman on a Rose Divan* seem to have little in common other than chronological proximity. A previous painting already cited, however, *Zorah on the Terrace* (fig. 4), in which a Moroccan woman contemplates a bowl of goldfish, provides a clue to their possible affinity. The inhabitant of a North African *oda*, or harem, is here joined, via the fishbowl, to the themes of enclosure and rapt contemplation. Although there is only one other oil that pairs an odalisquelike nude with a goldfish bowl, the themes are interrelated.[19]

FIGURE 11 *Malinconia (Melancholy)*. From Cesare Ripa, *Iconologia*, reprint, New York, 1976, p. 324.

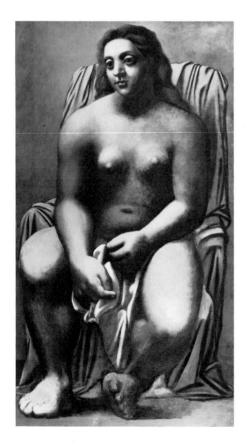

By the latter half of the Nice decade, odalisques were to dominate Matisse's oeuvre, replacing the troubled contemporary woman who had presided over the first half. One is tempted to suspect Matisse of being less than ingenuous when, in 1929, he gave his reasons for painting odalisques:

I do Odalisques in order to do nudes. But how does one do the nude without it being artificial? And then, because I know that they exist. I was in Morocco; I saw them. Rembrandt did his biblical subjects with authentic Turkish materials from the bazaar and his emotion was there. Tissot painted the Life of Christ with all the documentation possible, even going to Jerusalem. But his work is false and has no life of its own.[20]

Painting studio nudes was common among School of Paris artists in the 1920s; in what way could they be considered artificial? Charles Vildrac, in his introduction to Matisse's 1920 album of drawings, remarked that they "yielded neither to fashion nor to archaism," that they were neither *à la mode* nor *à l'antique*.[21] He meant that the artist avoided the then-widespread trend among advanced painters to imitate Ingres's svelte line, as well as the classicizing tendency of the day, which even Picasso (see fig.12) did not spurn. Neither of these current stylistic manners was without conservative implications in the general "call to order" of the postwar period.[22] To escape these styles, Matisse shaped a subject that could arouse his sensibility in such a way as to ensure authenticity of expression. In other words, the subjectivity of the Nice manner was a function of the artist's desire to safeguard his sincerity. "I belong to a generation for whom everything had to arise from feeling," he admitted. "If I had continued in that other path [i.e., Cubist-influenced abstractions]," he confided to an interviewer in 1919, "I would have ended in mannerism. One must keep one's freshness of vision and emotion; one must follow instinct."[23]

Matisse's experience with the exotic—two extended visits to Tangiers in 1912 and 1913—had left an indelible impression that could be called upon for an authentic emotional response.[24] In the above quotation on the Odalisques, Matisse identified with Rembrandt, who was inspired by provocative, exotic materials. While Matisse had visited the Middle East, his emotion was really triggered by the authentic fragments—carpets, ceramics, clothing—that he had collected and, even more, by the women who were the "seat of his energy." In the beginning, a bit of oriental fabric or clothing was enough to stir memory and desire; as with Marcel Proust's *madeleine*, even the savor was sufficient to evoke nostalgia. The earliest versions of the subject, between 1916 and 1921, simply suggest the ambiance of a North African setting.[25] Neither the costume nor the setting was fully developed: a prop or a bit of clothing suggested the whole.

Woman on a Rose Divan is an early, if not the earliest, example of the fully-staged harem subject. It is still a costume piece, a fake theatrical staging of the model in exotic garb. When Matisse took up the convention of the costumed studio model, both at the turn of the century and during the Nice period, he was reexamining the work of Edouard Manet (who had utilized that convention and called attention to its artificiality) and painting with something of Manet's direct style. Matisse's landscapes and still lifes painted at Etretat in the summers of 1920 and 1921 are veritable homages to Manet in their use of black and in the succulence of both subject (oysters, lemons, salt-spray seascapes) and technique (wet-on-wet paint and fluidly articulated brushstrokes). *Woman on a Rose Divan* shares the painterly handling of these Etretat landscapes.[26]

The composition of the canvas, however, belies the spontaneous immediacy

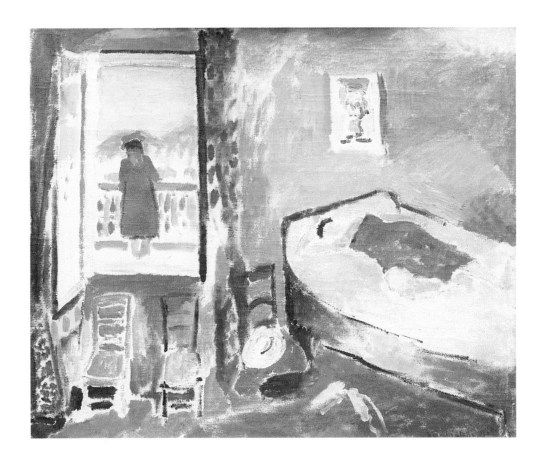

FIGURE 13 Henri Matisse. *Interior at Collioure*, 1905/06. Zurich, Kunsthaus.

of its surface manipulation. Against a background of warm earth-reds and cooler red-purples, a bulky figure is splayed across the picture plane in an inverted Y-configuration. Although the figure straddles the vertical-horizontal composition, she is locked firmly into its structure. From right elbow to toe, from heel back to the finger tips of her right hand, she spans the strong horizontal wedge of the couch and the frieze of wall patterns. Her right foot anchors the whole composition, becoming the fulcrum for a counter V-shape: its right side joins the edge of the red drape; its left side incorporates the diagonal black shading of the side of the burnoose and is discharged, via the pillow behind the head, into the vertical bands behind it. As in *Woman Before an Aquarium*, Matisse has effected a complex synthesis between a certain illusionism and post-Cézannean methods of pictorial construction.

The color scheme is a favorite of the artist's from the earliest days of Fauvism: the juxtaposition of complementary (pale) green against the split (warm and cool) reds can also be found in *Woman with a Hat* (Hans Collection, San Francisco), *Woman with a Green Stripe* (fig. 6), *Interior at Collioure* (fig. 13), and many other works from around 1905 and 1906. In *Rose Divan*, however, the pale green also functions as an aerating agent, the equivalent of light, that suggests an out-of-view window at the upper right. The warm reds lack the aniline-dye tartness of the Fauve reds; the back curtain is so worked with cream flowers and green leaves that it takes on an earthy brown inflection, a brown actually present in the neighboring pattern to the left. How earth-toned the drape has become is evident when it is compared to the sharp scarlet of the trousers. (In another version of the painting, also in The Barnes Foundation, discussed more completely below, the patterned drape has in fact a brown, rather than red, background.) Black, Manet's color, is oddly used, seemingly as an afterthought. The visual weight of the black pillow is necessary to support

the oversized arm, just as the visual weight of the rightmost shadow-fold of the drape is necessary to anchor the tumescent tip of the couch. Matisse resorted to drawing in black over the filmy burnoose, tightening the pattern of folds so that the torso is bound in their coils.

There is only one other known painting of the same model identically clothed: the *Odalisque* in The Barnes Foundation collection (fig. 14). Not differently worked than the Birch Bartlett painting, it is larger and the model seems more happily settled—physically and psychologically—into her role; hence, it is probably a later variant. There are no known sketches or drawings for these two works, and the striped garment, covering upper torso and head, is never used in this way again.

Both paintings are of interest because they are among the few stagings of the harem woman earlier than *Odalisque with Red Trousers* (fig. 15), the first painting by Matisse to be purchased, in 1922, by the French government. *Odalisque with Red Trousers* was painted shortly after Matisse had moved to a more permanent apartment on the Place Charles-Félix in October 1921. The Birch Bartlett and Barnes Foundation canvases were painted while Matisse was still at the old Hôtel de la Méditerranée, where Matisse confessed to finding the ambiance "fake, absurd, terrific, delicious!"[27] The two odalisques painted there seem undisguisedly fictitious. Still, even in the *Odalisque with Red Trousers*, where the larger new apartment was able to be fitted out as a "harem" with greater theatrical verisimilitude, the model remains a contemporary woman looking to the painter for stage directions. One only has to compare Renoir's model's expression in *Odalisque* (fig. 16) with that of Matisse's model in these 1921 canvases to see that, for Matisse, the subject was as yet unresolved.

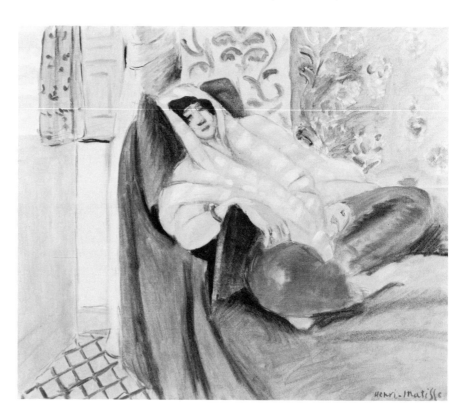

FIGURE 14 Henri Matisse. *Odalisque*, 1920. Oil on canvas; 55.9 × 66 cm. Merion Station, Penn., The Barnes Foundation.

214

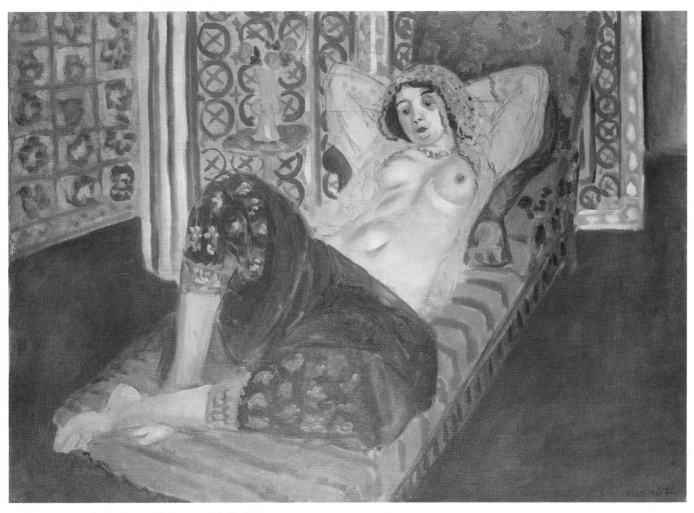

FIGURE 15 Henri Matisse. *Odalisque with Red Trousers*, 1921.
Oil on canvas; 65 × 90 cm. Paris, Musée national d'art moderne.

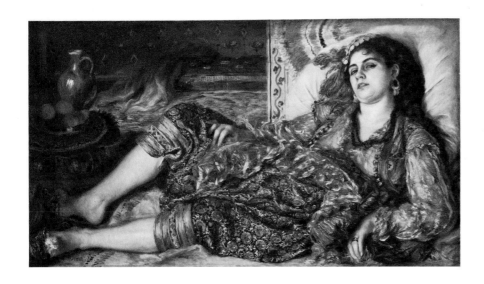

FIGURE 16 Pierre Auguste Renoir
(French, 1841–1919). *Odalisque*,
1870. Oil on canvas; 69.2 × 122.6
cm. Washington, D.C., National
Gallery of Art, Chester Dale
Collection.

215

FIGURE 17 Henri Matisse.
*Woman on the Sofa (Femme
au canapé)*, n. d. Paris,
Orangerie des Tuileries, col-
lection of Walter P.
Guillaume. Photo: Réunion
des Musées Nationaux.

FIGURE 18 Matisse drawing from a
model in his apartment on Place
Charles Félix, Nice, c. 1928. Photo:
Special Collections, Library,
The Museum of Modern Art,
New York.

Space in the Hôtel de la Méditerranée was relatively cramped.[28] Another painting, *Woman on the Sofa (Femme au canapé)* (fig. 17), better indicates the interior in which the Chicago *Rose Divan* was painted. In the former, we see the red couch set against the hanging drape at the right; in the latter, the painter has confronted the model head-on and at close range to eliminate the rest of the room. In The Barnes Foundation *Odalisque*, the figure is viewed from a slight angle, permitting the window more play both in light and space, though the modern furnishings are still eliminated. Several drawings, probably dating from after the Birch Bartlett and Barnes Foundation paintings and before the *Odalisque with Red Trousers*, indicate that Matisse tried different costumes on his model before settling on the open transparent blouse and filmy veil. The background of one of these drawings is identical to the Art Institute's *Rose Divan*, though the model's costume is partially changed and her gesture and expression are sensual.[29]

The "staged" quality of the odalisques is most evident at the beginning and end of the Nice period. From 1921 to 1923, the motif was just being developed and remained a transparent studio set-up. Later, from 1926 to 1929, Matisse

216

created a "real" stage such as can be seen in a celebrated photo of the era (fig. 18), a niche where the women, more doll-like than real, became impersonal mannequins in an overripe middle-eastern decor. These later works evidence a loss of belief in the subject's possibility for transformation, of a disillusionment with make-believe even as it is ironically enacted. But in the middle Nice years, 1923 to 1926, paintings such as *Odalisque with Magnolias* (private collection, New York) convey with utmost voluptuousness a radiant supra-sensible message of blissful self-absorption.

It would seem that even as the reclining odalisque was beginning to be explored as a major theme, the modern woman was removed from the room to the balcony (see fig. 19), distanced both compositionally and psychologically from the viewer. A related canvas, the aforementioned *Woman on the Sofa (Femme au canapé)* (fig. 17), reveals the moment when the two subjects— modern woman and odalisque exemplified by the Birch Bartlett canvases— split off from one another; the ghostly female on the sofa was soon to crystallize as the idealized odalisque. An early Fauve painting, the previously mentioned *Interior at Collioure* (fig. 13), sets up the two types: a partially clothed

FIGURE 19 Henri Matisse. *Interior at Nice*, 1921. Oil on canvas; 132 × 89 cm. The Art Institute of Chicago, gift of Mrs. Gilbert W. Chapman (1956.339).

woman lies sprawled on the bed, while another, clothed and hatted, stands on the balcony gazing at the outdoor scene. The reclining figure is the artist's wife and the girl on the balcony, at the juncture of inner and outer worlds, is significantly, the artist's daughter, Marguerite.[30]

The middle-period odalisques, which become precious icons of self-enjoyment, are not unlike the goldfish as Matisse portrayed them. The iridescent swimmers, exhibited in their transparent globes, lose none of the untrammeled exercise of their natures because they are viewed. So Matisse's harem creatures, though totally available to the viewer within the confines of the artist's depiction, yet function as symbols of fulfilled human nature. The Birch Bartlett painting of the meditating *Woman Before an Aquarium* has less of fantasy in its image of the female; the pensive woman's reverie on the goldfish seems tempered by the sobriety of a knowing realism.

The two Matisse paintings in the Helen Birch Bartlett Memorial Collection suggest the subtlety and range of Matisse's Nice period oeuvre. Stylistically, the paintings are a gauge of the artist's success in integrating a modern sense of color and structure with the intimacy of a highly personal, atmospheric style. Thematically, the two works comprise his major Nice motifs: the contemporary and the costumed woman. *Woman on a Rose Divan* demonstrates the deceptively simple development of the theme of the odalisque, which was to unfold fully from 1923 to 1926, representing a type rather than an individual. *Woman Before an Aquarium* is a special kind of portrait, that of an individual within the framework of a type. It brings to a unique resolution the theme of the modern postwar woman to which the artist had given such penetrating and varied expression in the preceding decade. Both pictures are full of surprises, of treasures, that establish them, with Matisse's other paintings of the Nice decade, as ambitious works of synthesis and as subtle reflections of postwar European sensibility.

NOTES

1. Matisse, cited in Pierre Courthion, "Rencontre avec Matisse," *Les Nouvelles littéraires* (June 27, 1931), p. 1; for a translation, see Jack D. Flam, *Matisse on Art* (New York, 1978), p. 65.

2. In addition to the two paintings in the Birch Bartlett Collection, The Art Institute of Chicago possesses six oil paintings by Matisse: *Still Life with Geranium Plant and Fruit*, 1906, 97.7 × 80 cm, Joseph Winterbotham Collection (1932.1342); *Apples*, 1916, 117 × 89 cm, gift of Mr. and Mrs. Samuel A. Marx (ex. Quinn) (1948.563); *Bathers by a River*, 1916, 262 × 391 cm, Worcester Collection (1953.158); *The Green Sash*, 1919, 49.1 × 43.3 cm, Worcester Collection (1947.91); *Interior at Nice*, 1921, 132 × 89 cm, gift of Mrs. Gilbert W. Chapman (1956.339); and *Daisies (Marguerites)*, 1939, 91.5 × 66 cm, gift of Helen Pauling Donnelley in memory of her parents, Mary Fredericka and Edward George Pauling (1983.206).

3. There is no major study of the Nice period; it is briefly treated in the basic monographs dealing with the total life and oeuvre of the artist: Alfred H. Barr, Jr., *Matisse, his Art and his Public* (New York, 1951); Gaston Diehl, *Henri Matisse* (Paris, 1954); Raymond Escholier, *Matisse, ce vivant* (Paris, 1956); Lawrence Gowing, *Matisse* (New York, 1979); and two more specialized studies: Louis Aragon, *Henri Matisse: roman* (Paris, 1971); and Pierre Schneider, *Henri Matisse* (Paris and New York, 1984). Specialized texts have appeared on Matisse's prints, drawings, and sculpture; the Fauve works and the paper cut-outs have been extensively treated. Although there is no catalogue raisonné of the paintings, a useful—though incomplete and sometimes inaccu-

rate—compilation has been made which includes the Nice period works: see Massimo Carra and Xavier Deryng, *Tout l'Oeuvre peint de Matisse, 1904–1928* (Paris, 1983; Ital. ed., Milan, 1971). A major exhibition of works of the period organized by the National Gallery of Art, Washington, D.C., is scheduled for November of 1986. The scholarly catalogue for this show will redress the neglect of the period and will undoubtedly revise the current assessment of it.

There are two collections of the written and recorded words of Matisse: Jack D. Flam (note 1) and Dominique Fourcade, *Henri Matisse, écrits et propos sur l'art* (Paris, 1972). Hereafter, in citing the words of Matisse, both the original source and the page reference in Flam's translation will be given.

4. No one has seriously challenged Alfred Barr's judgment that the period is "a rather unexciting and anticlimactic interim in which even the best paintings with all their charm and quiet gaity do not approach the masterpieces of 1905 to 1916" and that "there seems to be a falling off from the intensity, boldness, scale, and sheer pictorial excitement" and a setting in of "reaction and relaxation" (Barr [note 3]), pp. 208, 214). In the generally laudatory *The Art of Henri Matisse* (Merion Station, Pa., 1933) by Albert Barnes and Violette de Mazia, one reads: "Persons in his portraits, no less than in his compositions, are primarily assemblages of plastic traits. He lacks not only Rembrandt's religious sense of human personality, but also interest in characterization of the sort that appears in Dürer, Goya, or Daumier. . . . To Matisse nature and personality are mainly counters in the decorative game he plays" (pp. 204–05).

5. Matisse on modern methods of construction: E. Tériade, "Matisse Speaks," *Art News Annual* 21 (1952) (Flam [note 1], p. 132); for Alfred Barr's (note 3) assessment of the preceding period, see chapter 4.

6. The best indication of Matisse's intentions at this time is to be found in an interview with Ragnar Hoppe, translated from the original Swedish ("Pä visit hos Matisse," *Städer och Konstnärer, resebrev och essäer om Konst* [Stockholm, 1931]) into French by Cecilia Monteux in Dominique Fourcade, "Autre propos de Henri Matisse," *Macula* 1 (1976), p. 94. On the human element in his work, see Matisse's letter of February 14, 1934, to Alexander Romm cited in Flam (note 1), p. 68.

7. The 1905 citation, referring to the first Fauve works that were exhibited at the Salon d'Automne of that year, is from a letter by Matisse to Paul Signac of September 28, 1905, cited in Schneider (note 3), p. 188. The Cézanne quotation is from Jacques Guenne, "Entretien avec Henri Matisse," *L'Art Vivant* 18 (Sept. 15, 1925) (Flam [note 1], p. 55).

8. See the discussion of these goldfish paintings in John Elderfield, *Matisse in the Collection of the Museum of Modern Art* (New York, 1978), pp. 84–86, 100–02, 197–98, and 204–05, where the significance of the theme is thoroughly traced. Two later paintings, not mentioned by Elderfield, are *Nude with Goldfish*, 1922, Stephen Hahn Collection, New York (illustrated in Schneider [note 3], p. 352) and *Still Life: "Les Modes" (The Goldfish)*, 1922, The Metropolitan Museum of Art, New York.

9. Kate Linker, "Meditations on a Goldfish Bowl: Autonomy and Analogy in Matisse," *Artforum* 19, 2 (Oct. 1980), pp. 65–73; and "Matisse and the Language of Signs," *Arts Magazine* 49 (May 1975), pp. 76–78. Another major article on the theme is Theodore Reff, "Matisse: Meditations on a Statuette and Goldfish," *Arts Magazine* 51 (Nov. 1976), pp. 109–15. Schneider (note 3) also discussed the goldfish motif: see pp. 420–24.

10. Letter from Marguerite Duthuit to Courtney Donnell, March 25, 1976, in the Department of Twentieth-Century Painting and Sculpture, The Art Institute of Chicago:

Two paintings of the same subject were worked on by Matisse several years apart: in 1921, in the first contact with the subject, the painting was treated rather lightly and in a descriptive manner with respect to the background. . . . Then, two seasons later in 1923, Matisse took up the same subject again on a much larger canvas, worked on at length and treated in an entirely different manner; but in the two paintings, one recognizes the same expression of gravity in the person depicted. It is the latter painting which belongs to your museum. [Author's translation.]

Madame Duthuit's recollection is offered without hesitancy; therefore, until new evidence indicates otherwise, this author has accepted the 1923 date for the second version. The Bernheim-Jeune records also indicate a 1923 date for the painting, which was purchased by the Bartletts on June 4, 1923; *Woman on a Rose Divan*, dated 1921, was bought nine days earlier, on May 26, 1923.

11. The Barnes Foundation *Woman Regarding Fishbowl* is not illustrated in the Barnes and de Mazia monograph (note 4). It is reproduced, however, in Charles Vildrac, *Nice, 1921: Seize reproductions d'après les tableaux de Henri Matisse* (Paris, 1922), no. 6, under the title *Jeune fille devant un aquarium*.

12. I am indebted to my colleague, the painter Theodore Halkin, for sharing with me his insights regarding the formal structure of the painting under discussion.

13. Reff (note 9), p. 114.

14. Among the remarkable portraits that Matisse made just before or during the war were those of Yvonne Landsberg, a wealthy young Brazilian; Josette Gris, wife of the artist Juan Gris; Greta Prozor, actress; Eva Mudocci, violinist and former mistress of Edvard Munch; Germaine Raynal, wife of the Cubist critic and writer Maurice Raynal; Emma La Forge; Mme. Demetri Galanis, wife of the engraver and painter; Sarah Stein, painter and sister-in-law of Gertrude Stein; and the painter's daughter, Marguerite, then in her twenties. The series of paintings of Laurette must also be considered a substantial achievement in portraiture; see a selection reproduced in Schneider (note 3), pp. 478–82.
 From his 1908 "Notes of a Painter," *La Grande Revue* 52, 24 (Dec. 25, 1908) (Flam [note 1], pp. 32–39) to the late article entitled *Portraits* (Monte Carlo, 1954) (Flam [note 1], pp. 150–53), Matisse insists on the importance of the human figure, the model, in the expression of his profoundest feelings about life. "My models, human figures, are never just 'extras' in an interior. They are the principal theme in my work." In "Notes d'un peintre sur son dessin," *Le Point* 21 (July 1939), pp. 104–10 (Flam [note 1], p. 81).

15. The moral and physical devastation in Europe after World War I was universal, affecting victor and vanquished alike. Matisse's move to Nice, often seen as an escape, brought him to a city that hosted a transient multi national population, the flotsam of international displacement, and Matisse himself was aware of the insubstantiality and loneliness characteristic of the city: "Nice is a décor, a fragile thing—very beautiful, but where no one real is to be found. It isn't a city with depth. . . " (Matisse to Pierre Courthion, cited in Schneider [note 3], p. 517).

16. A longer study by this author on Matisse's early Nice period, which will explore the relation of Matisse's subject matter to the fiction(s) of the period, is in progress.

17. Madame Duthuit's letter (see note 10) does not mention her marriage, which took place on December 10, 1923, just six months after the painting was sold.
 Theodore Reff ([note 9], p. 114) found a Japanese source in which the goldfish, symbol of happiness and prosperity, is paired with the pine tree, symbol of longevity. He did not suggest that Matisse knew and worked from such a source but rather that he may have been aware, in a general way, of comparable oriental usages of motifs. The goldfish and pines, even if used unconsciously as symbols of long life and happiness, would permit an interpretation that accords with his daughter's impending marriage.

18. Jean Clay, "Sous le Signe de Saturne: notes sur l'allegorie de la Melancholie dans l'art de l'entre-deux-guerres en Allemagne et en Italie," *Cahiers du Musée Nationale d'Art Moderne* 7/8 (1980), pp. 176–206. Clay referred to the classic text by art historian Erwin Panofsky on Dürer's engraving of the subject, *Melancholia*, in *The Life and Art of Albrecht Dürer* (Princeton, 1955), pp. 157ff., where the full explication of the allegory is developed.

19. See note 8. In 1929, Matisse resumed the goldfish theme in a series of etchings. Those that pair the fishbowl and contemporary women's heads, often in modish cloche hats, retain the pensive quality of the *Woman Before an Aquarium*. Another group of etchings, however, uses the fishbowl merely as part of the nude model's oriental decor.

As a mere still-life element, the motif loses its significance beyond a certain exoticism. See: Fribourg, Musée d'art et d'histoire, *Henri Matisse, gravures et lithographies*, exh. cat. (Fribourg, 1982); nos. 146–49, 151, 155–56, 158–59, 165–66, 170, 172, 181, 195–97, 200, 206.

20. Matisse to E. Tériade, "Visite à Henri Matisse," *L'Intransigéant* (Jan. 17, 1929) (Flam [note 1], p. 59).

21. Charles Vildrac, *Cinquante dessins par Henri Matisse* (Paris, 1920), p. 6.

22. For the post-World War I situation in France as it affected the arts, see *Le Retour à l'ordre* (Saint-Etienne, 1974); Paris, Musée national d'art moderne, *Les Réalismes, 1919–1939*, exh. cat. (1980); and Kenneth Silver, *Esprit de Corps: The Great War and French Art, 1914–1925* (Ph.D. diss., Yale University, 1981).

23. Interview with Ragnar Hoppe (note 6), p. 94.

24. On the Morocco visits, see Flam, "Matisse in Morocco," *Connoisseur* (Aug. 1982), pp. 74–86, and Schneider (note 3), pp. 459–93.

25. For instance: Laurette in a turban or with turkish coffee, paired with the mulatto model Aïcha in eastern robes, or with Antoinette in trousers and transparent jacket. The motif dates from as early as 1916, when Matisse painted his large canvas *The Moroccans* (The Museum of Modern Art, New York).

26. *Woman on a Rose Divan*, first exhibited with Etretat landscapes, was once thought to have been painted there; the background, however, is clearly that of the artist's hotel room. Matisse wrote of Manet in 1932: "Edouard Manet vu par Henri Matisse," *L'Intransigéant* (Jan. 25, 1932), p. 5; (English trans. in Schneider [note 3], p. 306). See also Dominique Fourcade, "Matisse et Manet?," *Bonjour Monsieur Manet*, exh. cat., Paris, Musée national d'art moderne (Paris, 1983), pp. 25–32.

27. Matisse, cited in Francis Carco, "Conversation avec Henri Matisse," *L'Ami des peintres* (Paris, 1953); (Flam [note 1] p. 86). The original interview was conducted in 1941.

28. Charles Vildrac (note 11), p. 1, called attention to Matisse's transformation of his hotel room in 1922: "First of all, this chamber was not as large as I had supposed: I had, from certain canvases, the impression that one could walk freely there with large strides, even dance there with ease; but its size was totally in the length, rather crowded, and the window occupied the greater part of the width. Beyond that, I had to admit that the painter had lent it an airy soul and one totally subject, like flowers, to the variations of the skies—a soul it certainly did not possess in reality. It was a lovely hotel room, to be sure, but its soul was that of a hotel room."

29. This drawing, whose present location is unknown, is reproduced in Isabelle Monod-Fontaine, *Matisse, oeuvres de Henri Matisse, 1869–1954, dans le Musée National d'Art Moderne* (Paris, 1979), p. 112. It is shown in conjunction with a drawing in the museum entitled *Odalisque étendue, pantalon turc*. An oil painting that is very close to the museum's sheet is reproduced in *Cahiers d'Art* 6, 5/6 (1931), n.pag., that was devoted to Matisse. Related to these drawings (and to the Chicago painting) is a series of carefully worked pen and ink drawings which was published in Elie Faure, *Henri Matisse par Elie Faure, Jules Romain, Charles Vildrac, Léon Werth* (Paris, 1923), nos. 19, 35, 39, 41, and 53. Yet another variant drawing appears in Victor Carlson, *Matisse as a Draughtsman* (Baltimore, 1971), no. 39.

30. Louis Aragon ([note 3], vol. 2, pp. 67–80) has some affecting pages on the tender relationship between Matisse and his daughter and (vol. 1, pp. 138–41) recounts the artist's detailed reminiscences about *Interior at Collioure* some thirty-five years later: for example, the exact color used for Marguerite's dress and its harmonization throughout the composition. Jack Flam has also called attention ("Some Observations on Matisse's Self-Portraits," *Arts Magazine* 49 [May 1975], p. 51) to the projection by the artist of his own feelings onto some images of his daughter.

The Helen Birch Bartlett
Memorial Collection

PAUL CEZANNE (French, 1839–1906)

No. 1 *The Basket of Apples*, c. 1895. Oil on canvas; 65 × 80 cm (1926.252).

ANDRE DERAIN (French, 1880–1954)

No. 2 *The Fountain*, 1920/25. Oil on panel; 27.3 × 34.6 cm (1926.350).

No. 3 *Grapes*, 1920/25. Oil on canvas; 24.8 × 44.1 cm (1926.191).

No. 4 *Landscape*, 1920/25. Oil on panel; 59.5 × 72.9 cm (1926.190).

ANDRE DUNOYER DE SEGONZAC (French, 1884–1974)

No. 5 *Still Life*, c. 1920. Oil on panel; 55.1 × 45.4 cm (1926.194).

PAUL GAUGUIN (French, 1848–1903)

No. 6 *Day of the Gods*, 1894. See page 108, figure 4.

No. 7 *Tahitian Woman with Children*, 1901. Oil on canvas; 97.2 × 74.3 cm (1927.460).

VINCENT VAN GOGH (Dutch, 1853–1890)

No. 8 *Montmartre*, probably c. 1886. Oil on canvas; 43.6 × 33 cm (1926.202).

No. 9 *Bedroom at Arles*, 1888. See pages 136–37, figure 1.

No. 10 *Madame Roulin Rocking the Cradle (La Berceuse)*, 1888. See page 107, figure 3.

No. 11 *Still Life: Melon, Fish, Jar*, n.d. Oil on panel; 55.2 × 46.3 cm (1926.201). (The authorship of this painting is currently in question.)

No. 11

FERDINAND HODLER (Swiss, 1853–1918)

No. 12 *James Vibert, Sculptor*, 1907. See page 166, figure 1.

No. 13 *The Grand Muveran*, 1912. See page 168, figure 2.

No. 14 *Head of a Soldier*, 1915/17. See page 169, figure 3.

ANDRE LHOTE (French, 1885–1962)

No. 15 *The Ladies of Avignon*, c. 1923. Oil on canvas; 110.7 × 84.8 cm (1926.215).

HENRI MATISSE (French, 1869–1954)

No. 16 *Woman on a Rose Divan*, 1921. See page 202, figure 2.
No. 17 *Woman Before an Aquarium*, 1923. See page 200, figure 1.

AMEDEO MODIGLIANI (Italian, 1884–1920)

No. 18 *Jacques and Berthe Lipchitz*, 1916. See page 188, figure 1.

PABLO PICASSO (Spanish, 1881–1973)

No. 19 *The Old Guitarist*, 1903. See page 152, figure 1.

HENRI ROUSSEAU (Le Douanier) (French, 1844–1910)

No. 20 *The Waterfall*, 1910. Oil on canvas; 116.2 × 150.2 cm (1926.262).

GEORGES SEURAT (French, 1859–1891)

No. 21 *Sunday Afternoon on the Island of La Grande Jatte*, 1884–86. See pages 102–103, figure 1.

HENRI DE TOULOUSE-LAUTREC (French, 1864–1901)

No. 22 *Ballet Dancers*, 1885. Oil on plaster transferred to canvas; 153.5 × 152.5 cm (1931.571).
No. 23 *At the Moulin Rouge*, 1894/95. See page 114, figure 1.

MAURICE UTRILLO (French, 1883–1955)

No. 24 *Street in Paris*, 1914. Oil on canvas; 65.4 × 80.8 cm (1926.226).

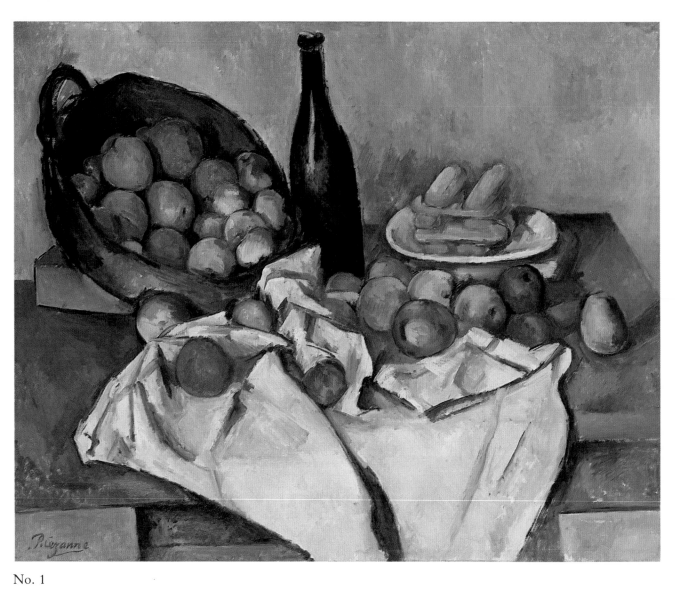

No. 1

No. 5

No. 24

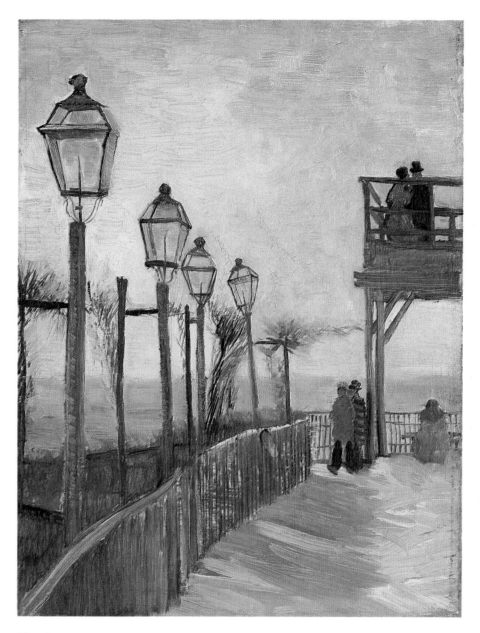

No. 8

228 No. 7

No. 20

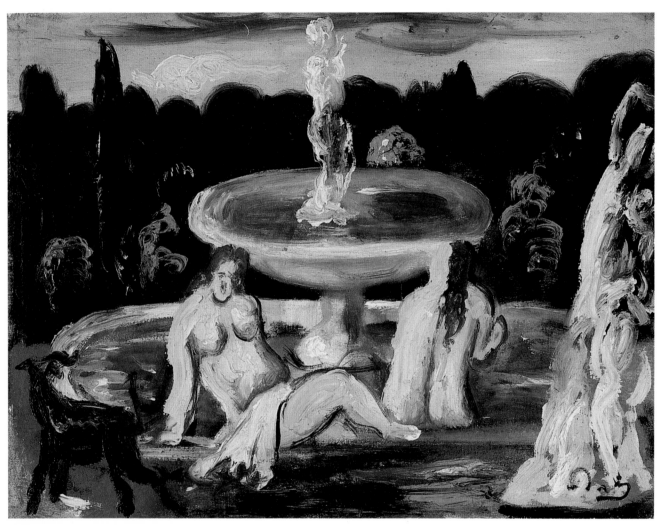

No. 2

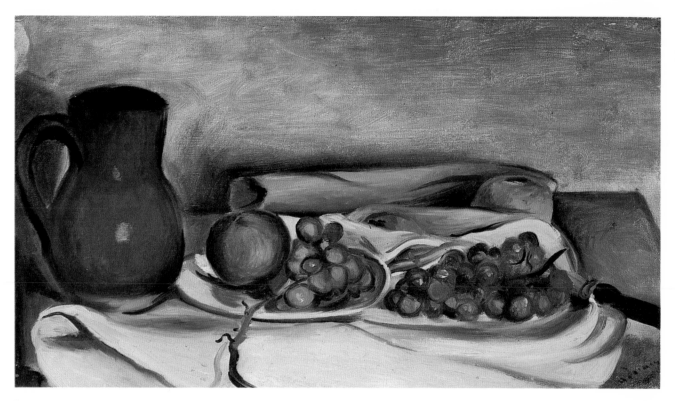

No. 3

No. 4

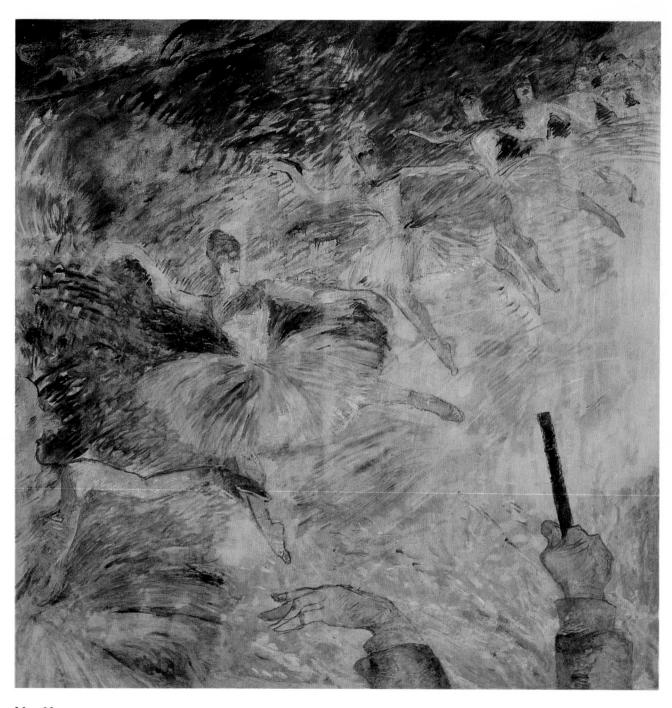

No. 22